03.06

FAR

the essential
BLACK &
WHITE
photography manual
for digital and film photographers

Mike Crawford

RotoVision

A RotoVision Book
Published and distributed by RotoVision SA
Route Suisse 9
CH-1295 Mies
Switzerland

RotoVision SA, Sales, Editorial & Production Office
Sheridan House, 114/116A Western Road
Hove BN3 1DD, UK

Tel: +44 (0)1273 72 72 68
Fax: +44 (0)1273 72 72 69
Email: sales@rotovision.com
Web: www.rotovision.com

10 9 8 7 6 5 4 3 2 1

ISBN: 2-88046-825-6

Editor: Chris Middleton
Art Director: Luke Herriott
Designed by Fineline Studios

Reprographics in Singapore by ProVision Pte. Ltd
Tel: +65 6334 7720
Fax: +65 6334 7721

the essential
BLACK & WHITE
photography manual

Contents

Introduction

The Essential Black & White Photography Manual is a complete and comprehensive guide, providing detailed instruction in both digital and traditional film-based techniques. Although both approaches require very different working methods, there is no doubt that a knowledge of one will enhance and enrich an understanding of the other.

Black and white is a cherished medium because it offers the photographer creative choices at every stage of the imaging process, from shooting, to making and presenting the final print. We can convey in our work a wide range of interpretations, emotions, and impressions through the choices available in either the darkroom, or on the computer.

Although digital technology has revolutionized photography in a relatively short space of time, ultimately it is just another method to take and print photographs. It is important to remember that black-and-white photography is an art that has

been evolving and changing, both technically and aesthetically, since the first photographs were presented to the world in 1839. Although color materials have been available for over a century, there is no sign of black and white losing its popularity.

This book will provide practical instruction in a variety of techniques to improve and enhance your black and white photography. Although knowledge of equipment is important, an understanding of what makes a great black and white photograph is equally valuable. The first half of the book will cover traditional film-based photography; how to expose and develop films correctly; the range of possibilities available in the darkroom; and the fine controls required for skillful printing. It also covers a variety of methods of toning prints, lith printing, and using historical processes from the 19th Century.

In recent years, many photographers have faced the choice of whether to continue making handcrafted prints

in the darkroom, or switch to digital imaging. As more have made the leap to digital, it is encouraging that so many have chosen to work in black and white. Manufacturers have responded by producing many inks and materials especially for what is now a growing market.

The second half of the book will provide clear guidance to the best ways to use the computer as a digital darkroom and how to achieve the highest quality prints. Further technical information is provided in a glossary and appendix with numerous chemical formulas, suppliers, Web sites, and other useful resources.

Throughout, the *Essential Black & White Photography Manual* will illustrate and inspire the reader, showcasing a wide variety of stunning work from leading photographers, all dedicated to achieving the best in this classic and reinvigorated medium.

While color landscape shots can be beautiful, black and white throws the emphasis onto form, line, and contrast, creating a timeless image.
Photo: Huw Walters.

Black-and-white photography can create stunning images that, in color, would lose their stark simplicity—like this study in shape and perspective.

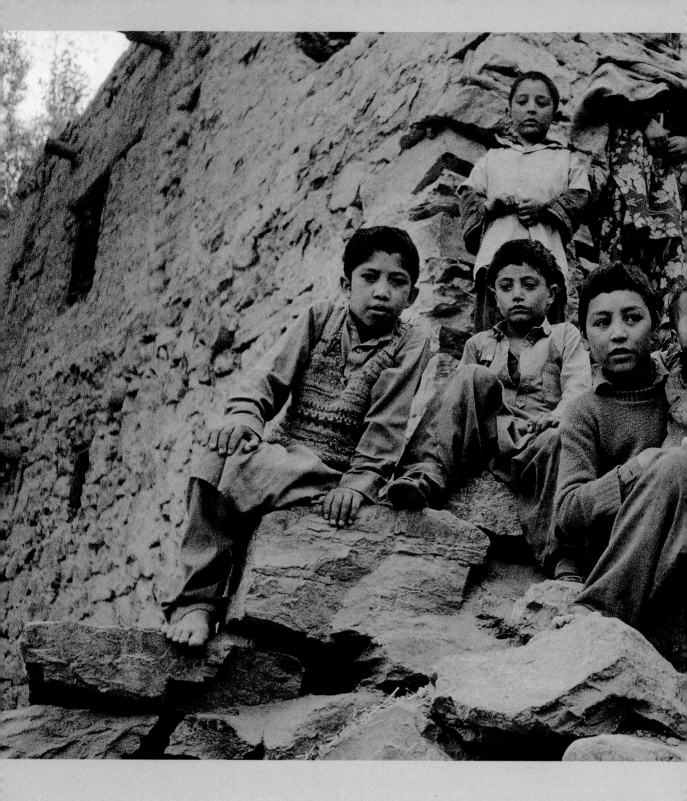

The Monochrome Image

Introduction

It ought to be an easy question to answer, but why should we want to photograph and print in black and white? Indeed, what are the particular qualities that make black and white such a special medium in photography? This question can, in parts, be answered by looking back over the history of photography.

Because the first photographs were monochromatic, and despite the eventual discovery of color photography in the early 1900s, we still retain a long tradition of seeing our world in black and white. It has applications in all types of photography—from portraiture and landscape, to photojournalism and fine art. We use many words to describe its unique attributes: a black-and-white portrait is often considered timeless, classic, and elegant; or a landscape is termed atmospheric and evocative. Styles as diverse as photojournalism and fashion work well in black and white because they can be bold, graphic, and direct. All these properties can be found in black and white—emotions that are not as easily realized or recognized when working in color.

An image's composition is naturally dominated by color, while in black and white we see the picture first and then its tonality. We can choose to preserve the mood and environment in an image, or we can exaggerate them to emphasize their presence.

Alternatively, we often radically change such features, thereby altering their meaning, as well as our perception of the photograph. To put it more plainly, in black and white we can take more control over the photograph.

Traditionally, working in black and white has also been the perfect introduction to taking photographs and crafting our own prints, because

Fathom, by Sharon Louise Aldridge, a dramatic and powerful image.

One of an exhibition sequence of Berlin images, by the author.

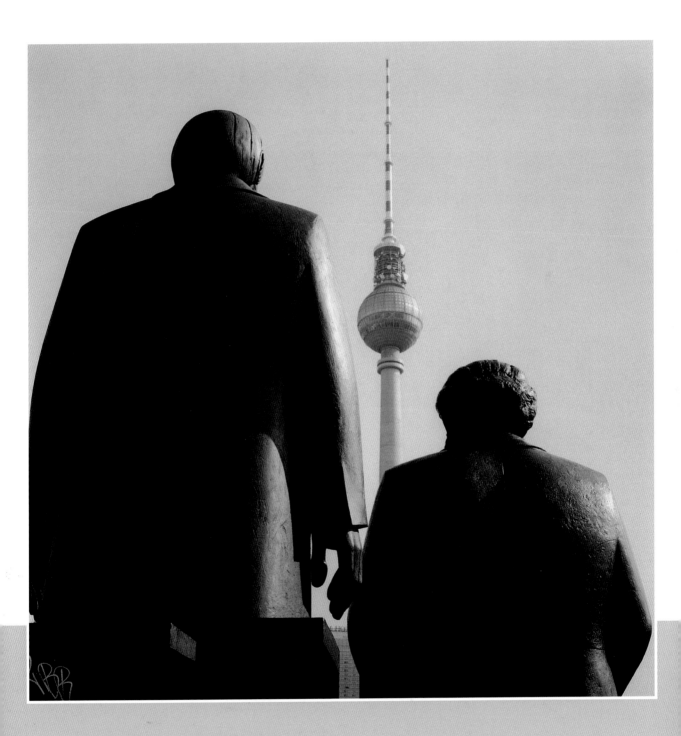

the simplicity of a black-and-white darkroom is preferable to the expense and complications of printing in color. This emphasis has inevitably changed with the increasing popularity—and, to an extent, dominance—of digital photography. Now it is easier to produce a color print on the computer than it is to produce a black-and-white print in the darkroom. This book will endeavor to show the best of both worlds, as well as the correct techniques needed to get great results both digitally and traditionally. Although digital photography is very different to traditional photography in the technicalities of how it records and prints an image, it is still a continuation of our photographic history—another way to make a photograph. Personally, I don't see it as a replacement for taking photographs on film—rather, it is merely another choice. Time will help us put this into perspective.

Methods requiring a negative and a print have been used since the beginning of photography. In 1839, the English scientist and sometime politician William Henry Fox Talbot demonstrated a miraculous process in which an image was recorded by a simple camera onto paper that had

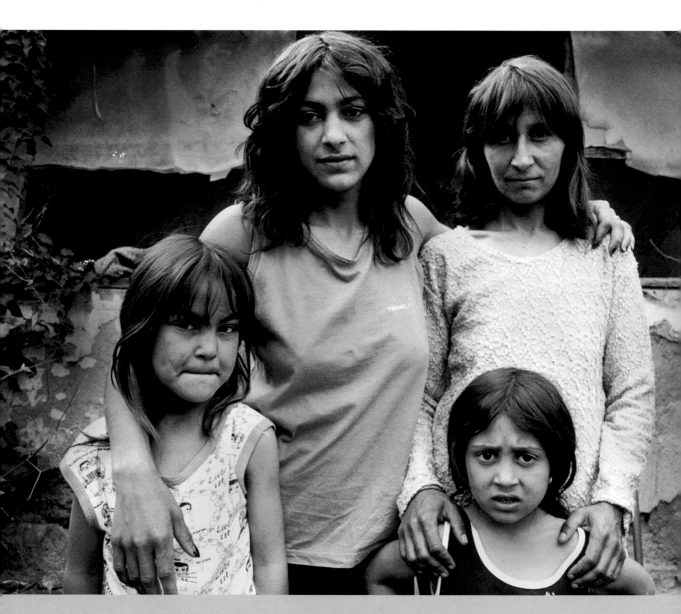

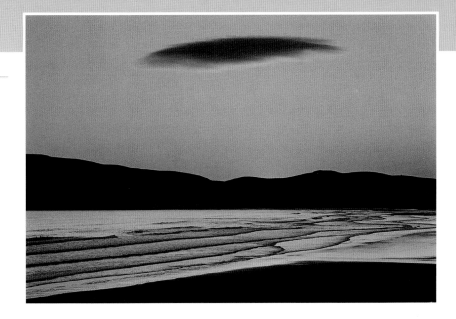

Ireland, Christopher Joyce. Note how black and white throws the emphasis onto line, composition, mood, and natural texture.

Gypsy Family in Serbia, Poppy Szaybo, 2002. An example of how black and white adds a grittiness and a timelessness to portrait images.

been made light-sensitive by silver salts. Since this process resulted in a "negative" (the tones of the image being seen in reverse), the paper, once processed, had to be contacted onto another sheet of sensitized paper, exposed to light, and then processed again to chemically stabilize the image. Only then could the image be seen in the correct tones. By today's standards these techniques were technically simple and basic (I would also describe them as beautiful and wondrous), however, after many changes, this process led directly to the photographic emulsions we use today. Silver salts are still used, though the paper negative has been replaced by film and the image is usually enlarged in the darkroom (though sometimes contacted) to make a print. Just as today, in 1839 there was more than one way to make a photograph.

Unbeknown to Talbot, Jacques Louis Daguerre and Joseph Niepce were collaborating in France on a different process to record the image formed by a camera. In fact, their discovery, by just a few months, was the first to be presented to the world. Only Daguerre (whose name the process was given) lived to see the results and profits of their partnership. Their method was unlike Talbot's, using very different chemistry and producing a delicate positive print directly onto polished copper. For the first 15 years, the "daguerreotype" was the favored process of the pioneering photographers for its ability to record portraits in incredible detail. Although the two techniques were different, they were both equally valid ways of making a photograph. Talbot's process only became dominant when two improvements were made (not by

him) to increase its sharpness, making it closer to the quality of a daguerreotype: a glass negative was used instead of paper, and the print's simple emulsion was augmented by albumen (egg white) to add a gloss finish. Eventually, the albumen print completely replaced the daguerreotype.

Perhaps these events can be seen as a parallel to the divisions in photography today. The debate still rages on the long-term future of traditional photography, though I firmly believe that there are too many benefits to shooting and printing conventionally for us to worry about its demise. The growth of digital technology is, however, a turning point in photographic history, and it should be embraced in order to make the most of our photography. There are occasions when the two mediums can effectively be used together, either by scanning and printing digitally from conventional negatives, or even by producing photographic prints from digital files. When we look at the final print, it should be the image we are looking at and not the technology used to achieve it. The camera, darkroom, computer, and ink-jet printer are essential tools for realizing this, but that is all they will ever be.

Lessons learnt

I have been a black-and-white printer for more than 20 years, and in that time I have been lucky enough to work for a wide variety of photographers. Whether printing portraiture, fashion, reportage, or landscape, there has always been something new to learn; and through working closely with photographers, I have gained more of an understanding of their approach to, and outlook on, photography. This has taught me that photography is an art with endless possibilities in subject, content, and realization. Though we can all use similar equipment and materials, there is little chance of two photographers producing the same photograph. A perfect example of this is the way in which press photographers often stand together, with their cameras pointing in the same direction, but only one might get the front page. Photography can be considered a language, in which we express various opinions.

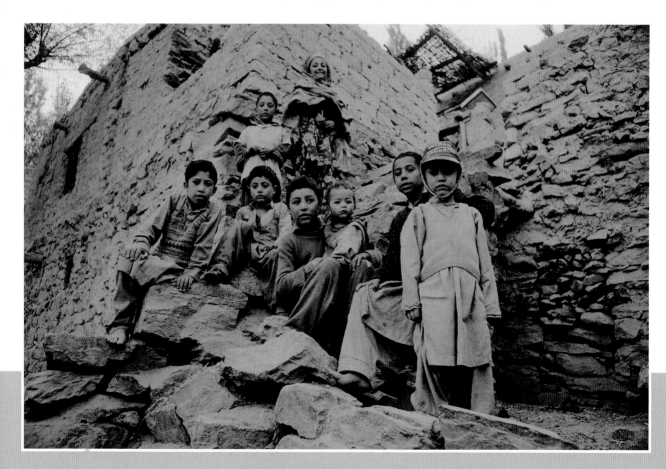

To make the most of your photographs, this notion of individuality should also continue into the work you do later, whether in the darkroom or on the computer. It is important to start by learning the basic techniques; once you are comfortable and familiar with them, you can apply and adapt them to suit your needs.

Communicating your passion

Joining a photo club or studying at college will expose you to new and different views. You should also spend time just looking at photographs, whether in a book or at an exhibition. In doing so, think about why a photograph works or, indeed, why it might not. Is it the subject, the lighting, or perhaps the quality of the print that influences your opinion? Photography is a visual medium and it is ultimately about images—it is not about having the best or latest equipment. As important as a good camera is, it is only there to help us take photographs.

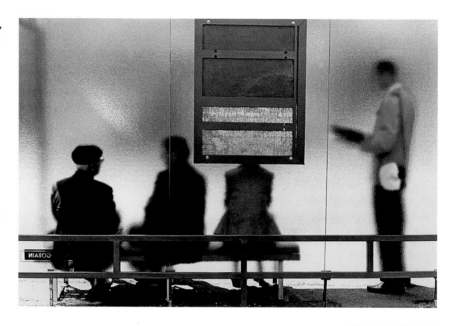

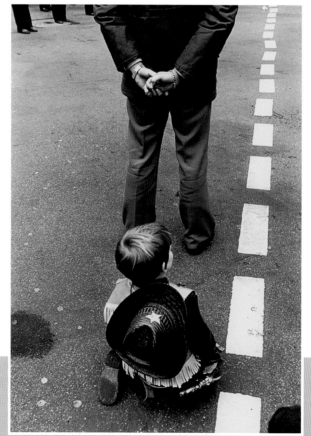

Arles 1980, **Wolfgang Zurborn. A still from life, that has more than a touch of surrealism about it.**

Cologne, 1981, **Wolfgang Zurborn. A frozen moment that communicates more the longer we gaze at it.**

Village Children, Pakistan, **Huw Walters, 1990. Lith printing can add extra warmth and contrast to black-and-white images.**

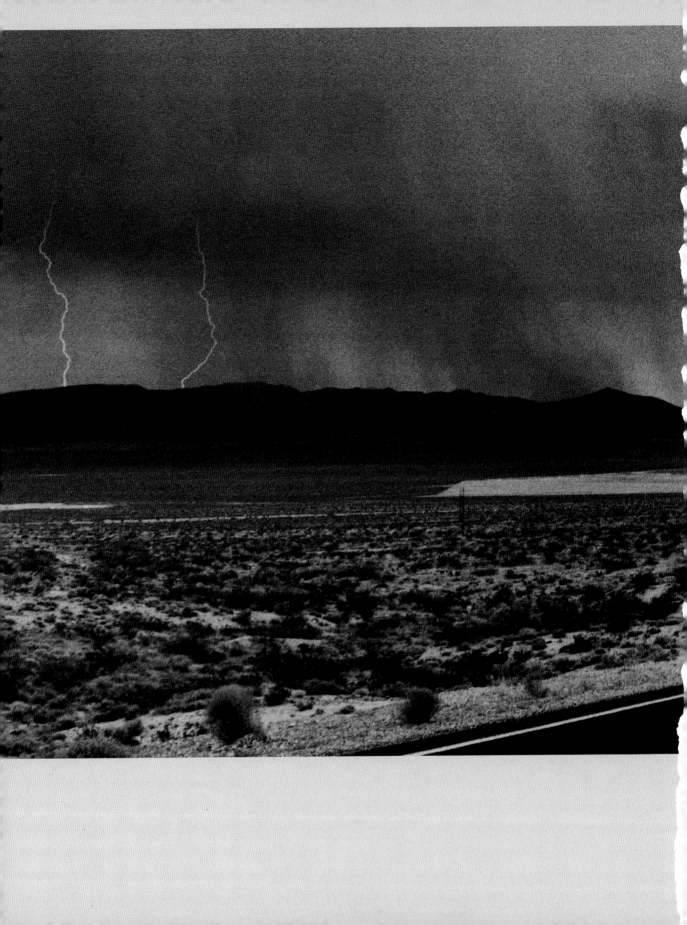

Cameras
and Lighting

02

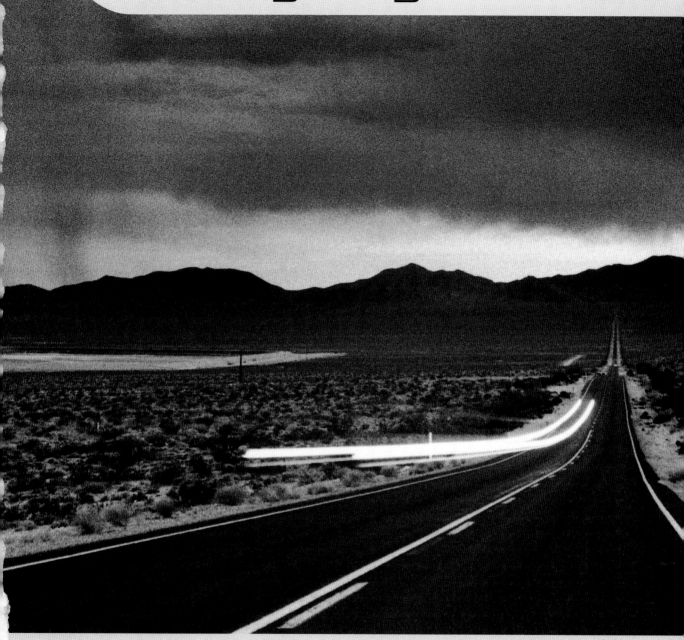

Cameras

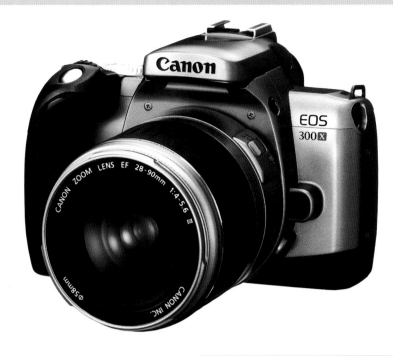

35mm Cameras

Of all the film formats available, 35mm remains the most popular. Cameras range from the simple compact to sophisticated SLR (single lens reflex) models capable of hosting a number of lenses. With all the advances in computing, SLRs are able to meter and expose film accurately under an extreme range of lighting conditions (for information on digital cameras, see p.133).

At their birth, still film cameras were an offshoot of early 20th century cinematic cameras. By the 1920s, the Leica, using a coupled rangefinder in its viewfinder for quick, accurate focusing, had become the classic 35mm camera. For photographers such as Henri Cartier Bresson, the simplicity of the Leica and the quality of its Zeiss lenses allowed new ways of working and a freedom unimaginable with the larger format cameras previously used.

The SLR was introduced in the 1940s. It uses a mirror and a pentaprism to enable the photographer to focus through the lens for greater accuracy. By the 1970s, Japanese companies, such as Canon, Nikon, and Pentax dominated the market for SLRs, producing cameras at all price ranges, accompanied by lenses of all sizes, from telephoto to extreme wide angle. The zoom lens, with its movable elements for changing the focal length, has given further versatility to 35mm cameras.

The 35mm compact is a relative newcomer. Originally produced as a cut-price snapshot camera, it is now available with the sophisticated optics and engineering of its older relatives. For a small and lightweight camera, the results can be remarkably good, and its size allows photographers to take pictures wherever they go.

Single Lens Reflex (SLR) Cameras such as the Canon EOS 300X, are now highly sophisticated, incorporating a zoom lens, motor drive, flash, and spot metering.

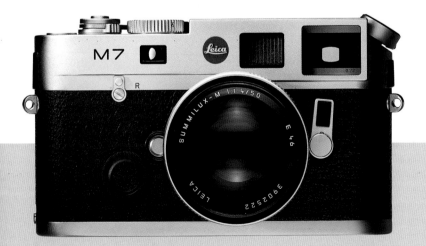

The Leica M7 continues in the tradition of high-quality rangefinders first made in the 1920s.

Tip

If you are starting out or experimenting in black-and-white photography, perhaps begin with a mid-priced 35mm SLR whose capabilities you can grow into, rather than opt for an expensive camera in a larger format.

120 Cameras

120 cameras offer a noticeable improvement in quality over 35mm. A larger negative will record greater resolution and detail, as well as requiring less magnification when printing, so film grain will be finer. There are several to choose from. The smallest is the 6x4.5cm camera, which can take up to 16 exposures on one roll; the largest is the panoramic 6x18cm, which can only manage four exposures per roll. In recent years, the 6x4.5 camera has become a very popular alternative to 35mm. It is handheld, the negative is more than twice the size of 35mm, and it is the most economical of the 120 formats.

The Hasselblad and Rolleiflex are old favorites of many photographers, and their 6x6 format will give you 12 exposures per roll. I have to admit that this is my preferred choice, but if you are unlikely to be taking square photographs and would end up cropping each print, then 6x4.5 would be a better option. The 6x7cm is another popular format, allowing ten frames per roll. Again, quality will be improved by an even larger negative, but many cameras this size are so heavy that a tripod is essential. However, the Pentax 6x7 looks just like an oversized 35mm SLR, and many photographers use this camera primarily because it handles like one.

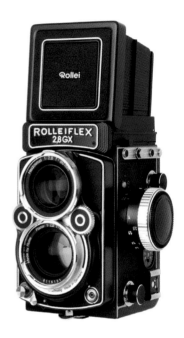

Rolleiflex twin-lens reflex cameras shoot on a 6x6 format. The 2.8GX is the latest in a long line of models dating back to 1927.

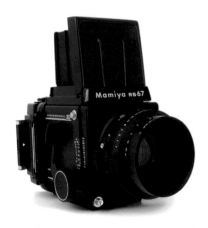

The 645 format has become increasingly popular, giving the flexibility of 35mm but with the quality of 120. The Mamiya 645 is one of the best-known models.

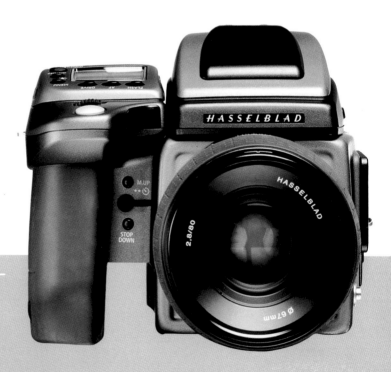

This Hasselblad H1 gives you the option of using a digital back as well as shooting on conventional film.

5x4-inch Cameras

With a 5x4in camera (and the even larger 10x8in), we can really achieve the ultimate in photographic quality. This format is the direct ancestor of the cameras of the 19th century, when negatives were almost always contact-printed. Enlargements made from 5x4 will contain an incredible amount of detail and clarity. There are two main types of 5x4: the studio camera, and the more portable field camera. Both will usually need a very sturdy tripod.

The studio camera is, at heart, a simple device, but it is loaded with precise engineering. A lens panel and a ground-glass screen are mounted on a monorail and are connected by a set of bellows. Both panels are movable; the position of the lens changes the image size, and the ground glass is used to focus the image, which is projected onto the screen upside down. Further to this is the ability to use "movements" on the lens and focusing panel. This means that perspective, depth of field, and distortion of the image can be controlled by using swing, tilt, shift, drop, or rise, each one an accurate description of a particular movement. The single sheets of film are loaded into a dark slide, which is then placed in front of the (spring-loaded) focusing screen. Alternatively, a Polaroid film holder (see p.40) or a 120 film back can be used.

The field camera is compactable, making it easier to use on location (in the field, as it were). Although it will have fewer movements than a studio camera, it has more than enough for most occasions. Remarkably, up until the 1940s, press photographers were still using similar models, handheld with a large flashbulb, to cover news stories.

Though similar in appearance to Victorian equipment, the Wista field camera is popular for shooting in large format on location. The lens panel retracts into the camera body, the baseboard is then folded and closed, making it an extremely lightweight and portable camera.

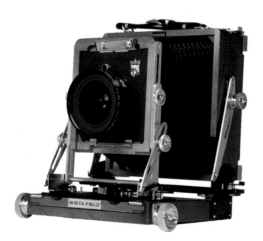

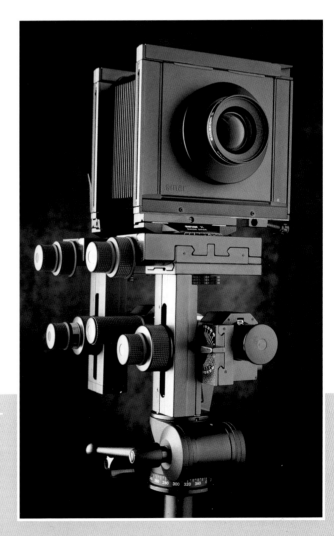

The Sinar X is a 5x4 studio camera offering full control over camera movements. It can be used with a variety of large-format lenses, each containing its own shutter.

Film Formats

The difference in format size is best described visually, and the actual-size contacts reproduced here demonstrate the wide range of available films (except for the 10x8in, which would be too big for the page). But is there an ideal format to use overall? I really don't think so, because they all have individual advantages and disadvantages. A 5x4in will give incredible detail compared to a 35mm, but the ease and portability of a 35mm camera allows for the types of photography that would be impossible with a 5x4.

35mm

6x7

645

5x4

Lighting and Exposure

I was always somewhat amused by the hopeful suggestions that were often included with rolls of film, encouraging the user to estimate the exposure by looking at cartoon illustrations. Dull weather, symbolized by a big cloud, would require f4, while a bright happy sun would demand a faster exposure of f22. As a starting point it was better than nothing, but the accuracy of exposure depends on the intensity of light, and that will change depending on the time of day, season, and geographical location. These symbols were a throwback to the days when it was not unusual to use a camera without an exposure meter. These days, it is normally just large-format cameras (5x4in and 10x8in) or older medium-format models that don't have a built-in meter. However, it is important not to rely absolutely on automatic exposures. Most cameras will have overrides that allow either aperture or shutter speed to be given priority, and the camera will then calculate the corresponding exposure time or f-stop. Consult the camera's manual to see what other exposure controls are possible; there will doubtless be a wide range.

One important feature of camera metering is the ability to select an area from the subject's tonal range that gives the most balanced tone between the highlights and shadows. You can normally do this by aiming a circle or square in the viewfinder at the correct area, holding the shutter down halfway, and then reframing the subject to take the photograph. Often this action is combined with autofocus. It will prevent a dominant tone, such as a bright sky, from influencing the exposure, which would result in darker tones in the foreground becoming underexposed. However, do not expose just on the deepest shadows unless you are going to process accordingly (see p.36). Instead, find a tone that naturally falls into the middle of the tonal range.

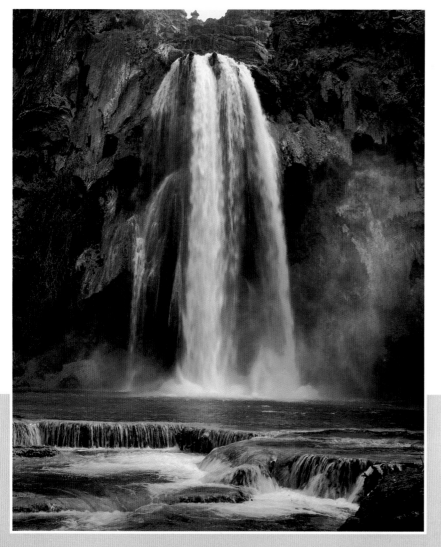

This photograph required careful exposure metering to balance the highlights of the waterfall and the dark rockface. As there were two stops of difference, an in-between f-stop was selected. The print was then exposed for the rocks and the water and the glimpse of sky given extra exposure to compensate. Photo: Huw Walters.

Natural Lighting Against the Elements

In black-and-white photography, lighting becomes part of the subject and influences the atmosphere of the photograph. Effective black-and-white photographs can be taken in all conditions, and if the results are initially soft and undefined, then you can add contrast or manipulate them to exaggerate the mood once you are in the darkroom. Misty mornings are wonderful times for photography (see image, right), since the fog and soft light will transform familiar places. Of course, many landscape shots will only work with good lighting to give the scene definition and shape, but if it looks like the sun will never come out, then think about photographing the scene in a different way.

Working in a thunderstorm (see image below) requires dedication, suitable clothing, and a camera that is well protected. Cameras should be shielded from excessively cold or wet conditions. In the 1980s, British photographer Martin Parr published a book called *Bad Weather*, shot in England. The conditions in which he took his photographs were so inhospitable that he finally resorted to using an underwater camera.

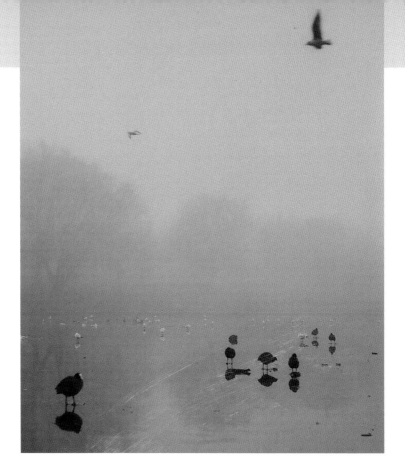

A foggy day in London was accentuated with a slight sepia tone.

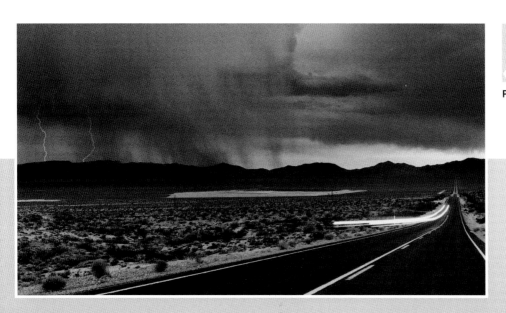

The trails from a car's lights indicate how long an exposure was required while shooting in a thunderstorm. Photo: Huw Walters.

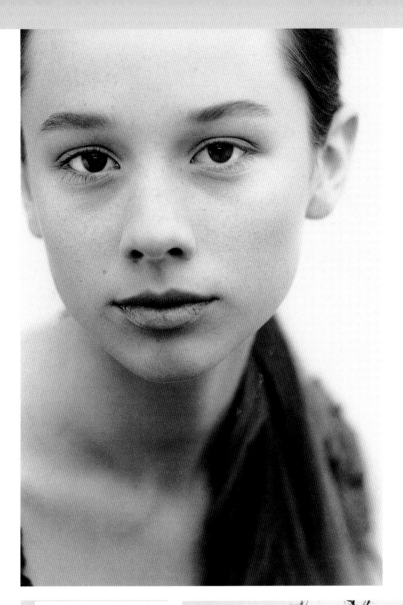

Soft daylight can be ideal for capturing a smooth range of skin tones. Photo: Huw Walters.

Portrait Lighting in Daylight

When using daylight for portraiture, perhaps the worst thing to do is to use bright sunshine as a direct light. This is not as strange as it sounds. The trouble is that once you position your subject, set up your equipment with the sun directly behind the camera, and ask the model to look toward the lens, the first thing he or she will do is squint. On top of this, the hard light may form shadows, emphasizing lines and wrinkles, especially if taken around midday when the sun is at its highest. A lot of fashion photographers prefer to use evening lighting, when the sun is lower; or if they must work in bright sunshine, the eyes might be hidden by sunglasses. The light is often kinder when the sun is not so intense—so you could try a cloudy day, which will help diffuse the light. Otherwise, it is best to use bright sunlight at an angle, or place the subject in the shade, and then bounce the light back into the face with a portable silver reflector, a white sheet, or some white card to lift the shadows. Alternatively, "fill-in" flash can be used to brighten up the face. When working in black and white, shooting in overcast or dull light is often very effective, since the flat (but hopefully tonal) negative can then be printed on higher-contrast paper to provide you with a good strong range of tones.

In this fashion shot for *iD* magazine by Donald Christie the atmosphere of the landscape is a key element.

 Tip

Try taking some indoor portrait shots without flash using daylight, by getting your subject to stand facing a nearby window that is not in direct sunlight. Try faster film speeds than usual, and compare the range of tones and textures.

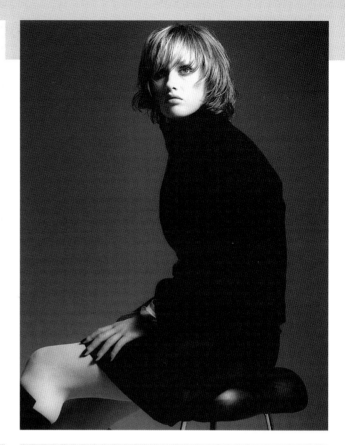

Portraits against a white background will highlight and add extra definition to the subjects, but take care to balance the exposure between the two. Photo: Dean Chalkley.

Likewise, when using a gray background take great care in controlling the lighting to ensure separation of tones. Photo: Tessa Hallmann.

Portraits with Flash

Whether you are in the studio or on location, using flash (or tungsten lights) can give you total control over the lighting of your subject, but it requires care and practice. Learn the differences between floodlighting, usually with a soft-box attached to the flash, and spotlighting. The first will give an even spread of light, while the second is a concentrated, harder light, useful for accentuating shadows or edges. Unless you are going for a dramatic effect, think of your lights as if they were sunlight. (Remember, some of the most beautiful studio portraits are shot using only natural light.) Do not place them too low or straight onto the subject, but direct them down, at an angle. And if the shadows are too severe, a softer, weaker light or reflectors can be used to fill them in. Don't place lights too near the subject because he or she may appear overlit. The choice of background will also affect tonality. Think about how tones will separate— white on white, or gray on gray—and adjust the lighting or use filters (see p.42) accordingly.

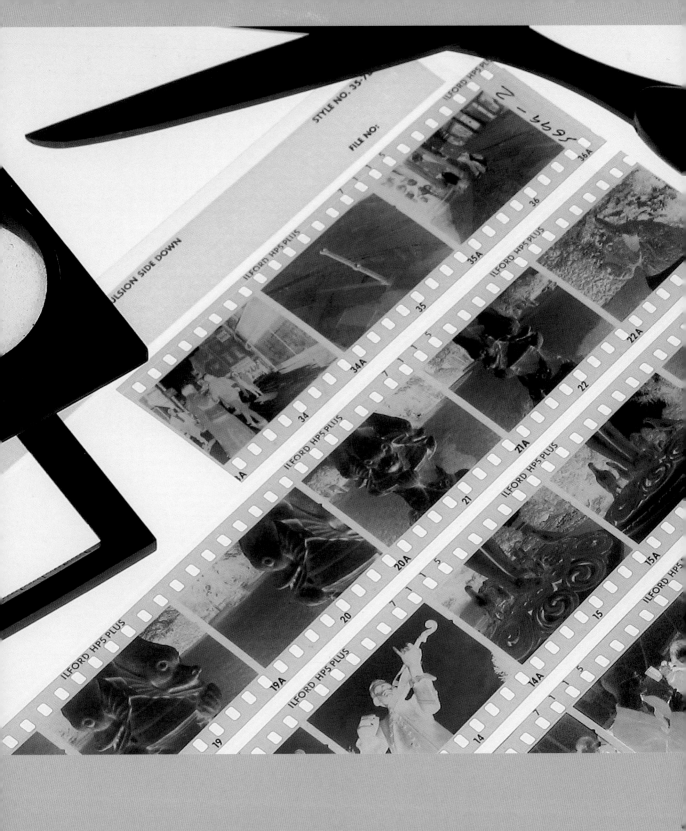

Film and
Processing

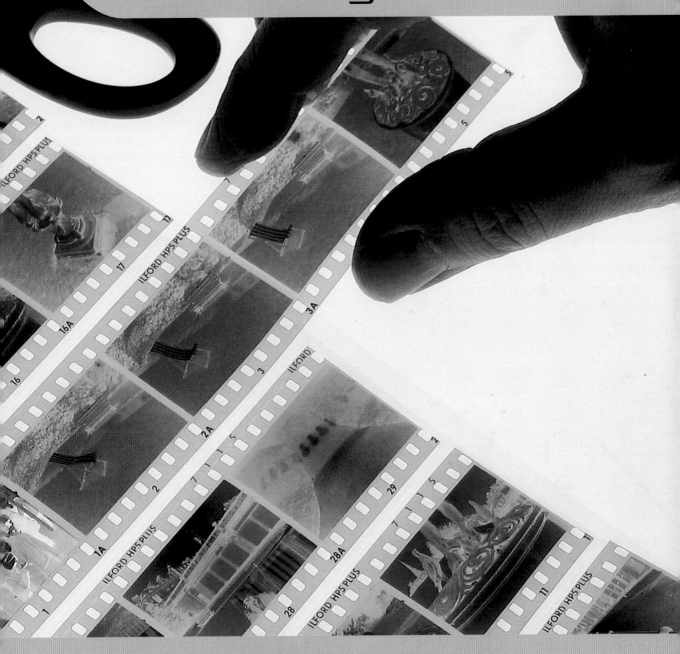

Black-and-White Film

There is a wide range of black-and-white negative films available in many formats, from 35mm to 10x8in. When selecting a film, you must consider its speed (how sensitive it is to light) and the type of film—whether it has a traditional black-and-white or a chromogenic emulsion (see below). We should first examine the differences between these two types.

Film and its predecessor, glass plates, have been commercially manufactured since the 1860s. Before this time, photographers had to coat their own plates with light-sensitive chemicals, whether they were working in the studio or on location. Early film was "orthochromatic" and could not record a full range of tones, being sensitive to blue and green light but not red. True panchromatic black-and-white film, which could record all visible wavelengths of light in monochrome, was finally produced at the end of the 19th century, and by the 1920s it was being manufactured as 35mm and 120 roll films. The plastic base was coated with an emulsion containing light-sensitive silver halides, which are visible as grain when developed. Films such as Kodak TriX and Ilford FP4 are the direct descendants of these early films. In the 1980s, a new structure of emulsions was introduced that used a "T-Grain" formula. These films—Kodak Tmax and Ilford Delta, for example—are similar to the older emulsions but use additional chemical dyes to improve sensitivity. The grain is formed in a "tabular" shape, which, though bigger than traditional grain, is smoother, so negatives appear sharper. Both these types of emulsion are processed using the same chemistry, so are often seen together as "conventional" black-and-white film.

Chromogenic film, first manufactured in the early 1980s, uses color-negative technology to form a black-and-white negative. The silver halides are coupled with dyes that, when processed, will form the image as the silver contained in the emulsion is bleached away. These films, including Ilford XP2 and Kodak TC400N, must be processed in the same way as a color negative, but they can then be printed as a normal black-and-white photograph. They are very fine-grained but often lack contrast if not exposed and processed correctly.

Most photographers usually settle on one or two favorite films. This was shot on Ilford HP5 Plus (see opposite), which I normally rate between ISO 200 and 400. It is still relatively fine grained, but fast enough to use in different lighting conditions.

Film Speed

The amount, size, and distribution of grain is what determines the speed of a film. This is described as its ISO (see Tip below) rating. A film rated 50 ISO will have relatively small grains of silver halide, so will not be as sensitive to light as a 400 ISO film, which has far larger grains. But this increase in sensitivity means that a faster film will appear grainier than a slower film, although this is less of a problem with modern films. It will also be less "contrasty," but this can be changed in processing and printing. As the ISO rating doubles, the film's sensitivity changes by exactly one stop of exposure. So a photograph shot at 1/30 second at f4 on a 50 ISO film, could be shot at f5.6 on 100 ISO, f8 on 200, and f11 on 400.

With these options, we can consider what are the most practical films to use. If you wish to process the images yourself, you would have to use a conventional black-and-white film, but if you want the film processed quickly at any normal processing lab, a chromogenic film is ideal. For a general-purpose film that can respond to a variety of lighting, 400 ISO films are perfect. However, for very fine-detailed work, a 50 ISO film, preferably on a larger format, would be the best option. See page 38 for more on films.

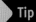 **Tip**

Although many photographers use films rated up to 400 ISO (which stands for International Standards Organization), you can purchase films as fast as 1600 or 3200 ISO. Experimenting with these is worthwhile.

Film Processing

The emulsion of black-and-white film consists primarily of light-sensitive silver-halide molecules suspended in gelatin and coated onto an acetate base (see p.28). When a photograph is taken, a minute number of these millions of molecules will be darkened by the action of the light. You cannot see this photograph on the film—at this stage it is known as the "latent image"—until you use the correct chemical (a "developer") to greatly intensify the image by darkening the molecules surrounding those of the latent image. These collections of silver halides are what form the grain in a negative, and areas of the film that have been exposed to more light (the highlights) will be far more intensified than those in the shadows. To stop this reaction, another chemical is used (a "fixer") to dissolve the halides that have not yet turned to black.

Spirals and darkness

In practical terms, you'll have to load the film onto spirals in total darkness and then process them in development tanks for this chemical reaction to take place. Spirals are made from either plastic or stainless steel. With plastic, you have to cut off the end of the film and carefully push it into the opening of the spiral. Next, you twist the two halves of the spiral—which contain ball bearings to advance the film—backward and forward until it is fully loaded. Last, cut the end of the film away from the plastic spool and place the film into the developing tank. Stainless-steel spirals can only be used for one size of film, but they will last for years. They are loaded by holding the end of the film, bending the edges carefully, and clipping it onto the center of the spiral. You then rotate the spiral (which should be placed on a work surface) with one hand, while the other hand holds the film, guiding it into the spiral.

Next, prepare the chemicals. Always use solutions at 68°F (20°C), unless otherwise stated, and to begin with, use the recommended dilutions and

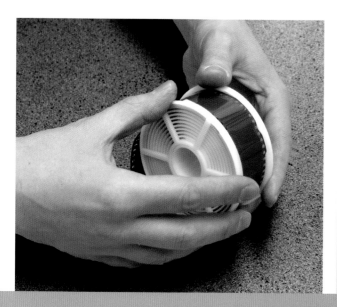

Take great care when loading film onto the spiral, (especially 120 film) to avoid getting any kinks into it, which will print as white, crescent moon shapes.

All chemicals should be carefully poured into the development tank as smoothly as possible, though take care not to be so quick that air bubbles will form on the film. A prewash in still water for three minutes (at 68°F / 20°C with intermittent agitation) will help the developer to coat the film evenly.

development times. Once you have learned more about exposure, these times can be altered to suit your requirements. The developer, stop bath, and fixer should all be in jugs ready to be used one after the other. It is advisable to develop film in a sink, so that any chemical spills can be washed away. You should also wear rubber gloves to prevent chemicals from harming the skin.

Spirals and darkness

Carefully pour the developer into the tank (into which you have already placed the film), and start your darkroom timer (or clock) once you have put the lid on. The tank needs to be regularly "agitated" to keep fresh developer moving over all parts of the film. Do not shake the tank, because this can cause uneven development; instead, hold the top of the tank and invert it by 180 degrees, return it, and repeat throughout the agitation. A normal agitation pattern would be 30 seconds at the start of the processing, and then 3–5 seconds every 30 seconds. After each time, tap the bottom of the tank on the sink to remove any air bubbles caused by the agitation. When the tank is inverted, it is a good idea to twist the tank slightly in your hand. This is to ensure the developer moves freely around the film. If the agitation is too regular, there is a chance that development streaks may form, especially on 35mm film where the developer will be forced through the sprocket holes and run down the film, slightly overdeveloping those areas. Whether you use a precise darkroom timer or a clock, make sure that timing becomes part of an accurate and repeatable routine that also includes discarding and replacing chemicals.

After development, open the lid, pour away the developer, replace with the stop bath, and agitate continuously for 30 seconds. The developer is an alkaline solution, and the stop bath is made from dilute acetic acid, which "stops" the action

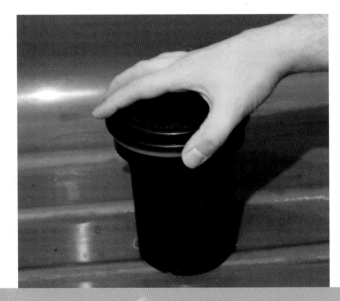

The pattern of agitation should be accurate. Being overly vigorous will cause streaking, and air bubbles will cling to the film. Gently tap the bottom of the tank on the sink and slightly open the light-proof lid now and again to release any air.

During this process, inverting the tank regularly will give the best agitation pattern.

of the developer left on the film by neutralizing its alkalinity. When this is finished, it is replaced by the fixer. Again, this should be given a similar agitation to that for the developer, though the fix time will usually be shorter. The fixer and stop bath can be reused, but keep a note of how many films have been processed, and discard them before they reach the recommended limit.

After fixing, the film needs to be washed—if possible at 68°F (20°C), though certainly no warmer. You can simply connect a hose from a faucet to the tank and wash for 30 minutes; however, I would recommend that you first pour in a jug of water and agitate 20 times. This should be discarded and then repeated twice before giving the full wash. This is a very effective method of removing most of the fixer quickly, and it ensures a thorough and archival wash. Afterward, the film must be carefully removed from the spirals, have film clips placed on each end, and be hung to dry in a dust-free environment. Before doing this, it is advisable to pour into the tank a solution of wetting agent for a minute—this will help the film dry evenly. To reduce drying time, a film squeegee can be used to remove the surface moisture, but keep this helpful tool meticulously clean and free of dust and dirt to prevent it scratching the film. Before and after use, always rinse it in clean water. A film-drying cabinet, if available, is useful for cutting down on drying times, but never let it get too hot because the films may curl and dry unevenly. The minimum heat possible will dry films very quickly, though I usually just use the fan in my cabinet, which means that air is passed over the films but no heat is used; this will dry film in about 20 minutes. Afterward, cut the film into strips on a clean surface and file it in negative sleeves (see p.41) for contacting and printing.

Make sure the wash hose is properly connected so the water is pushed to the bottom of the tank.

A squeegee will help to dry the film quickly, but be sure that it is clean, as any grit will leave scratches throughout the length of the film.

If possible, use a lightbox to rest the film on for cutting.
Alternatively, use a large sheet of clean, white paper.

Chemistry

There is a large choice of different developers available for processing black-and-white film. This will affect the final quality of the negative, its tonality, granularity, and sharpness, all of which will ultimately be reflected in the final print. A developer consists of a combination of different chemicals, known as developing agents, which work together to darken the exposed silver-halide grains.

A general-purpose developer, such as Kodak D76 or Ilford ID11, will provide a negative with a good tonal range and relatively fine grain, depending on the choice of film used. It can be used undiluted—in what is known as a stock solution—and, if made in large volumes in deep tanks, can also be reused. However, a quantity of "replenisher," which is a stronger version of the same developer, must be added after each process to ensure the developing agents remain active. Some developers can be diluted—from 1:1 to 1:5—which usually provides a smoother negative, but development times must be increased accordingly and the chemistry discarded after use.

Fine-grain developers—for example, Ilford Perceptol or Tetenal Ultrafin—are recommended to be used diluted, which will decrease the size of the grain. The disadvantage of this is that the film will usually have to be shot at a lower ISO rating than normal. When choosing a developer for a certain processing characteristic, there is always a trade-off, such as finer grain requiring a lower speed for shooting. Alternatively, when you want to increase the speed of a film (see p.36), the recommended developers will allow a 400 ISO film to be shot at 800 or 1600 ISO, depending on the contrast of the light, by extending the development time. Naturally you don't get this for nothing, and the grain will increase in size slightly depending on the change in development time. You will then have to use developers such as Kodak TMax or Acufine as a stock solution to preserve their strength for increased development.

Agfa Rodinal is a particular favorite developer of mine. It uses a formula that is more than 100 years old and gives very detailed and tonal negatives with sharp, crisp edges (referred to as high acutance). It is also highly economical, with recommended dilutions of either 1:25 or 1:50. Of course, for all these good points, you have to accept that the grain is slightly increased, although it is very sharp. However, you also have to consider what speed and format of film is to be used. A slower emulsion shot on medium-format and developed in Rodinal would appear finer in quality than a similar 35mm film processed in Perceptol. Another classic developer is Pyro, which stains the negative and then acts like a filter on the negative to balance the tones. When enlarged, this can make for smooth prints and sparkling highlights. The drawback is that it is toxic and must only be used with excellent ventilation. It should never come into contact with the skin.

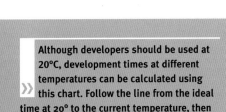

Although developers should be used at 20°C, development times at different temperatures can be calculated using this chart. Follow the line from the ideal time at 20° to the current temperature, then read the new time at the bottom.

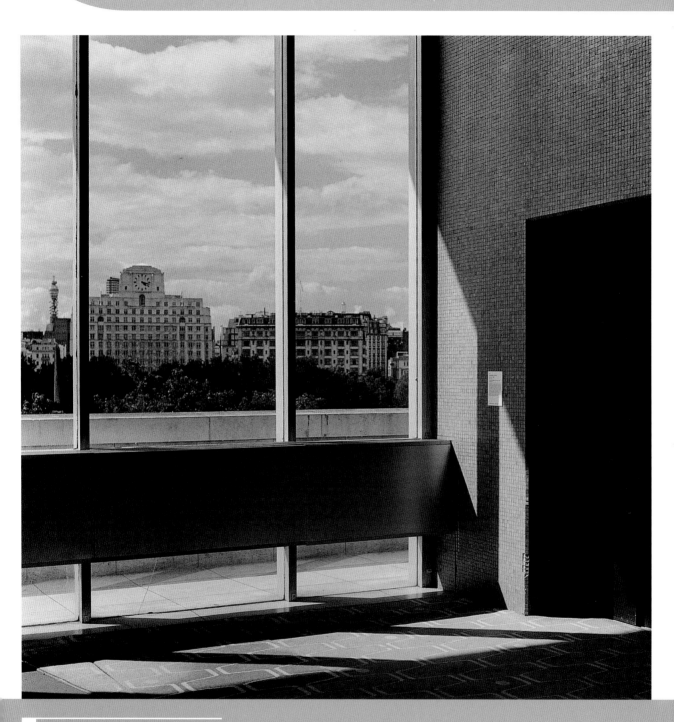

Pyro developer has been used since the 19th Century, but due to its toxic components it should be handled with care. It will however, give sparkling highlights, smooth grain, and a very balanced range of tones—as above.

Exposure

Understanding how film exposure relates to development is the key to achieving the best results for your negatives. The important point to remember is that the length of development will affect the contrast and density of the negative. Less development will mean less contrast, and more will increase the contrast. The recommended time at the suggested rating should, if the photograph has been accurately metered, result in a negative of normal contrast with good detail throughout the tonal range—though this will work best when the subject matter itself has a balanced tonal range.

Altering the rating

You may also want to alter the rating of the film to accommodate either a more extreme tonal range—such as bright highlights next to deep shadows—or a far lower range, where the light is flat and a negative processed normally would result in very low contrast. To give an example of the first condition, think what would happen if you took a photograph on a very bright day of a white wall, half of which is in shadow, cast from a nearby building. The speed of film used will affect the contrast, with a higher speed film (400 ISO) giving softer results, but this will still not give you the tonality you want. Decreasing the development time will lower the contrast but, to compensate, more exposure will have to be given. The negative will be effectively overexposed and then underprocessed. How much depends on the level of contrast, but the conditions described would merit at least one stop extra, and maybe two. This would mean you have to reset the meter from 400 to either 200 or 100. Even though it may sound a strange idea to purposely overexpose a very bright scene, the contrast range will be lowered by less development, the negative will have more details in the shadows, and the highlights will not be so overblown. Needless to say, it is best to make a series of tests, but decreasing the development time by 15 percent for each stop should be a good starting point. I tend to rate nearly all my film one stop over, unless I know it is going to be low-contrast light. This is because I prefer to have a more tonal negative that, although slightly on the flat side, can be increased in contrast in the printing but still hold better shadow detail. Bear in mind that unless you are using single sheets of large-format film, which can be processed separately, the complete roll of film will have to be rated at the same speed.

Setting for the sun

To return to our imaginary wall, what if you wanted to take a portrait against it, but the sun had gone in and the scene was totally in the shade? You would obviously want to raise the contrast on the negative by overprocessing, and again you would have to compensate your exposure by using a higher rating. Or in other words, you will be starting with a potentially thin negative, but extra development will bring back the tonality at a higher contrast than normal. One stop extra usually requires a 25 percent increase in development time: This is referred to as "pushing" film, as opposed to the previous example, which is called "pulling." We often push film in low-light conditions. However, do not think that by doing so you will get a full range of tones. The more you push the film, the less detail there will be in the shadows and the more the film grain will increase in size (pulling decreases the granularity), but the contrast of the negative will hopefully be raised enough to get a good print from it.

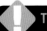

Tip

If you are starting out with no great photographic knowledge, try photographing a friend holding up a series of cards that detail the aperture, film speed, and exposure time of each image, and print these up as a reference.

Underrating film will decrease its contrast and give more shadow detail.

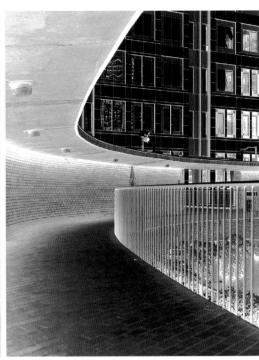

Pushing film will allow you to expose in lower light conditions, but there will usually be a loss of shadow detail and the negative will increase in contrast.

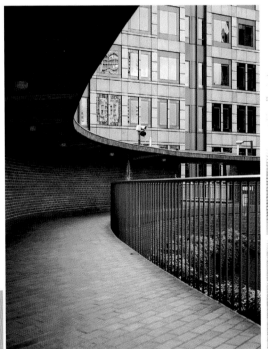

Further Specialist Films

High-Speed Films

Today we have a choice of two emulsions using T-Grain technology (see p.28) that are faster and less grainy than previous high-speed films. Kodak TMax 3200 and Ilford Delta 3200 can be used in extremely low-light conditions, but will certainly display more grain than a standard 400 ISO film. They can be processed in normal developers (see p.110 if more grain is required), but care should be taken to ensure correct exposure. "Low-light conditions" often mean very contrasty lighting, such as photographing at concerts under stage lights. If so, it is usually advisable to pull (downrate) the film by one stop and process accordingly (see p.36) to lower the contrast range of the negative. High-speed films work best under relatively normal or slightly flat lighting, but they can be pushed (uprated) by at least one stop.

High-speed films make night time exposures far more practical than pushing normal emulsions.

Tip

35mm infrared film is by its nature very grainy. To emphasize this when printing, choose a negative which is slightly thin, but contains a full tonal range. Use a higher filter setting than normal to get a print with sharp, biting grain.

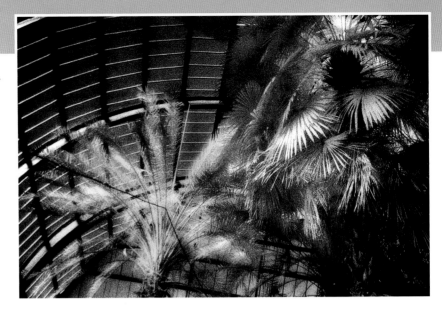

» Here is an image shot on Kodak infrared film. Note the almost unearthly effect on the tonal range in the image.

Infrared Films

This type of film was originally created for scientific research to record infrared radiation. However, the distinctive nature of the results soon made them popular for creative and experimental photography. When used with a deep-red filter, infrared film displays some curious changes to the tonal range of a photograph. This is due to its sensitivity toward the light waves (or radiation) just beyond our visible spectrum. In a way, infrared allows you to photograph something not visible to the human eye. The red filter blocks out the blue light, so this will print as black (very effective when photographing clouds), but it is with living matter, which reflects infrared radiation, that strange things start to happen: Green foliage can be turned white due to the chlorophyll in plants, and skin tones appear significantly paler because our skin pigment reflects this unseen light. The best results with infrared film are achieved in good strong sunlight, because without a filter it reacts like a normal (and grainy) black-and-white film. It is also said that the lens must be slightly unfocused when using this film, and many lenses have an infrared dot just beside the normal focusing mark; however, this is not necessary unless you are using an infrared filter, which is virtually opaque and does not transmit any visible light.

When handling, exposing, and developing infrared film, always keep the film securely in its light-tight container, and load and unload the camera in darkness. Although the film has a recommended speed, this will ultimately depend on the intensity of the light and the strength of the filter—if in doubt, bracket your shots. When processing, be careful not to overagitate in the developer and fixer, since it is very prone to uneven development. It is a good idea to presoak the film in water (three minutes at 68°F [20°C]) prior to development. Last, dry the film with great care and preferably no heat.

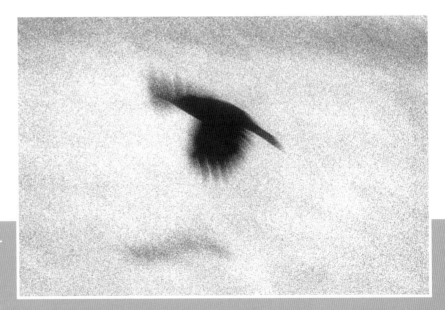

» As well as changing the tonal values of the photograph, the high grain will also add to the texture and atmosphere of an infrared photograph.

Polaroid Film

Polaroid materials are fun to use for making instant photographs but, professionally, they are invaluable for checking focus, exposure, and composition. There are also two Polaroid films that will supply a negative as well as a print that can then be printed conventionally; the only drawback is that they must be used with either special Polaroid cameras (which can often be found cheap secondhand) or professional cameras that can be used with a Polaroid back. If either of these options is possible for you, it is well worth trying out Polaroid film, since it is incredibly fine-grained, has an excellent tonal range, and can produce superb prints. Type 665 is used for medium-format and Type 55 for 5x4. A slight drawback of Polaroid films is that they require some care and attention when treating and washing the negatives. Once the film and print are peeled apart, the negative must be soaked in a clearing bath to remove the processing gel. An 18 percent solution of sodium sulfite is used for this (6.5oz. [180g] of chemical to 1 litre of water), though there is no exact time required—anything between 10 minutes and two days seems to work, but avoid the solution getting too warm, since this can cause the emulsion to float off.

If you are shooting on location, it is common to use a "Polaroid bucket," where the film is held on a frame that sits in the solution. Back in the darkroom, the sheets are then washed and dried normally. If there are chalky marks left on the film from the sulfite, a weak stop bath can be used to clear them, but they will need to be washed again. Many photographers shoot exclusively on Polaroid and often use the distinctive borders as part of their prints. When using these films, note that it is important to overexpose the film by one to two stops to get a correctly exposed negative. The Polaroid itself will appear too bright and contrasty, but the negative will produce an outstanding print.

This shot was printed showing the full frame of a Polaroid 665 negative and then slightly sepia toned to add warmth to the print. Photo: Dean Chalkley.

Filing and Storing Negatives

Having carefully exposed and processed your negatives, it would seem pointless to throw them in a shoe box in a cupboard until they may be required someday for printing. Negatives are delicate and fragile, so if you want them to last a long time and provide prints that are free of marks, dust, and scratches, you should treat them with respect and care. It goes without saying that touching the film should be avoided except for by the clear edges. A fingerprint on the back of the film may be removed with lighter fuel and cotton wool, but one placed on the emulsion will be there for good and will usually show in a print. There are many types of filing and storage systems available, and any reputable darkroom supplier can give you advice on the most suitable products.

For long-term archival storage, negative sheets made from glassine (which most are, unfortunately) should be avoided. Although they are soft and will not scratch negatives, the paper fibers will probably contain trace elements of sulfur, which may cause problems in the future. The very thin "print-through" sleeves made from brittle and easily torn plastic should not be used either. Instead, buy proper archival sleeves (above right) made from polyethylene; these are not much more expensive and are chemically inert. To keep your films ordered, proper negative files should be used; and for extra

Archival sleeves made from polyethylene are ideal for filing negatives.

protection, consider getting museum boxes (see below) that combine a ring file with an acid-free archival box. Lastly, do not store negatives in a hot, humid, or damp room, above a radiator, or, if you use it for printing, in the bathroom. Instead, find somewhere well ventilated and dry with a relatively even room temperature of around 68°F (20°C).

Museum-quality presentation boxes will offer negatives the best protection possible.

Filters

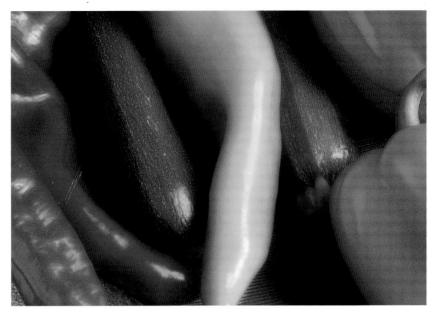

Many different filters can be used in front of the lens to change the qualities of the light that the film receives. They will either alter the tonal scale or affect the detail and clarity of the image. The most common filters used in black-and-white photography are colored gels that will brighten (on a print) subjects similar in color to the filter and darken its opposite color. If we think of white light, it actually consists of red, green, and blue—or this is how it is perceived by the cones in our eyes, which are responsible for our color sensitivity. We can see this division when light is passed through a prism, or in the formation of a rainbow. It splits light into these basic colors, divided by secondary colors—cyan, magenta, and yellow, being visually the opposites of red, green, and blue.

So with a filter such as red, it will darken colors close to cyan and brighten tones containing red. What this means in practice is that a blue sky will be darkened toward a black depending on the depth of the blue, as will green foliage and trees, while skin tones (which contain red) will be brightened. Likewise, an orange filter will also darken the sky (see right), though not as dramatically as red; and a yellow filter is useful if you want to darken the blue of the sky slightly to emphasize clouds. Because the yellow will also brighten greens, many landscape photographers use a yellow filter as a matter of course. Colored filters can also be useful to improve the separation of tones in a black-and-white photograph. A green and a blue object seen together will appear to us visually correct and would naturally be recognizable on color film, but with black and white they may appear the same shade of gray. If a light-blue or green filter was used, one of the tones would be lightened enough to make the separation between the objects more obvious. All color filters will affect exposure time, though most cameras will compensate for this if the metering is done through the lens.

There are many other filters that can be used that don't affect the tones of the photograph. An ultraviolet (UV) filter will cut down on distant haze, but since it makes no difference to the color of the light, it is also commonly used to protect the lens. Neutral-density (ND) filters are available in different strengths of gray and will reduce the exposure by one to four stops. These are essential if you want to give a longer exposure or use a wider f-stop, but the strength of light or the speed of the film does not make this possible. A polarizer filter will also cut down the light, but it is primarily used to reduce reflections in a photograph.

> **!** **Tip**

Always keep your filters clean. Scratches, dust, fingerprints, and accumulated grime will eventually act like a soft-focus filter to diffuse the clarity of the lens.

 To make clouds stand out from a blue sky, use a yellow, orange, or red filter. This photograph was shot with an orange filter, which darkens the green trees as well as the blue sky. Photo: Huw Walters.

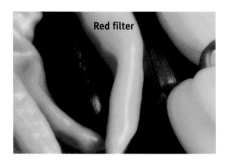
Red filter

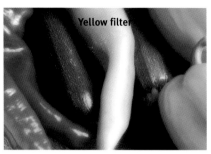
Yellow filter

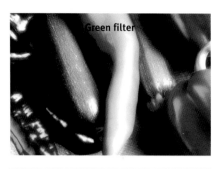
Green filter

Other filters can add visual effects to a photograph—such as soft-focus filters, which are available in a variety of strengths. These can also be used in the darkroom to soften the print (see p.76). There are other filters that can best be described as gimmicky, such as the starburst, which will make highlights sparkle, or filters with cutout shapes for "keyhole" effects. Perhaps the least suitable, though, is the graduated filter. Although with color film it will make the sky darker and a different color, with black-and-white film it will make part of your negative severely underexposed. Careful printing is a better option.

These photographs compare the results of using red, yellow, and green filters.

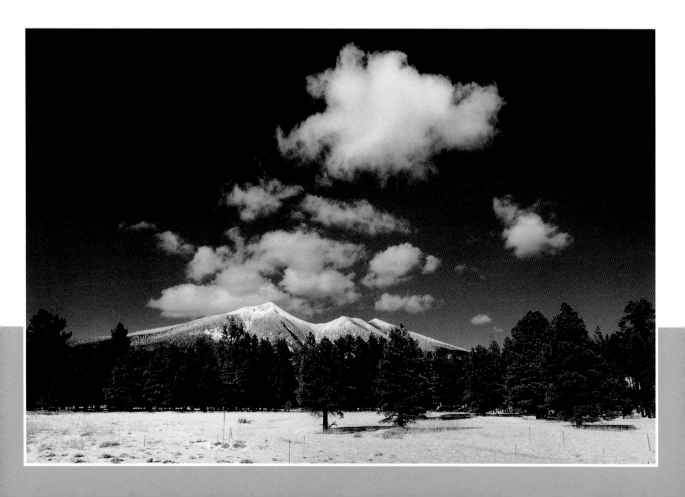

Darkroom Layout

Although darkrooms at home are often temporary setups using a kitchen or a bathroom, it is important to print in as much comfort and safety as possible. If you are able to have a permanent darkroom, there is no excuse not to create an agreeable working space.

Fig. 1: Victorian darkrooms rarely offered comfortable working conditions. Image from *A History and Handbook of Photography*, Gaston Tissandier, 1875.

Photographers have complained since the 1840s of the dark, dank, and noxious conditions in which they must operate (see Fig.1); that is their choice if they wish to suffer for their art. I prefer not to, and I have deliberately chosen the start of this chapter to highlight the importance of good darkroom layout and basic health-and-safety guidelines.

A darkroom sink will be required to contain all the developing and wash trays, so this should be as long and wide as space allows (see fig. 2). Ideally it should be built or adapted to the correct height for the user, since stooping over or stretching up to a sink for a long period of time will prove harmful to posture and may later cause serious back problems. For ventilation, a lightproof extractor fan at the top of a wall is essential to remove the smells and vapors of the chemistry, though a small ventilation grille, positioned lower down on the wall opposite the fan, will be needed to bring fresh air into the darkroom. For printing, a red safelight is used because photographic paper is not sensitive to this color (see Fig.3). Alternatively, yellow light is fine to use with most modern papers and is more comfortable on the eyes. Bear in mind that paper can be slightly fogged by

lengthy exposure to even a safelight, so follow the recommendations supplied with each paper. The color of the darkroom walls will depend on whether the room has another application when not being used for printing. Ideally, the walls around the sink should be painted white so it is easier to see what is happening during print processing. The area behind the enlarger should be either black or a color that will appear black through the color of the safelight—green or purple, for example. This minimizes the amount of stray light from the enlarger reflecting on the walls, which could lower the contrast of the print.

Other practical considerations for the darkroom are to have a dry and a wet side to avoid chemical splashes onto papers and negatives, and also to keep electrical equipment away from the water. The sinks are obviously placed on the wet side, and the enlarger and printing area (which should also be at the correct working height) are on the dry side. It is important to think about workflow, or, in other words, the order in which things are done in the darkroom to make printing, processing, and washing an efficient routine. Skin contact with processing chemistry should be avoided, so prints are best handled when wet with either

Tip

Although the reality for most non-professional photographers will be that their darkrooms are cramped or spare spaces at home, it is important to put safety first and not to work in conditions that are dangerous or unhealthy. See pages 192-193 for tips on working safely with photographic chemicals.

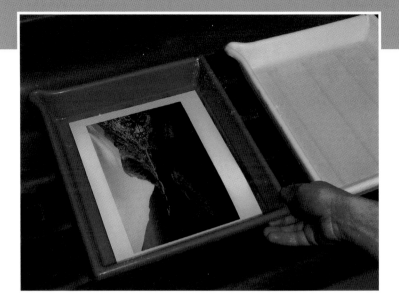

»

Fig. 2: Darkroom sinks should be able to accommodate a number of trays.

tongs or rubber gloves: disposable vinyl or normal domestic rubber gloves are equally fine.

The floor should be easy to clean for obvious reasons, so carpets ought to be avoided. And, finally, a darkroom has to be dark. Either temporary or permanent covers must be placed over the windows, and these can be made from a variety of materials. Thick trash-can liners are quick, cheap, and effective, though longer lasting and more attractive is wood paneling. If expense is not an issue, specialist blackout material can be found at darkroom suppliers.

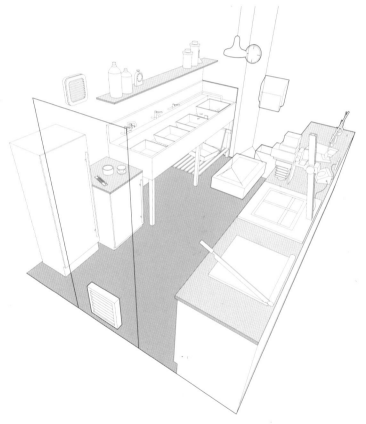

Fig. 3: The author hard at work...
Photo: Gaby Gassner.

«

Fig. 4: If space allows, here is an ideal darkroom layout.

»

Enlargers

The enlarger, which is used for printing photographs, is the heart of the darkroom, and once purchased it should provide years of service. We have to consider, though, what light source (or enlarger head) is used, which formats of film it can print, and how sturdy and reliable the enlarger is.

It is a simple machine, consisting of a column with a movable head that contains the lamp, negative, and lens; the latter focuses the enlarged image onto a baseboard. Enlargers vary in size depending on the maximum format of film used—from 35mm up to 11x14in (29x35cm). If you are sure

that you will only ever print 35mm, buy a smaller enlarger. However, if you may want to use bigger formats in the future, it is worth buying a larger, more versatile modular model.

Specialist enlargers

Black-and-white enlargers have traditionally been manufactured with a choice of two different heads. The "condenser" uses a tungsten lightbulb focused through a set of condensing lenses onto the negative. It gives a very sharp light with strong contrast, though any marks on the film will be exaggerated. Condensing lenses have to be focused accurately to ensure an even spread of light. The alternative to this is the "cold cathode," a bright cathode light (cooled by a water jacket) that is diffused by perspex for a softer contrast. Both of these are still used today, but they are designed to be used with graded papers. This means that when you are using variable contrast, filters have to be placed either below the lens or, with some heads, in a filter drawer underneath the lamp.

The most practical and easiest light source in use today is the dedicated multigrade, or variable-contrast, head, such as the Ilford H500. This uses two lamps of different colors, representing the colors used in multigrade printing

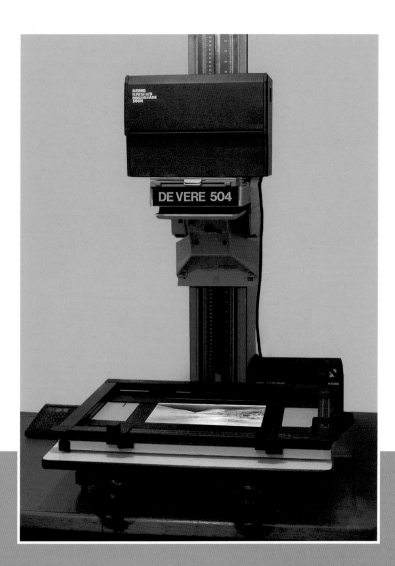

The De Vere 504 will print all negatives up to 5x4. The enlarger head can be changed to provide various light sources. The Ilford Multigrade head can be set for any grade between 0 and 5.

(see p.58), which are diffused through a mixing box. Grades are set by a control panel, which sends a signal to the enlarger head to mix the two lamps at different levels; these levels correspond to individual grades.

Other manufacturers use heads with variable filters that can be set at any level between grades 0 and 5. This is similar to color enlarger heads, which have three filters for cyan, magenta, and yellow, and they, too, can be used for black-and-white printing. Each box of paper should have recommendations for filter settings.

You need two other, vitally important items for your enlarger: a timer that will give you accurate, repeatable exposures (some models can also be programmed to give a sequence of different exposures), and a good-quality lens. The correct focal length for an enlarging lens corresponds with the standard lenses of a camera—50mm for 35mm, 80mm for 6x6cm, 105mm for 6x7cm, 150mm for 5x4in—so if you are printing from more than one format, you will need to buy several lenses.

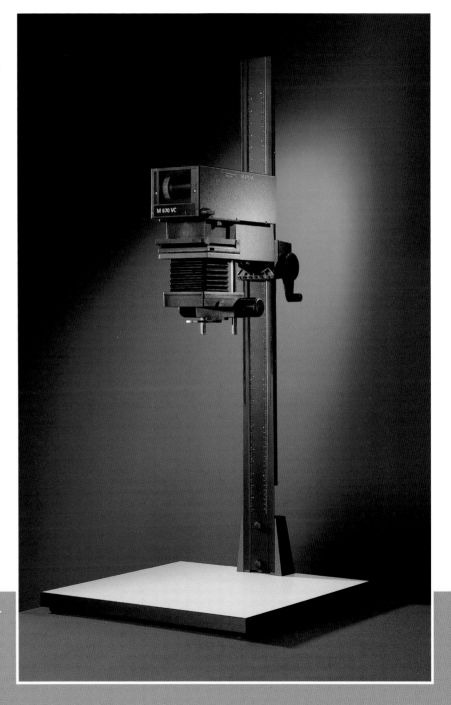

» **The Durst M670 can be used with negatives up to 6x7. The Variable Contrast head is controlled by a dial, which can be used even between half grades, giving fine control of contrast.**

Paper Choice

It is difficult to write about black-and-white photographic papers without getting nostalgic and reminiscing about brands long since discontinued. It is inevitable that photographers will get used to a particular product and learn how to get the results best suited to their work only to find that the manufacturers make changes to the emulsion (sometimes unannounced) or—in the worst-case scenario—replace the paper with a different product. I highlight this only to reinforce that paper, like film, is always evolving and changing—often for the better, but sometimes for the worse. What is important is that we do not wallow in regret; we must simply make the best use of the materials that are available today.

There are various options when choosing a paper. The first is between resin-coated (RC) and fiber-based materials. Fiber paper, often referred to as "bromide," is a traditional photographic paper in which the emulsion is coated onto rag-based paper stock; when processed correctly, it will yield prints with a very long life span. However, because the paper's fibers absorb the developing chemistry, it needs to be washed for a long time (at least an hour) to remove all traces of the chemicals. Resin paper is similar to fiber except that the paper is coated with a very thin layer of plastic; this allows the chemistry to get to the emulsion but not into the paper base, so prints can be washed very quickly (within several minutes). The advantage of this is obvious, making resin a far more convenient paper to use; but because of its plastic coating, it does not have the depth of tone and the tactile and archival qualities of a fiber-based print. This is not to say that resin papers cannot produce excellent prints—they certainly can. Indeed, often—when darkroom and washing space is limited, for example—resin is the best paper to use.

The next consideration is the paper's surface, which today is usually a choice between glossy, matt, and, for resin materials, pearl. This choice is down to the personal preference of the photographer. Glossy papers will always give the strongest contrast and the deepest blacks, though many photographers prefer a matt surface because its smoother finish makes it less reflective. Fiber papers were once available in many surfaces, including velvet luster—a matt paper with a slight texture that increased the contrast. The closest we have to this today is pearl, which is the resin-coated alternative to matt, being a cross between a dead matt and a glossy paper.

Photographic paper used to be available in a number of grades and surfaces, like this mid-20th-century example from Agfa.

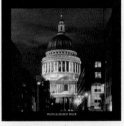

A modern box of multigrade paper from another industry stalwart.

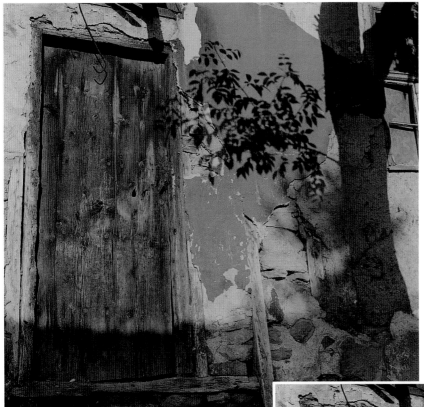

« **Fig. 3: A print on warm-tone paper. The paper's natural quality is enhanced by overexposure and underdevelopment.**

The final choice to make is the tone of the paper, or the color of the black. Black and white is a loose definition since, depending on which paper we use, the tone of the print can vary from a warm to a cold black. Some appear almost brown, while others look blue in comparison. Many papers will give prints a very neutral, monochrome tone. This range of options allows us to suit the mood of the image.

A print on cold-tone paper. Notice the tone of the deep shadows, and of the wall textures, creates a graphical feel.

»

 Tip

Many photographers use resin-coated paper for making test prints from their edited contact sheets as it is very quick to process and wash, but they will then use fiber-based paper for their final selections.

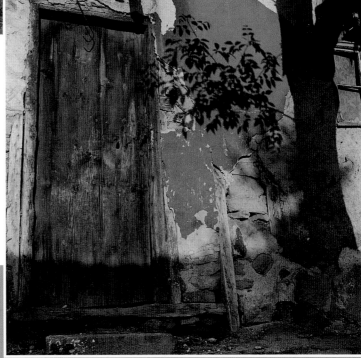

Contacts

Fig. 1: Making a test for exposure. First lay the negatives emulsion to emulsion on a sheet or strip of paper, place the glass on top, and then give a series of exposures.

There are two ways to assess what has been shot on a roll of film. One is to have a small set of prints made by the local lab—this is the easy and expensive route. The second, and most practical, option is to make a contact sheet in the darkroom. Of course, some photographers do neither, believing they can edit simply by looking at the negatives. Personally, I don't believe we can really judge an image this way. Time and material will be wasted on photographs that looked great through the camera but became boring as prints. A worse possibility is wonderful shots are never printed.

First, you need to prepare your chemistry, which is exactly the same as that used for printing (see p.54). All solutions—developer, stop bath, and fixer—should be mixed at their recommended dilutions and temperatures before being poured into their own trays labelled "dev," "stop," and "fix" (or something equally obvious) to prevent future contamination. Apart from the enlarger, a simple heavy sheet of glass is the only equipment required, although specialist contacting frames are available if this seems too basic! The enlarger is focused (with no negative) so that a frame of light appears on the baseboard bigger than the sheet of paper used, which will usually be either 10x8in (25x20cm) or 10x12in (25x30cm). To test for

exposure, choose one or two strips of negatives, lay them on a strip of paper (emulsion to emulsion), place the glass on top, and select what grade to set the filter to if using variable-contrast, or multigrade, paper (see p.58). Grade 2 is usually a good starting point.

The exposure will depend on the density of the negatives, the brightness of the enlarger, and what f-stop the lens is set to. An initial exposure is given overall—for example, two seconds—and then a further five exposures of two seconds are made, each time covering up another frame (see Fig. 1). Under the red safelight, this strip is processed, again keeping to the manufacturer's recommended times. The image appears during the development,

which is normally between one and two minutes. This is followed by about 15 seconds in the stop bath, which neutralizes the action of the developer and also prevents the last bath—the fixer—from becoming weakened. Throughout the process, the trays have to be rocked continuously, but gently, to ensure fresh chemistry is always passing over the print. The light can be switched on halfway through the fix, and the test strip assessed when in the wash. Hopefully, one of the exposures will be correct, though we may need to increase or lower the contrast. We then repeat this at the new exposure, using the complete film (see Fig. 2), which should fit on a

Tip

To save time, exposed sheets can be placed in the developer in batches of two. Keep them back to back, emulsion sides outwards. When developing, slide the bottom pair out, place on the top for ten seconds. Repeat for each.

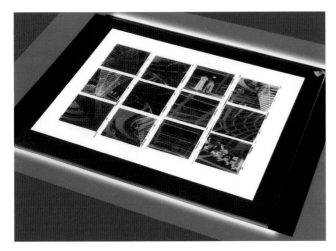

Fig. 2: When making the contact, ensure all the strips are the correct way around. Using clear negative sleeves to print through will make contacting quicker.

Fig. 3: If the density of the film varies, give selected frames more exposure.

whole sheet of paper. It is possible to use clear "print through" negative sleeves, laying the whole sheet on the paper. This may reduce the sharpness of the contact slightly, depending on the thickness of the sleeve, but it does make contacting quicker and protects the negatives from mishandling. The contact is processed as before and is then washed fully before drying. If parts of the contact are too light or dark, you can expose a new sheet, using small pieces of card (see Fig. 3) to give frames less or more exposure selectively.

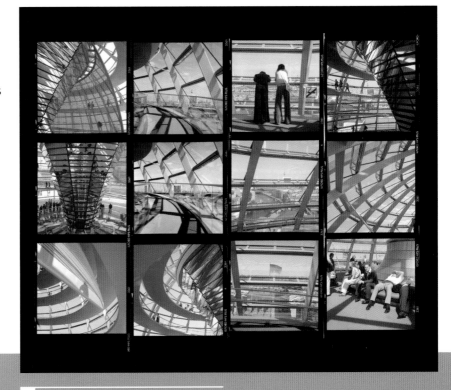

Fig. 4: The finished contact should ideally not be too contrasty, so you can see all the detail in each shot.

The First Print

When making your first print, you should place the negative in the enlarger carrier, with the emulsion facing downward and the image upside down, so that when it is projected onto the paper it will appear the correct way around. It is important to keep the negative clean and free of dust—a can of compressed air or a soft antistatic brush is helpful for this. You should use an easel to keep the paper flat and to determine the size of the image and its border. There are various types available with either two or four movable blades, the latter offering greater flexibility and a better choice of image sizes (see Fig. 1). Move the enlarger head until you have the correct crop, and then focus the lens.

A fine-grain focuser is very useful to achieve the sharpest grain possible. Although it is best to focus with the lens wide open, it is usual to close the aperture down by two or three stops to ensure sharpness.

Similar to contacting (see p.52), a test strip will be made at a variety of increasing exposures at a standard grade (providing the negative is well exposed) in order to determine the initial exposure. Even though you may eventually want to produce a contrasty print, it is best not to make the first test too punchy since you need to determine what information is on the negative. Having assessed your test (see Fig.2), you are ready to make a print at the selected exposure,

changing the contrast with the multigrade filters if necessary (see Fig. 3). In this example, I have chosen an overall exposure of 16 seconds at grade 2, which is correct for the mountains (the photograph's midtones) but appears too bright in the sky and lacks detail in the dark lake.

Before considering what actions to take to improve this print (as on p.56), it is important to make sure the prints are being properly processed. After the developer and stop bath, the print should be fixed in a fresh bath of fixer for the correct time. Too little time or using an exhausted solution will result in the whites of the print discoloring at some point in the near future because the unfixed silver salts react with exposure to light; too much fixer can eventually turn the whole print brown because it would be impossible to wash this acidic chemical out fully from the paper base. To prevent this, I use a two-bath fix. If my normal fix time is four minutes, I give two minutes in each bath. The first tray of fix will need to be replaced before the second, so when it is exhausted I discard this tray, pour the second tray into the first, and then make up a fresh bath for the second tray.

Fig. 1: When enlarging the negative on the easel, ensure the borders are set to give an even frame to the print.

> **Tip**
>
> For less experienced black-and-white photographers, the first print is very much the launching point for further experiments and fine adjustments. For those of us with a real passion for the craft, that process lasts a lifetime.

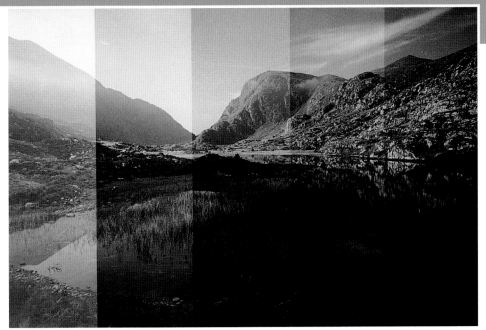

Fig. 2: A test strip should show a good variety of exposures so that detail can be seen throughout the complete tonal range. This test was given five exposures of four seconds each on grade 2.

Fig. 3: The first print at 16 seconds is satisfactory, but it will need less exposure in the lake and more in the sky.

Dodging and Burning

To achieve the detail lacking in a print's tonal range, we have to selectively give areas of the print more exposure, known as "burning in," or reduce the exposure to other parts, referred to as "dodging" or "holding back." These are quite straightforward procedures, and most prints will require some dodging and burning.

Dodging

Looking back at our test strip, the exposure that gave the best rendition of the dark lake was eight seconds— half the total exposure time—so we have to cut the exposure to this part by eight seconds. There are three ways to do this. The easiest is to block the exposure with a hand (or both hands) forming the shape of the underexposed area for the time required to reduce the exposure (see Fig. 4). Some enlarger timers will give a bleep every second, which is a help in keeping track of the dodging, but I prefer to count out loud, "Thousand and one, thousand and two," and so on, since this longer word will help give a more accurate and repeatable timing than just saying "One, two, three, four." Some photographers can be heard shouting out "Elephant one" or "Rhinoceros two" when printing! Whatever words you use, ensure each count is four or five syllables long.

Instead of a hand, a piece of card can be used to block out the light. The advantage of card is that it can be bent to form a curve, and if the shape is too

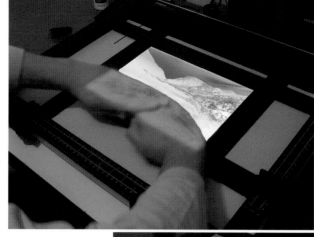

Fig. 4: The bottom part of the print is held back for half the exposure with either a hand or a piece of card.

tricky to use either your hand(s) or a bent piece of card, you can trace an outline of the shadow onto the card, cut it out, and use this instead.

When areas are too small or not touching the edge of the frame, a simple dodging tool can be made by taping a cutout shape onto thin wire (circles and ovals of various sizes are always useful); you can then hold this over the print (see Fig. 5). The most important thing to bear in mind while

dodging and burning is that there should be no evidence of any of this work on the finished print, so you have to keep your hands, cards, and dodgers moving to prevent an obvious line forming between the normal and corrected exposure. If a dodger was used to hold back a print but not moved, it would definitely be noticeable. Not only would a lighter shape appear, but so would the line of the wire.

Tip

It is possible to buy ready-made dodgers, but I've yet to meet a photographer or printer who will admit to using them! Thick fuse wire, available from hardware stores, is the perfect material to use. It can be twisted into a plait which will make it strong but very pliable.

Fig. 6: The finished print has improved shadow detail in the lake, and the extra exposure to the sky has balanced the top of the image.

Burning

To increase the exposure to a section of a print, use the opposite approach. In this situation, the card or hand will mask the part of the print that has been correctly exposed and allow more light to fall on the highlights. In this print, the sky required another four seconds, so I used my hands to cover the hill, moving them slightly, to let part of the exposure bleed into the mountains. If my hand had moved the other way, a "halo" would have formed between sky and mountain.

The combination of dodging and burning has certainly improved the latest print (see Fig. 6), but one last thought should be given to its final appearance. When prints are dry, they will always appear slightly darker than

Fig. 5: Alternatively, use a dodger made of card and wire.

when wet. "Drying down," as it is known, is caused by the paper expanding slightly when wet and contracting when dry. To counteract this, you must give the print slightly less exposure.

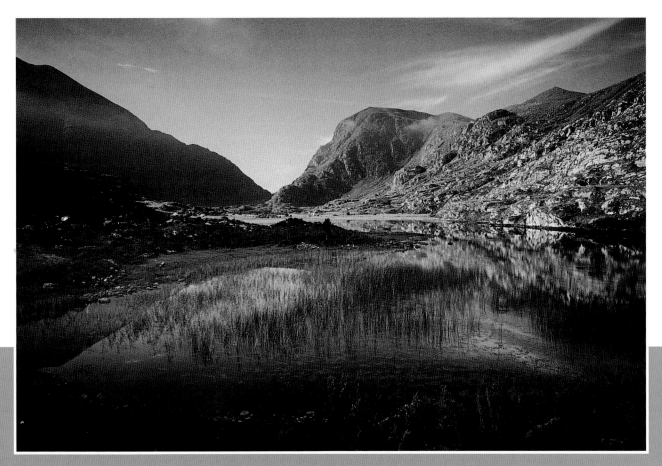

Contrast

One of the advantages of black-and-white photography is your ability to control the contrast of prints in order to enhance the mood of photographs. As we have seen in making contacts, paper can be exposed through a range of filters—from the very soft grade 0, to the superhard grade 5. What we call "normal" contrast usually falls between 2 and 3, though this can vary depending on the enlarger's light source and the strength of the developer. Before the advent of multigrade (or variable-contrast) emulsions, papers were manufactured in individual grades, meaning that darkrooms would have separate boxes of each particular grade required for each brand of paper used.

Multigrade paper, which became popular in the 1980s, uses two layers of emulsion—one sensitive to strong contrast, the other soft. The color of the filtered light exposed onto these two layers determines the contrast by distributing the amount of light each layer will receive. The negative for this example (see Fig. 1) was well exposed and correctly processed, so the contrast required for a standard print of normal contrast with good tonality was grade 2. However, because I wanted to increase the depth of the shadows slightly, I used a filtration of $2^{1}/_{2}$. The examples opposite (Fig. 2) show the wide range of contrasts possible from using multigrade filters.

Sadly, it is inevitable that, either through incorrect processing or exposure (and sometimes both), there will be times when we don't always have a perfect negative; in such cases, altering the grades of the print will help rescue the shot. Underexposed or underprocessed negatives lack density and contrast, so you can compensate for this by using a higher grade of filter; similarly, for dense, punchy negatives, a lower grade will hopefully achieve a good print.

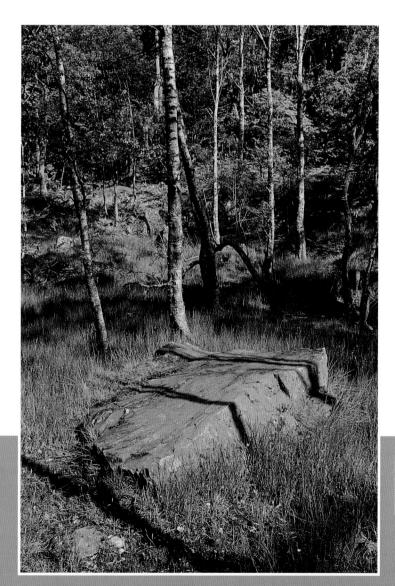

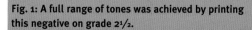

Fig. 1: A full range of tones was achieved by printing this negative on grade $2^{1}/_{2}$.

«

| 00 | 0 | $1/2$ | 1 | $1^1/_2$ | 2 |

| $2^1/_2$ | 3 | $3^1/_2$ | 4 | $4^1/_2$ | 5 |

Tip

Contrast will change depending on the size of the print. Larger prints require a higher grade. The same negative printed on 5x7in and then on 20x24in may need at least a grade higher filter.

Fig. 2: This is a comparison of all the grades of contrast possible with variable-contrast (VC) paper. On the lower grades, while there is more detail to be seen in the shadows, the highlights and midtones have turned to similar grays through lack of contrast between the tones. The highest grades have the strongest definition between the shadows and highlights, which have effectively become black and white, but detail has been lost in these deep shadows.

The Fine Print

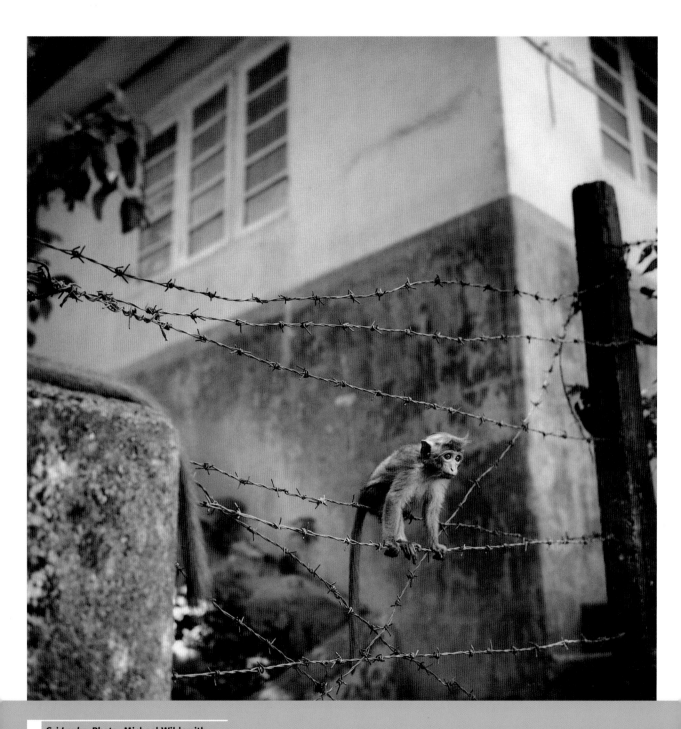

Sri Lanka. Photo: Michael Wildsmith,
courtesy of Millennium Images UK.

Introduction

Good printing should enhance a photograph and not just show the array of possible darkroom effects. Unless I deliberately want to emphasize or radically change the mood of an image, I try to minimize my use of techniques such as diffusion and flashing—which are covered in this chapter. One of the most important notions to bear in mind in the darkroom is to try to create a print that is compositionally well balanced.

The elements of a photograph's composition should work together so that there is obvious meaning to the image; this is because our eyes will naturally scan the photograph looking for the subjects. In printing, we can alter the tones to enhance this balance so that we immediately see what the photograph is about. However, this does not mean we should create regimented compositions. In this photograph, left, by Michael Wildsmith, we notice the startled-looking monkey straight away, even though it does not dominate the composition. The building, posts, and barbed wire form shapes and lines that make us read the image in a circular motion. As we follow the spiral, it leads us directly to the subject, but in doing so we quickly take in all the secondary subjects: the building, the uncomfortable fence on which the

monkey is perched. The top of the building has been darkened to ensure the viewer is not distracted by a large white area at the top of the frame. This is no linear, orderly composition.

Unlike moving pictures, photographs are individual stories in themselves. There is little point spending hours in the darkroom if our fine prints are let down by not being displayed to their best effect. One of the strengths of

traditional black-and-white printing is the ability to make archival, lasting prints. This chapter will conclude by looking at methods of correct processing, washing, and drying.

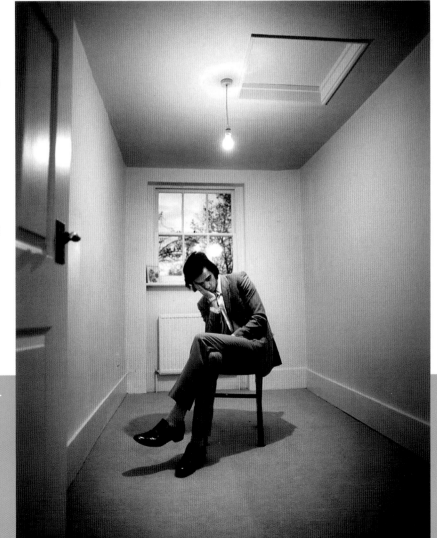

Nick Cave. Photo: Donald Christie, 1997

Advanced Multigrade

Multigrade paper was first introduced by the British company Ilford in the 1940s, but it was by no means a great success. The results were unfavorable compared to the quality possible from graded papers, and it would be another 30 years until Ilford produced a popular working product. Initially, multigrade was only available as a resin-coated material, but by the 1990s most photographic companies were making fiber-based multigrade (variable-contrast) papers that soon led to a decline in the manufacture and popularity of graded papers. We can use these papers as recommended, changing the grades to find the contrast required, or we can apply more advanced methods to fine-tune the print and achieve the best range of contrast by "split grading."

The concept is very simple. As we saw earlier, the paper has two layers of emulsion of different contrasts. Each multigrade filter allows different amounts of light to fall on the separate emulsion layers, therefore each filter will result in a different contrast. However, instead of giving one exposure on grade 2, for example, we could give half the exposure on grade 0, and then replace the filter with grade 5 to complete the exposure. In theory, we have given the same amount of light to the paper, and in mixing the colors of the filters together (yellow for 0, magenta for 5), the same color filtration as grade 2 is achieved. There are two advantages to this. By exposing the emulsion layers separately, we improve shadow detail from the results of a single exposure on a set grade. In fact, if 0 and 5 provide a contrast of approximately grade 2, we could raise the filtration of the first exposure to grade half and still keep the same amount of shadow detail, but gain a slight increase in the print's overall contrast. It all depends on the contrast of the negative, and the results required. The second advantage is that we can selectively change the contrast on parts of the print. If there are areas of shadows that can be conveniently held back, it is possible to do this during the softer exposure. Portraits that have deep, dark eyes (see p.70) will benefit from dodging during the softer exposure. Likewise, a landscape with a strong, overexposed sky that prints well in the foreground on a normal split-grade exposure may benefit from further burning in on a softer grade. If the light is flat, or if storm clouds need to be emphasized, they may print with more presence following an extra exposure on a harder grade. Sometimes a short final exposure on grade 5 will enhance depth without affecting tonality.

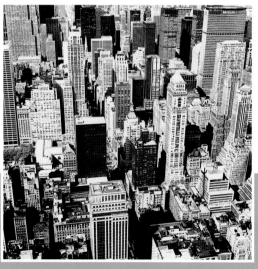

A comparison of the same image printed on grade 0 and grade 5.

>>

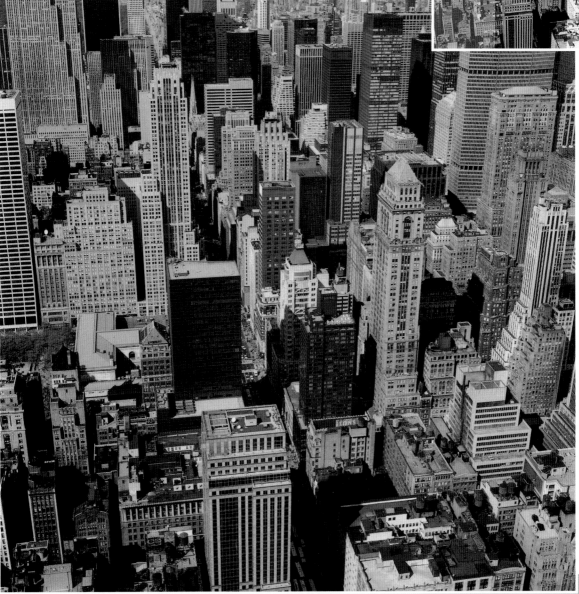

The finished split-graded print retains good shadow details while holding the contrast.

Developer Control

Due to the fact that photographic paper is available in a variety of tones—from a warm brown to a cold blue-black (see pp.50–51)—it is possible to alter the mood of a photograph simply by changing the paper used. We can further control the tones and contrast of our prints through our choice of developer, its dilution, and the length of the processing time. Similar to pushing and pulling film (which are, primarily, ways of altering the emulsion's contrast), changes to print development will also affect the contrast of the print and often the tone. In the past, when graded papers were used, it was standard practice to use this approach to vary the contrast between single grades. Now that we almost exclusively use multigrade paper—with which filtration is set at half grades, offering more flexibility— is there still a need to use such techniques? I firmly believe there is, since it gives us even more choice in the darkroom to fine-tune and enhance our prints. Most bottles of developer will give a recommended dilution and development time—but remember, these are only recommendations.

I find with some standard papers, such as Agfa Multicontrast and Ilford Multigrade, that a set development— for example, two minutes in a normal print developer diluted 1:9—will give a perfectly acceptable result, but will lack real depth in the blacks. If we use a developer like Kodak Dektol, dilute it at 1:5 or even 1:3, and increase the development time to three or four minutes, there will be a noticeable improvement in the D Max and an increase in contrast by about one grade. This is particularly useful when

using matt papers, which yield inherently softer results (see pp.50–51), and also when printing negatives on the thin side.

Likewise, for very contrasty negatives, a weaker dilution of developer (1:15 or less) and a short development time (no more than two minutes) will help achieve a better tonal range—though it may be prudent to increase the filtration by half a grade or more. We are simply overexposing and underdeveloping the print to get a good tonal range,

» Fig. 1: Printed on a matt Ilford paper, the contrast and the blacks were strengthened by overdeveloping in strong Kodak Dektol developer.

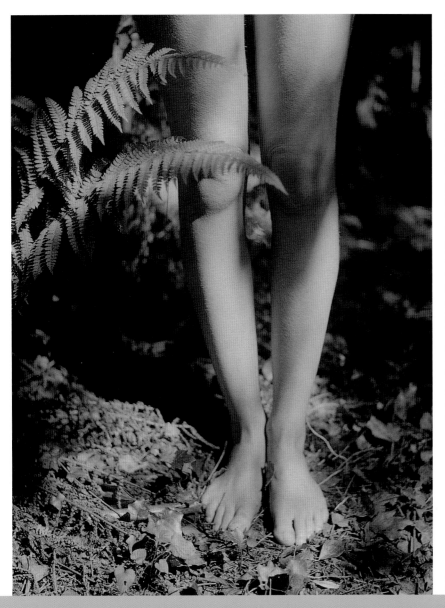

the same as when we pull film (see pp.36–37). However, even if we increase the printing contrast, it is possible that the blacks will lack depth. This can be used to our advantage if we want to emphasize the warmth of a paper and strong shadows are not desired, since an underprocessed print will often give a warmer tone. This print (see Fig. 2) was printed on Seagull Warmtone paper from an overexposed negative but given only one minute's development in Agfa Neutol diluted at 1:15. To add further warmth and softness, I mixed in a little potassium bromide (available from specialist darkroom retailers), which is used in developers as a restrainer and further exhausts the solution. Working in this method requires careful timing in the "dev" tray, since even another 15 seconds will increase the density and contrast of the print. It is also important to replace the diluted developer regularly because, of course, there is always a limit to how weak a developer can be.

Fig. 2: The very diluted developer and short "dev" time brought out the warmth of this print on Seagull Warmtone paper. Photo: Huw Walters.

 Tip

Remember to keep developer temperature constant, especially when the darkroom is cold. To raise developer temperature, place the tray in another tray containing warm water.

Flashing and Fogging

No matter how skillfully you burn in troublesome highlights in the darkroom, there will be occasions when it is impossible to tone down the bright areas of a print without affecting the adjacent midtones. Masks cut out of card or your hands shaped to control the light (see p.56) work best when stray light falls onto shadows, where the difference of tone is less noticeable. To help in this situation, you can "flash" the paper to a very small and exact amount of light to introduce a slight degree of tone in the highlights. This can be done either before or after the exposure and is known as pre- and post-flashing, respectively.

There are two ways to do this. The first method is to expose the paper to white light by removing the negative from the carrier and giving it a brief exposure. It is essential to make a test strip on an exposed print to determine the amount of flashing required (see Figs. 1 and 2), although it is inevitable that the lens will have to be stopped down to the smallest aperture, because an exposure at the working f-stop may be too brief to cope with. For this, an accurate timer that can expose in tenths of a second will be required. Alternatively, if the darkroom has a second enlarger, this can be used instead of removing the negative after every print. Either way, it is best

to keep the paper in the easel during the flash exposure. A flash that brings the slightest tone into the highlights will probably not affect the white of the print's border, but if it is a dense negative, the longer flash will leave an off-gray, instead of white, border.

The second method is to leave the aperture and the negative as they are and flash through a thick, opaque sheet of perspex, which will diffuse the light to an overall gray. During the flash exposure, I slowly move the perspex up and down from just under the lens to a point halfway between lens and paper. Instead of fractions of seconds, the flash becomes a more manageable exposure. Another advantage of this

Fig. 1: This print has only a hint of detail in the sky.

Fig. 2: The print has been tested again, with increasing levels of post-flash. Notice how the flash darkens the highlights with very little change to the shadows and midtones.

Fig. 3: The finished print is improved by the flash, which helps hold the shape of the image frame.

method is that it is easier to flash a print partially using a large piece of card, especially if it is a bright sky at the top of the photograph that needs help. A strong highlight within the image that needs some tone can be flashed with a hole cut in a piece of card, the same way as when burning in prints. It is important to use flashing techniques with subtlety, otherwise what should be the highlights in the photograph will soon become muddy.

However, overflashing parts of the print ("fogging") does have its applications. Because the sky was so bland and empty in this shot of a country lane (see Figs. 4 and 5), I gave the print an overall flash to tone down the whole image; I then flashed the sky to a gray tone, moving a piece of card up and down to give a slight gradation. To compensate for the loss of contrast, the initial print was exposed a grade more contrasty than usual, and when combined with the flash, it resulted in a photograph with more depth and atmosphere.

Figs. 4 and 5: This photograph needed more tone and atmosphere, which was achieved by giving the sky a heavy flash, effectively fogging this part of the print.

Analyzing the Print: 1

Andrew K, by Dean Chalkley

This striking portrait of musician Andrew K was shot for a music magazine by Dean Chalkley. On seeing the contacts and a proof print of the full negative (see Fig. 1), Dean wanted to change the original composition to focus on the subject's strong facial features, so he marked the contacts with a new crop. To work out how best to crop an image, the ideal tools are two large L-shaped pieces of thin card. Place both of the Ls on the print or contact (the top one upside down) to frame the image, and bring the inside corners together until you find a crop that you feel is correct. It's usually a good idea to consider a few choices before selecting the final crop.

The proof had been printed on grade 2 and definitely needed some more contrast, so the first cropped print was taken up to grade 3 and given an exposure of 24 seconds. The new crop (see Fig. 2) worked well, but it still looked too "clean" and straightforward. Dean had emphasized that he wanted the face to look quite dark and menacing, so I then tried a more contrasty and darker exposure

of 28 seconds, split between ten seconds on grade 3 and 18 seconds on grade 5. In doing so, I held the eyes back throughout the first exposure with two dodgers so they would shine out of the face. Split grading in this manner (see pp.64–65) ensured the eyes were as contrasty as the paper allowed, since they were effectively printed on grade 5, and the face certainly had more depth and grit to it. Even so, I felt there was some further work required.

The hair surrounding the face was still very detailed and slightly distracting, so in giving each side another exposure of an extra stop (28 seconds) on grade 5, I allowed the face to appear out of the depth of his hair, and this reinforced the piercing stare of his eyes. Further to this, I added four seconds on grade 3 to his forehead, to make it the same tone as the rest of the face, and six seconds to the beard and mouth, just enough to let it blend into the hair. Finally, the neck was burnt in for another stop, making it almost black, so that in the final print (see Fig. 4) the face was fully framed by darkness.

Fig. 1: The first print, full frame, printed on grade 2.

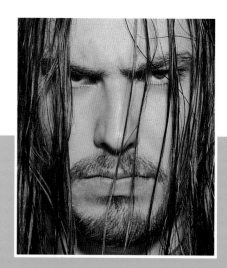

Fig. 2: When cropped to highlight the face, the photograph becomes much more powerful.

Fig. 3: Printing instructions for the final print.

+4 seconds; grade 3

−8 −8

+28 seconds; grade 5

+28 seconds; grade 5

+6 seconds; grade 3

+28 seconds; grade 5

Fig. 3: This is the finished print with increased exposure and contrast. Photo: Dean Chalkley.

Analyzing the print: 2

Spanish Mission, Arizona by Huw Walters

There are so many ways of printing a photograph, with all the choices available in the darkroom, that it is important not to get so involved in making the print that you lose sight of the original photograph. We can radically alter an image to make something new and exciting, but it is a mistake to think that every photograph needs such excessive intervention.

Making light work

This photograph is dominated by the relationship between the bell tower and the two cacti, complemented by the evening side-light. My first print, on grade 3 (Fig. 1) was acceptable, but I felt there was a lot missing. The balance was all to the right of the frame, as the deep shadow in the right-hand corner dragged the eye away from the central elements. Photography would be boring if everything was presented in a regimented fashion, but in this shot it worked perfectly to lose some of the shadow and let the tower be framed by the cacti in a more balanced composition. I knew split grading would help reduce the shadow, so I broke the initial exposure down to eight seconds on grade 0 holding

Fig. 1: On grade 3 the first print has too much contrast and needs cropping to balance the photograph.

back the shadow with my hand, and then another eight seconds on grade 4. From there, I wanted to add more density to the sky and to recreate the feeling of soft, evening sunlight. I burned in the top corners on grade 0, to make the gradation subtle; ten seconds on the left and 20 seconds on the brighter right hand side. To add more density, I gave the print a slight flash overall to add some tonality to the brightest highlights, and then flashed selectively the top, left, and right hand sides to make the darkening delicate and smooth.

Finally, after washing the print for an hour, I bleached and toned it in thiocarbamide (see pages 88–91) to further add to the warmth and mood of the photograph. I felt it important to keep some black in the shadows so I pulled it from the bleach just after the midtones started to lighten. Although not radically different, the final print has greater visual appeal.

Tip

Spend time printing a negative, and you will get to know the photograph very well. This should lead you to think about what in the finished print would be the most suitable and sympathetic interpretation.

Fig. 2: Split-grading on grade 0 and 4 reduces the contrast, and allows the shadow to be held back on the softer grade, gaining more contrast and detail.

+10 seconds; grade 0
20 seconds flash
+20 seconds; grade 0
20 seconds flash
20 seconds flash
−8 seconds; grade 0

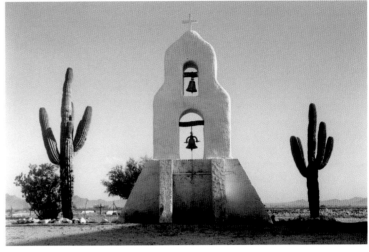

Fig. 3: Printing instructions after the initial exposure.

Fig. 4: The finished print improved by selective flashing and toning. Photo: Huw Walters.

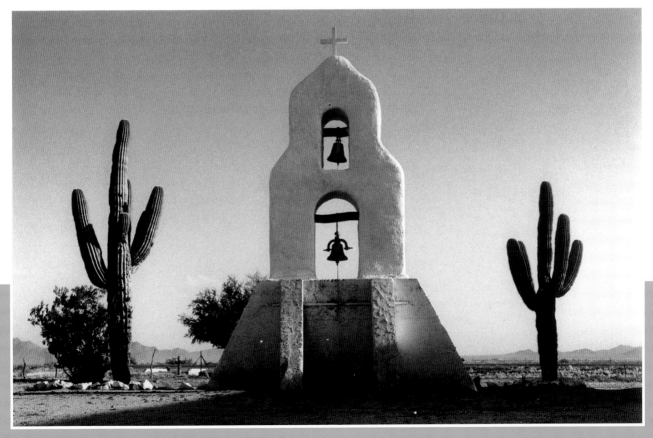

Print Sequence

Prague, by Michael Wildsmith

Often we will want to show a sequence of prints, rather than a single image, to present a complete picture of a place or an event. In this way, we can capture more of the atmosphere, and the photographs become a visual story or even a diary. Just think of holiday photographs: We would never show our friends a single snap to convey all the fun of our time away—instead they have to sit through prints from the whole film (or sometimes many films), with a commentary on each photograph, whether good or bad.

This series was taken in Prague, in the Czech Republic, by Michael Wildsmith in the early 1990s, and although each shot stands alone as an excellent photograph, together they paint a fuller picture of the city. I had never been to Prague when I first saw these prints, but they fascinated me because I felt they captured what I perceived as the mood, romance, and mystique of the place. At the time, all I knew of Prague were the haunting photographs of Josef Sudek, who spent his life documenting the streets and buildings of the city, and the books of Franz Kafka, which conveyed a far more troubled, darker, and mysterious outlook on the Czech capital.

In showing a series of photographs, it is important to think about how the work will be seen and, therefore, in what sequence to order the prints. The 1950s was a classic period for photojournalism, and the photo story became an important feature in many magazines. Photographers such as W. Eugene Smith made their reputation from telling a story with their pictures, and they were heavily involved in the final choice of photographs and the order in which they would be used. Likewise, mounting an exhibition or putting together a portfolio of work requires careful thought as to which photographs will naturally look good together. It may be that they are of the same subjects or they have compositional similarities that are reinforced when seen together. In all cases, it is good to lay out all the prints and change the sequence until the order and relationship of the photographs makes sense.

Incidentally, I did eventually get to Prague, and I found it to be one of the most photogenic cities imaginable.

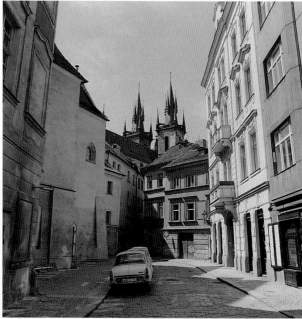

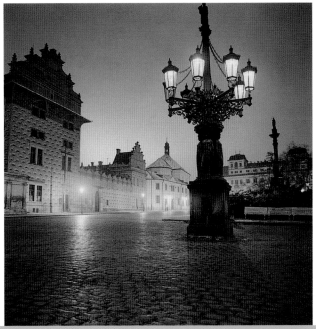

While one image can portray a scene or a place, a sequence of photographs can tell us more of a story, or capture the atmosphere in a location such as Prague. Photos: Michael Wildsmith.

Diffusion

Fig. 2: This print was heavily diffused and then toned in sepia to add to the atmosphere.

Having spent as much money as possible on the best lenses you can afford for both the camera and the enlarger, it would seem perverse to then degrade the quality of these optics by diffusing the light with a filter or a screen that softens the sharpness of the image. Before looking at how it is achieved in the darkroom, it is worth considering what happens technically when an image is diffused. Light rays that normally pass directly through a lens giving a sharp image will, when diffused, be scattered by the filter. Since some of the rays will still pass through in a straight line, the results on the film or paper will still visually appear sharp (to a degree), but this will depend on how diffuse the filter is and thus how far the light rays have been scattered. Highlights always bleed into the shadows, so if the diffusion has occurred in camera, the whites will glow. However, if the diffusion is done in the printing, this process is reversed, and the shadows will bleed into the highlights.

We can use a number of methods to diffuse our prints and achieve different levels of softening. Soft-focus filters are sold in various strengths and can be taped directly to the lens, though it is usually preferable to hold them underneath. This way it is easier to partially diffuse the exposure, which will control how much (or how little) softening will occur. For portraiture, a very slight diffusion (see Fig. 1) will help soften wrinkles and lines without giving the impression that the shot has been altered—though there will always be a point at which diffusion becomes obvious. Extreme diffusion (see Fig. 2) can certainly add atmosphere; in this example, it was combined with flashing (see p.68) and toning (see p.86) to create an even stronger effect.

The classic Hollywood portraits of actresses (and sometimes actors) from the 1930s were often shot with a stocking stretched on a homemade frame over the lens. The softness could be varied depending on the thickness of the denier and how tightly it was stretched. This simple device can be used to achieve similar results in the darkroom. Another popular method is to use a small sheet of anti-Newton glass, which has a slight texture on one side to disperse the light. The cheapest and crudest way to diffuse is to scrunch up a sheet of glassine paper (the material that print bags are made of), then flatten this paper out and give a small part of the exposure through the sheet placed on top of the photographic paper. It must be moved continuously, though, or the texture of the paper will show. With all methods, it is always best to move the filter slowly during the exposure to prevent any dirt or scratches on the filter from causing soft patterns to form on the print.

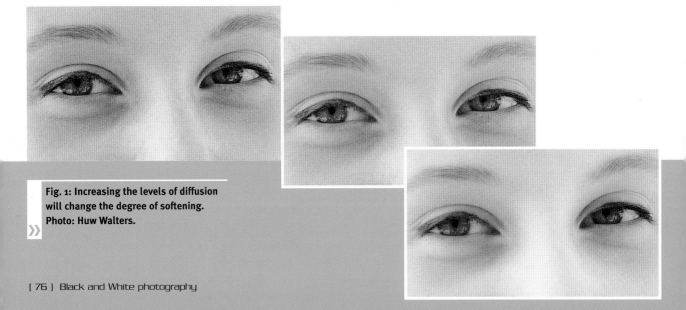

Fig. 1: Increasing the levels of diffusion will change the degree of softening. Photo: Huw Walters.

Key Lines and Black Borders

To add a key-line border around a print is simply a matter of printing the full negative and including an even amount of its clear rebate, which will print as a black frame (see Fig. 1). You can either sandwich the negative between glass, ideally the top sheet being anti-Newton glass, or you can carefully file out the plate of the negative carrier so that it prints more than just the usual negative frame. If these plates are removable, it is a good idea to use glass on top of the carrier to hold the negative down and then place the filed-out plate underneath. It is important to clean the plates after filing, whether metal or plastic, and perhaps rub the edge with emery paper to remove any sharp scratches that could damage a negative.

Fig. 2: This rough edge was achieved by carefully filing out a negative carrier.

Fig. 3: When the negative is printed between glass, various sizes of border can be used.

A black border can sometimes help hold the shape of a print together, and some photographers prefer to print all their photographs with a key line to unify their work (as long as no cropping is required). Different border effects can be achieved in a variety of ways. The rough edge in Fig. 2 is from simply printing the edges of a filed-out carrier. The negative in Fig. 3 was printed between glass, but given a large black border showing the negative's edge numbering, while Fig. 4 used the movable metal blades that some carriers use to control stray light in order to give the print a soft, diffused edge.

Fig. 4: Many enlargers use metal blades in the negative carrier, and these can be used to create a variety of border effects. Photo: Huw Walters

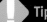

Tip

Make a mask slightly smaller than the image. After exposure, place the card on the paper while still in the printing easel and align it. Take the negative out and expose on grade 5 to form a black key line.

Archival Washing

One of the drawbacks of printing with fiber-based papers is the necessity for extended periods of washing to remove all traces of fixer. If possible, it is best to avoid large open-wash baths or sinks, since the prints tend to cling together and will not receive a fresh flow of water. If using this method, it is useful to have two or three trays for washing, so the residual fixer is removed in the first wash of 20 minutes. The prints are then transferred to the next wash for a further 20 minutes, before being given a final wash in clean water for an hour. Because this is quite a cumbersome procedure, the easiest and most efficient way is to invest in an archival washer (see Fig. 1): Since the prints all have separate channels, they will each receive a steady flow of fresh water, which does not need to be of high pressure. The amount of water forced over the prints is less important than the water being continuously changed. If possible, keep the water at a temperature of 68°F (20°C), since prints will need a far longer wash in cold water. Also, never put prints into the archival washer straight from the fix, because it will take a while for the fixer introduced into the wash channel to be dispersed. The best way is to connect an outlet pipe from the washer to a holding tray, so the prints can receive an initial 10-minute wash to remove the residual fixer—but make sure the prints in this tray have space to move and do not stick together. Some papers have a tendency to float in the archival washer, so if an edge appears above the water line, turn the print around halfway through the wash.

Tip

Hypo Eliminator is a salt-based chemical that neutralizes fixer in the paper's fibers. After 20 minutes' washing, place the print in the solution and agitate for the recommended time. Wash again.

Fig. 1: Archival washers, such as the Silverprint washer, have separate channels for each print. The texture of each perspex screen prevents the prints sticking to its surface allowing a full and complete wash.

Drying Prints

It must be said that washing and drying resin-coated prints is a lot easier than with fiber papers. Resin can be washed in ten minutes and will stay flat once dried, but fiber-based prints need a great deal more care and attention. The most efficient way is to buy, or build, drying screens with a fiberglass mesh (see Fig. 2). These can be found from several dealers (see appendix), and once washed, the print is squeegeed on a clean sheet of glass or perspex and laid face down on the mesh to dry. Alternatively, large sheets of photographic blotting paper can be used and the prints spread out wherever space can be found. Depending on the temperature and humidity of the room, the prints will take between four and 12 hours to dry. To save space, the prints and blotting paper can be stacked together; it may take a day or more for them to dry, but they will be much flatter. Pegging prints on a line does work, and this is recommended for resin, but it is best to hang fiber-based prints back to back to prevent excessive curling. Bear in mind, though, that the prints will then have ugly clip marks that will need to be trimmed later.

Whatever method you use, the prints will always have an inherent curl, so you must find a way to flatten them. It is possible to buy print driers, in which the print is sandwiched between a hot metal drum (or plate) and canvas, and these will dry and flatten prints in 10 minutes. They are useful, but the prints need to be meticulously clean to avoid staining the canvas and thus harming later prints. The most efficient archival method is to use a dry mounting press (see Fig. 3), which can often be found quite cheaply secondhand. The dry print is placed between two sheets of acid-free mounting board and left in the press for three to five minutes. If this is not possible, flatten the prints between two large sheets of heavy glass, or alternatively, use a sheet of wood (first protecting the prints with blotting paper) and place a very heavy weight on top for about 24 hours.

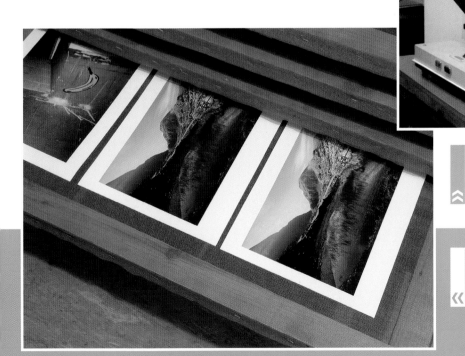

Fig. 3: If available, a dry mounting press with two sheets of acid-free mount card will flatten prints perfectly.

Fig. 2: Drying screens are the most effective way to dry fiber-based prints archivally, though they should be kept clean and free of dust.

Print Spotting

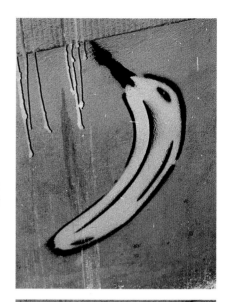

No matter how careful you are in keeping your negatives clean and dust-free, most prints will require "spotting" to remove small white marks caused by dust or scratches on the film. All you need to do this is a small bottle of spotting ink (or retouching dye), a thin paintbrush, and a ceramic or plastic palette (or white saucer). The ink is available in different shades of black, but I find that most untoned prints can be spotted with a neutral tone. Drop a small measure of ink onto the palette and let the brush absorb it (a standard sable brush, size 0–1 is fine). Test the tone of the black on a sheet of paper or on the border of an unwanted print. The idea is to match the tone of the gray that is to be spotted, so keep diluting the ink on the brush by dabbing it into a little water and then testing on the paper until the right gray is achieved. From here, you simply dab spots of ink onto the white mark, using the sheet of paper to protect the print, until it disappears. The brush should not absorb too much water, since the print can easily receive the ink, while the water will take some time to soak into the paper's surface. If there are large marks to spot, it is best to do small amounts at a time, coming back periodically to add more tone. Likewise, for white lines, do not try to draw the line back in, but dab intermittent spots along its length, repeating until the line is disguised.

Most white marks on the print can be removed quickly using spotting dye. If done well, it will not be noticed, though without spotting a print will look badly presented and unfinished.

Always spot prints in a good light, and protect the surface from fingerprints.

Portfolio Presentation

Whether prints are digital or traditional silver gelatin, careful consideration should be given to their final presentation. In the darkroom, prints can be made with a variety of borders, and if the photographer wishes to show a series of prints in a portfolio, the images can be unified through use of a standard paper and image size. Some photographers choose to fill the paper, while others prefer smaller images printed with a large border to give the photograph space, allowing the viewer to concentrate on each isolated image. Likewise, a series should be printed on the same paper stock—switching between warm and cold or matt and glossy papers within one series would break the continuity.

There are many choices of folio available at a wide range of prices. If you want to use a "book" type, it is a good idea to buy one with removable pages or sleeves so it is easier to edit your work, removing older photographs in favor of new ones (see Fig. 1). An

Fig. 1: A simple portfolio book with removable sleeves makes editing your work simple.

alternative is to use an archival presentation box (see Fig. 2), in which prints can be viewed using the two halves of the open box as a presentation area. It is worth protecting prints with sleeves, though they can detract from the image.

Fig. 2: An archival box allows the content and sequence of prints to be changed easily.

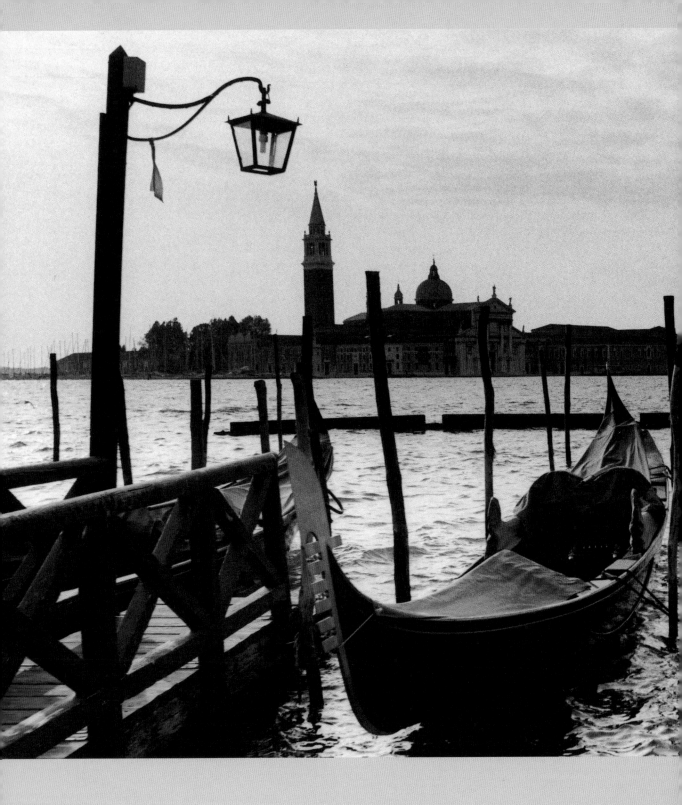

Toning

Fig. 1: Although we think of sepia toning as warm and comforting, it can, if used subtly, add just a touch of color to the highlights. Note how the color of the shadows appears cold in comparison.

Introduction

Before the introduction of silver-gelatin papers in the late 19th century, the various processes available to the Victorian photographer (see Chapter 8, pp.114–21) produced prints of many tones—often brown, sometimes red or violet, and even at times bright blue. Except for those using the luxurious platinum process, prints could seldom be described as "black and white." It has been suggested that chemical toners, which change the color or tone of a print, were first used with silver papers purposely to make the photographs look more like the familiar colors of these older processes. Whether true or not, toning has, in fact, been part of photography since the 1840s. Just as then, it is still used today for two very different purposes: to "tone" the print and to improve its archival qualities.

Sepia and browns are the most common toners used, but they should not be seen only as a way of adding instant nostalgia to a print. The range of shades varies from deep, dark-purple browns to warm, bright yellows; and they can be altered in intensity from just providing a sparkle of color in the highlights, to full conversion of the grayscale, to a range of browns (see Figs. 1 and 2). Other commonly used toners are blue, selenium (which gives tones from purple to red), and gold

(which is used to cool down the tone of most papers while adding to some a delicate shade of blue). This range of colors and effects increases when more than one toner is subsequently applied to a print, resulting in an endless array of combined tones. Many toners can be mixed from raw chemicals quite easily, very economically, and quite safely, although the chemistry used in selenium is best avoided if possible. Besides, it is still relatively cheap to buy a bottle!

Most toners—though not all—will increase the longevity of a monochrome print by converting its silver content to a more stable metal. This can be combined with a color

change if required, though if the photographer wants to maintain a pure black-and-white image, a dilute selenium toner will give the work archival qualities to museum standard and also slightly increase the intensity and visual strength of the print. While debate still rages about the life span of digital materials, we can be assured that our traditional silver prints receive the best possible chance of survival in the future.

Fig. 2: Sepia toning will add warmth and color, ideal for this photograph of sand dunes. Photo: Huw Walters.

Sepia Toning

Redeveloping

Although many toners can convert the image tone with a single bath, sepia toning requires the print to be bleached first, and then toned (or, to be more accurate, "redeveloped") in a solution that brings back the bleached image in a new color. Traditionally, sodium sulfide was used as a sepia toner that can give rich, warm browns, but this was always a very unpleasant chemical to use due to its pungent sulfuric smell, similar to rotten eggs. Today, the most commonly used toner is thiourea (also called thiocarbamide, or "thio" for short)—again, a sulfide, but relatively odorless. Its other advantage is that, when mixed with sodium hydroxide (caustic soda) in varying proportions, it can produce a wide range of different browns.

Because you are working with fully fixed and washed prints, all toning baths can be used in the light. For thio, you need to make a tray of bleach, a tray of toner with a wash tray in between, and your normal washing facilities for after toning. It is advisable to keep trays marked solely for each toner used. There are several brands of thio toner available to buy premixed in bottles, or you can make your own chemistry (see appendix). Whichever route you decide to take, you need a bottle of bleach (a combination of potassium bromide and potassium ferricyanide) and two bottles of toner, part A being thio and B sodium hydroxide. As ever, it is best to handle all chemicals with caution, and suitable protection should be taken.

Brown intensity

Bleaching will depend on the intensity of brown you want, so thorough testing should be done on a spare print. Both resin-coated and fiber prints tone well, though the latter will provide the best range of tones. Prints must be wet before any toning, so you can either bleach a print after it has been properly washed or presoak a dry print for ten minutes. The bleach stock solution needs to be diluted between 1:10 and 1:20 (at 68°F [20°C]), depending on which paper is used. Warmer emulsion tends to bleach faster and so need a weaker dilution to control the process. The bleach affects the highlights first, spreading to the midtones and then the shadows. You should make a series of tests—in this example, two, three, and

Fig. 1: The bleach time will affect the intensity of the toning. From left to right, two, three, and four minutes bleach.

four minutes. Constant agitation throughout the process is essential to ensure even bleaching—this is very important when the print is first placed in the tray to avoid marks and streaking. Once bleached, the tests are washed in running water for a short time (two to five minutes) to remove the yellow stain caused by the bleach. They are then placed in the toning bath until the full tonal range has returned (see Fig. 1).

The final color of the print depends on the paper used and the ratio of parts A and B. Neutral-tone papers such as Ilford Multigrade and Agfa Multicontrast give the widest range of tones, while warmer emulsion tends to stay on the warm side despite the dilution.

Mixing the chemicals

As a starting point, equal amounts of the two toning chemicals should be mixed with water at a ratio of one part A, one part B, and 40 parts water to provide a mid-brown. For colder browns, solution B (caustic soda) can be increased by up to five parts, and likewise for warmer tones; solution A (thio) can be added by up to five parts (see Fig. 2). It is wise to use the toning bath at 75°F (24°C), because if it is too cold the highlights may not completely redevelop. Once toned, prints should be washed fully, ideally at 68°F (20°C), and dried. Prints that have been toned with a high concentration of caustic soda, which is a strong alkaline, may show some white marks when dry. This can be prevented by a short bath of two percent acetic acid after toning.

Tip

Some papers require slight overexposure to ensure a full range of tones when the print is bleached and toned. Large areas of light tone may benefit from Print Flashing (see p.80) to ensure there is enough density.

Fig. 2: Different shades of brown are possible by changing the ratio of thio to sodium hydroxide in the toning bath. From left to right: cold brown (more sodium hydroxide), mid-brown (equal measures of thio and sodium hydroxide), and warm brown (more thio).

There are so many variants possible in using this toner that it really is worth making extensive tests with different papers and various strengths of solutions to discover the most suitable results. I personally like thio-toned prints to have a subtle, colder tone, while others may prefer the strong tones of a well-bleached print toned in a warm solution. For even more choices, a slightly toned print, once washed, can be bleached and toned again to create an even broader range of sepia tones.

The image was printed on Agfa Multicontrast and bleached for a shorter length of time than the image below, giving a colder tone.

This image was printed on Seagull Warmtone and then heavily bleached before toning in a mild thio solution.

Thio-toned prints can always be rebleached and toned again in a colder or warmer solution for subtle color shifts within the print.

Tip

Make sure your prints have been properly fixed and washed before toning, otherwise it is possible that the toned print will show uneven brown staining.

Selenium Toning

Selenium is an extremely versatile and useful toner to have at hand in the darkroom. It is known for its protective qualities, converting the silver in a print to a more stable silver selenide, but it is also used for producing rich, warm prints. If one looks back at the printing techniques of nearly every serious photographer working since the mid-1900s, selenium toning will doubtless have been part of their working routine.

The toner is usually available in one-liter bottles from various manufacturers, and its instructions will list a broad range of possible dilutions and toning times. For archival purposes, a solution mixed between 1:20 and 1:40 is suggested, though even at this strength, the print's color may change depending on what paper is toned and for how long. As a standard practice, I mix a fresh solution of toner at 1:30 and tone my prints in a large tray for three minutes. To speed things up, several prints can be treated at one time, though the toning time may have to be increased to four minutes. They can be placed back to back, stacked together in the toner, and carefully interleaved. The tray is rocked throughout and the top two prints are replaced with the bottom two every 10–15 seconds.

Fig. 1: A warm-toned paper (Forte Polywarmtone) can produce strong crimson-red colors. The first print was toned in Kodak Rapid Selenium diluted 1:7 for two minutes, the second for four minutes.

Shifts in tone

Even though archival toning uses only a very dilute solution of selenium, there will probably have been a slight change in image tone. The blacks—or, to be precise, the print's D Max—will appear stronger, and usually there will be a slight cooling of the tone. This can be very useful with matt papers, which have a lower contrast than similar papers with a glossy surface.

Used at a stronger concentration, between 1:3 and 1:10, selenium will tone prints to a stronger and more noticeable color, depending on the paper used and the time of toning. Warmer papers will initially appear colder and then rapidly take on more warmth, eventually turning an attractive reddish brown (see Fig. 1), while colder emulsions are more likely to shift toward purple or crimson (see Fig. 2). Because toning will continue for a short time in the wash, it is prudent to remove the print to a tray of water and watch it slowly change. If this doesn't happen, it can easily be toned again until the right color has been reached. With many papers it used to be possible to achieve a split tone after a short amount of toning, the shadows turning red and the highlights staying cold. This is not always possible now because the cadmium (which increases the paper's warmth) has been removed from many papers for environmental reasons. This effect can still be achieved if prints are slightly overexposed and given a short bleach (see p.88) before toning.

Finally, all selenium-toned prints should be given another full wash of at least an hour before drying. Depending on the hardness of the water, stronger dilutions of toner may leave white, chalky marks on the print. If so, the prints should be given, after 30 minutes of washing, a one-minute bath of two percent acetic acid (20ml per liter) followed by the usual wash.

Fig. 2: On colder papers such as Agfa Multicontrast, selenium will shift the color toward a purple.

Gold Toning

Fig. 1: This example shows a short gold tone of two minutes on Forte Polywarmtone.

Fig. 2: Extending the toning will deepen the blue, but it will also intensify the print.

Gold toning can offer even more archival protection than selenium, but as its name suggests, it is not the cheapest toner available. It can be bought premade in one-liter bottles—though it is also possible to mix it yourself from gold chloride and sodium thiocyanate—and it is used undiluted. With most papers, it shifts the tone toward a colder black, but because the change is quite subtle, it is difficult to judge how much toning is required and also how exhausted the solution is.

Personally, I use gold with certain warm-tone papers (Seagull Warmtone and Forte Polywarmtone) that respond well, giving a variety of blue tones. Be warned, however, that gold will slightly intensify the print. Standard blue toner (see opposite) can provide a wider range of colors but cannot match the permanence of gold. A short bath of about two minutes in fresh solution will result in a very pleasing metallic blue color (see Fig. 1), though further toning of up to eight minutes can give

a far stronger tone (see Fig. 2). Once used, it is best to pour the toner back into the bottle for future usage, making a note of how many prints have been toned so far; a liter will not go far and may well be exhausted after five or six prints. If it is still usable, toning times can be more than ten minutes. Like most toners, it requires a standard wash of one hour. Gold can also be combined with other toners (see p.97) to achieve a wide range of interesting colors.

Blue Toning

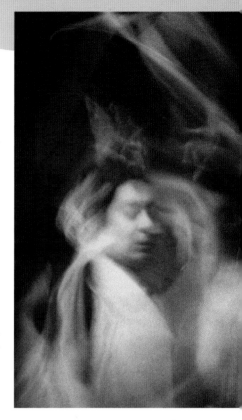

Blue toner is a very simple and straightforward bath to use. Again, it can be bought in bottles premixed, but the raw chemistry required is easy to make up (see appendix). Toning is done by inspection, gently agitating a presoaked print until the blue has reached a satisfactory color. Less than a minute will give subtle, blue-gray tones, while increasing the time to two to four minutes gives strong, vibrant shades. After toning, you should wash the print very carefully. The paper base will have taken on a yellow stain, and the print should be washed until this is removed. However, do not use a normal print washer—the flow of water will create an uneven tone, and overwashing will remove the color. Instead, pour some water at 68°F (20°C) into a clean tray and agitate the print so the water gently removes the stain. The water will have to be replaced several times. Washing will be complete when the stain has been removed from the paper and the water.

A few words of warning. Prints will intensify in tone and contrast, so always print slightly lighter and softer. Both fiber-based and resin-coated prints respond well, but be careful not to touch the surface, since it will mark easily. Tongs can also cause problems, so clean vinyl gloves should be used. And because the toner quickly stains

plastic, you should keep a tray solely for use with blue. While this toner is extremely versatile, it is not archival due to the inclusion of potassium ferricyanide in its formula.

A very slight blue toner will cool the tone of the paper—but don't overwash the print or the subtle color will be removed.

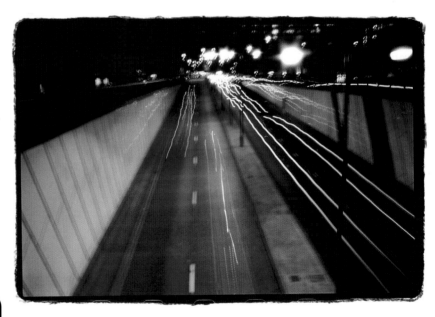

This example was toned for three minutes in blue toner. Resin-coated paper was used, since it allows the toner to be washed out from the paper base very quickly.

> **Tip**
>
> To remove blue toner from a print, place it in a tray of developer and agitate. The print will revert to black and white, but with harder contrast. Wash it again.

Combination Toning

If toning can bring a variety of colors and hues to black-and-white photography, then applying more than one toner to a print can introduce a whole new spectrum of possible tones and combinations. Most toned prints will react to a subsequent toning, though some will do so more effectively than others.

Sepia/blue

A classic double tone is to apply blue toner to a thio print. What must be remembered is that when we bleach and sepia tone a print, the highlights will be affected first, and the shadows will only take on a strong color with a longer bleach. If we give a short bleach and tone the print, it can then be toned in blue toner (following a normal wash) and the shadows will take on a blue color resulting in a split-toned print (see Fig. 1 and 2). This depends on several factors. Because the color of thio is variable (see p.88), the intensity of the split will depend on the color of the first toning. Warm yellow thio combines with blue to give a yellow/green effect, while a colder brown keeps the shadows a more definite blue. A split only occurs when the bleaching for the sepia has not been taken to finality. If a print was fully bleached and toned in thio, it would still work well with a blue tone but would instead remain one color (a variable shade of green), since all the silver has been bleached away, thus preventing a split. It is advisable, given the variations possible, to make a series of tests on spare prints first. Following the final toning, the print must be washed carefully, the same as for a normal blue tone (see p.95).

Fig. 1: Agfa Multicontrast is an ideal paper for sepia/blue toning, since it can provide a variety of brown colors that combine well with blue. This print was given a light bleach and toned in a cold thio solution. The subsequent blue toning was only long enough to affect the shadows of the print.

Fig. 2: This is the same image but toned initially in a warm thio solution. This has been mixed with a longer blue toning to form green midtones.

Sepia/gold

While gold has limited uses with most papers, combined with sepia it can give a variety of warm colors. Again, prints must be washed well between stages, and thorough tests should be made to explore the possibilities. A cold thio followed by gold results in a beautiful chalk red, while a very warm sepia will give orange tones (see Fig. 3). The intensity will be dictated by how strong the initial bleaching was, though the highlights of a sepia/gold-toned print will usually shine with vibrancy. Because gold will intensify a print, it is best to use a print that is slightly underexposed but maintaining a full tonal range.

Gold/selenium

Warm-tone papers work well with both selenium and gold, so a subtle red/blue split can be achieved if a print is partially toned in selenium followed by a bath of fresh gold toner (see Fig. 4). Similar to achieving a split with selenium (see p.92), the effect can be intensified if a slight bleach is used prior to gold toning. There are many possibilities other than those illustrated here. If a stronger red/blue split is required, try blue toning a selenium-toned print or even a sepia/gold print for a triple tone. Sepia and selenium can also be combined for intense browns or reds, depending on the order of toning. Keep notes!

Fig. 3: The combinations possible with thio and gold could fill a whole book. This print was lightly toned in a warm thio, so when later toned with gold, the highlights turned a glowing orange-red and the shadows shifted toward green.

Fig. 4: This is a short selenium tone on Forte Polywarmtone followed by gold toning—probably the most archival toning possible. Photo: Huw Walters

Tinting and Hand-Coloring

A very straightforward way of changing the color of a print is to tint or dye the paper base. This will create a very different look because the highlights and white paper base will take on the color of the tint (or staining), unlike conventional toning, which affects the silver of the emulsion. A variety of materials can be used for tinting, giving different strengths of color. Coffee and tea are old favorites for an alternative sepia tone, and these are best applied by soaking the print in a bath of the cooled beverage (see Fig. 1). For vibrant, bold colors, fabric dyes work well, especially with resin materials. After the print has been stained, it can be given a short wash to remove any surface dye, but hopefully the print's fibers should have absorbed the color, so there will be little point in an extended wash. Needless to say, any drying racks or blotting paper that are used for normal prints should be avoided to prevent future contamination.

Diluted retouching dyes and inks can be swabbed onto a dry print with cotton wool for an endless range of colors. Matt surfaces work well, though it can be difficult getting an even coating onto prints that have large clear areas of tone. Five to ten drops of retouching dye in half a cup of water should give a light tint when applied to the print, but it may need several coats to build up the correct intensity. After you have applied each wash, wipe the surface of the print with kitchen towel to remove excess moisture (see Fig. 2). Prints will naturally curl when dampened, so it is a good idea to tape the print to a board with masking tape. To prevent the borders from staining, adhesive masking film (available from art and craft suppliers) should be applied to the print, and the area to be tinted should be carefully cut out with a scalpel. This film can be used if selected or multiple areas need to be tinted; once the print is complete, it can be peeled off easily. It is water-resistant, so it can also be used with normal toners to tone selected areas of a print.

Fig. 1: This print was soaked in two liters of strong tea (ten teabags of English Breakfast) for two hours. For lighter results, try fewer teabags or a more delicate infusion, such as Earl Grey.

Hand-coloring was very common before the invention of color materials, and it is best applied to smaller prints that have been previously toned in sepia or selenium. This will give the print a base color that distracts from the usual black-and-white tone and will then hopefully require less overall coloring. Most fiber papers will respond well, though matt surfaces will give the best results. Due to their plastic coating, resin papers are best avoided. Diluted retouching dyes can be applied to individual areas carefully with a brush (or an airbrush); watercolor paint will give stronger tones but is less translucent. Water-based crayons can also be used, and this can be the easiest way of applying color to smaller areas—however, it is best to coat the print in a mixture of turpentine and linseed oil first. Cotton buds are useful to smooth and manipulate areas colored with crayons. Once finished, it is advisable to protect the surface of the print with a matt fixative spray, available from art shops.

Fig. 2: Diluted violet retouching dye was used to tint this print. Since it has a large empty area of tone, I had to apply the color quickly to prevent the formation of color patches.

The original toned print before coloring—it lacks the vibrancy of the finished article.

A sepia-toned print hand-colored with water based retouching dyes.

More Darkroom Techniques

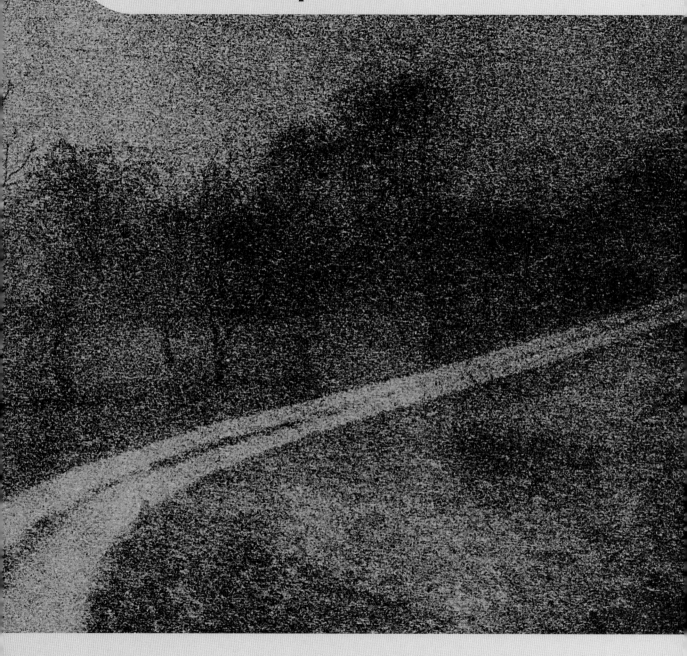

Lith Printing

Fig. 1: The contrast and texture possible in lith printing can give an exciting atmosphere and edge to a print, as shown in Malcolm Venville's distinctive style of portraiture.

The process was discovered as a by-product of materials that were once commonly used in the reprographic industry, before the advent of digital technology, to prepare pure black text and illustrations for reproduction. Dedicated lith film and papers were processed in lith developer, which would only give an image of black with no midtones. If a continuous-tone negative was printed this way, it was noticed that before the image was fully developed to a strong black, there was a brief period near the end of the development when a reddish tonal image appeared before quickly accelerating to its final tone. For this use, lith developer, which is supplied in two parts, was diluted at 1:3 and given a strict three-minute development. However, if the developer was further diluted, then it was possible, with an extended development time, to snatch the print during the process, resulting in a photograph in which the shadows had formed to a black, while the rest of the tonal range had not fully developed and showed as a rich, warm color.

Sadly, most of the lith papers used for this were discontinued in the 1980s (many photographers still mourn the loss of their favored material, Kodalith), but the process still works very well with certain photographic papers such as Seagull Oriental and Forte Polywarmtone (see Figs. 2–4).

Lith printing is an exciting process that can bring a whole new style and approach to your photography. Using conventional papers with specialist developers, a lith print is recognizable by its strong, contrasty shadows and delicately colored midtones and highlights. It is an incredibly variable process and is controlled by careful darkroom technique. Contrary to popular belief, however, it is not complicated or difficult; it simply requires methodical working, an understanding of contrast and development, and some patience.

Tip

Large-format lith or line film can be used to produce transparencies. Dedicated lith film can produce outstanding results, however, it is only available from specialist suppliers. (See appendix.)

There are various brands of lith developer still available, and all are supplied as parts A and B. You need to mix equal quantities of both and then dilute the developer 1:9 with water—though this dilution can be fine-tuned depending on the paper. Lith prints require a lengthy exposure, sometimes up to ten times what you would give the paper normally, and then a long process, during which, for several minutes, nothing appears to happen in the "dev" tray. Slowly an image will appear, and when you feel the image looks right under the safelight, quickly remove the print to the stop bath and then into the fix. The development time is determined by the exposure, and the relationship between these two factors is what controls the contrast of the print (see Figs. 5–7). This is exactly the same principle behind the contrast and speed changes we make in film development (see p.36).

If you make a print with an exposure of two minutes and find that when processed for six minutes the result is too flat, you have to give less exposure and more development. It may need just one minute of exposure (or less) and to have the dev time extended to seven or eight minutes. Likewise, if the first print is too contrasty, more exposure will be required and subsequently less development.

There are also some important details that I need to mention about fine-tuning lith printing. Most papers will respond best to lith when the developer has been partially used (though a few work best in fresh dev). To age the solution, many photographers save some exhausted lith developer, known affectionately as "old brown," and add about 100ml per liter to the new bath. After several prints, we will probably notice increasingly longer dev times and a build-up of contrast, so be prepared

to mix new chemistry when required. At the start of the process, you must slide the paper into the developer smoothly, because any splashes or areas not initially soaked will show as uneven development. Meanwhile, at the end of the process, it can be difficult to judge the contrast and tone of a print under the safelight. You need to get a feel for each paper you use—some will intensify slightly in the fix, while others will actually get brighter.

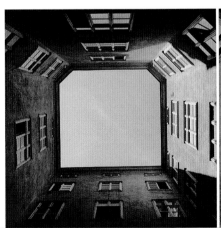

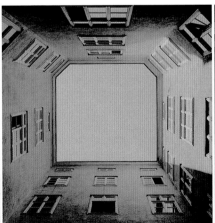

Fig. 2: Forte Museum grade 3: contrasty with deep blacks and bright highlights.

Fig. 3: Seagull Oriental grade 2: colder and almost metallic looking in this shot.

Fig. 4: Forte Polywarmtone: subtler than Fig. 1; warm, but still contrasty.

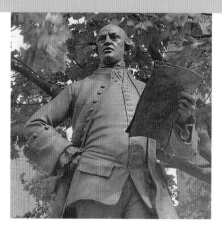

Fig. 5: Too little. The shadows haven't yet formed, though there is plenty of detail throughout the print.

Fig. 6: Too much. Very contrasty, but detail has been lost in the midtones.

Fig. 7: About right. Lith printing is very subjective, but I felt the balance of tones and print color worked well. All prints were printed on Forte Museum grade 3.

The only way to predict how the print will appear when the lights have been turned on is by carrying out some tests in advance.

Though lith prints are often considered extremely contrasty, they can be printed very softly (long exposure and short development) and can give beautifully detailed results. The colors of a soft lith print are usually stronger, and the shadows can appear greenish compared to the warm highlights. Again, this depends on the papers used—and the choice of paper further adds to the many variations possible with lith printing.

Figs. 8 and 9: Lith printing can produce very atmospheric results, as seen in these photographs taken in Slovenia by Spela Vrbjnac. They were printed on Kentmere paper and processed in very dilute and used lith developer, which increased the textural qualities and colors of the process.

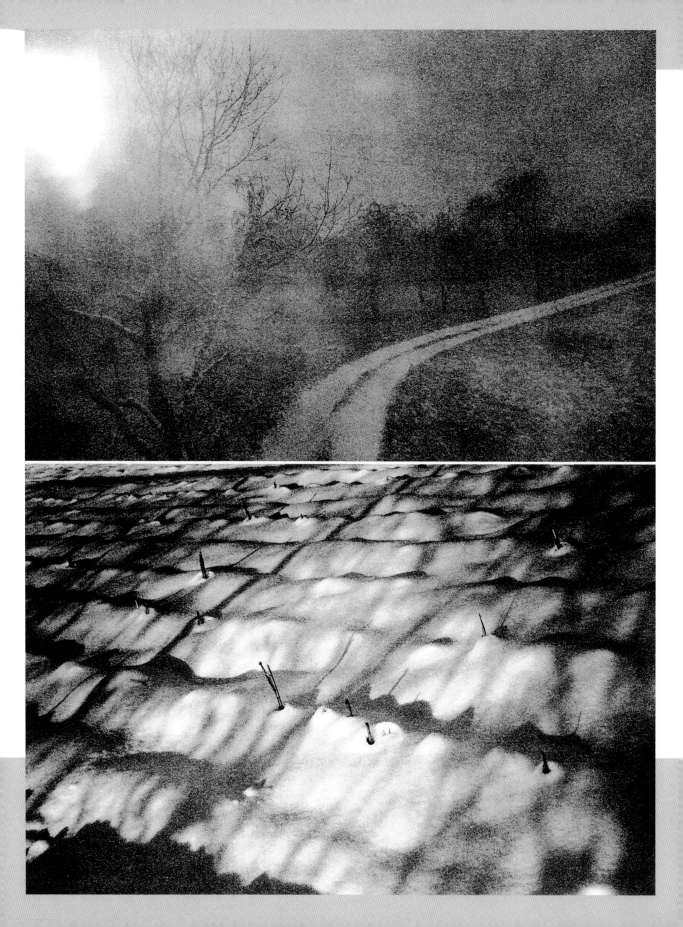

Toning Lith

Although lith printing will offer many variations in the range of possible contrasts and tones, the color of the print can also be changed by using various toners. All of the different toning baths and techniques featured in Chapter 6 (see pp.84–99) can be used, though some exaggerate the lith effect, while others can disguise it. Using thio can be very effective, but because the print's midtones are basically under-processed—due to the nature of lith development— very little bleaching will be required to change

the color. Very dilute bleach is recommended to retain black shadows, but if these too are bleached, the print will appear a uniform brown color.

Fig. 1 was originally printed on Seagull but was subsequently gold toned to produce an attractive blue. Since the gold toner would intensify the image, the print was given a very slight bleach in dilute potassium ferricyanide (2g in 2 liters of water) before toning, to reduce the density. This also cleared the highlights, letting the white rim of the boat shine out.

Selenium will provide very warm colors, possibly forming a split tone if stopped in time, while a very dilute bath—which would be used with a normal fiber print just to improve its archival qualities—will turn the lith print a cool gray or possibly slightly blue, depending on the paper used. This is very useful if you want to use the lith technique to achieve contrast, but would prefer the color to be closer to conventional black-and-white. Another way of achieving neutral tones is to bleach and redevelop a lith print.

As mentioned in Chapter 6, when a print is bleached and sepia toned, we are actually redeveloping the image to bring back the silver in a different color. Instead of thio, normal print developer can be used; this will return the image, but the distinctive colors of the lith process will have been replaced by a slightly warm, neutral tone. With many papers, it redevelops as an olive-green black, which can be a very attractive (see Figs. 2 and 3). It is best not to use the bleach mixed for thio toning because this contains potassium bromide, which acts as a restrainer and reduces the strength of the bleach. Since we want to remove all the silver from the print, a strong solution of potassium ferricyanide can be prepared using approximately 20g (0.7 ounces) to 2 liters (4.2 pints) of water. This is not critical, but we want

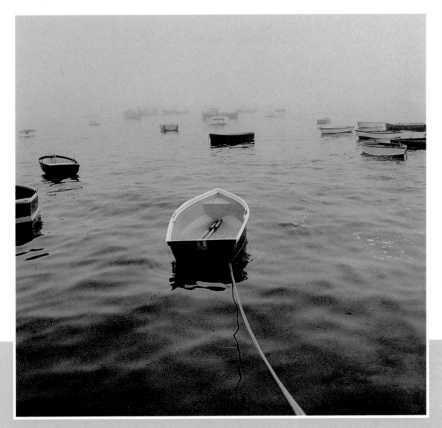

Fig. 1: Gold-toned lith print on Seagull Oriental Grade 2.
Photo: Richard Pullar.

to make a solution that will quickly bleach the print until it is a soft, thin brown tone. It then needs to be washed well to remove the yellow stain—perhaps for 15 minutes—and then placed in the print developer. It will quickly tone, though density and contrast will be increased, so the original print may have to be slightly lighter to compensate. This technique also works well on conventional prints to cool the original tone of the paper.

Tip

Some lith prints will benefit from toning, especially if you want to produce a more neutral tonal range, but be careful not to sacrifice the unique quality of a lith print by over toning it.

Fig. 2: Conventional lith print on Seagull Oriental.

Fig. 3: Bleached and redeveloped in Kodak Dektol, the print now has the qualities of a lith print but without the warm tones.

Solarization

A print or a roll of film will turn to black if the light is accidentally switched on during processing. This is a regrettable occurrence that will happen to most photographers at some point in the darkroom. However, if the exposure is brief, only part of the image will be affected and this can be used to our advantage to create the strange technique known as solarization. This is the name given to the effect in which part of the photograph (the highlights on a print, or the shadows on a negative) is tonally reversed. Although this phenomenon had first been noticed in the 1840s, it was Man Ray and his then assistant Lee Miller who rediscovered and perfected the technique in the 1920s (thanks to an accident in the darkroom); they went on to use it to create stunning, surreal images. Solarization only works when the image is partly developed, because the exposure to light will not greatly affect the shadows that have already been processed. It is the clear areas that can still darken if fogged. Between these two areas, a soft clear line often appears; this is because the intensity of the developed silver at the edge of the black is so much greater than its adjoining highlight that a chemical barrier of exhausted developer is formed.

To use solarization successfully, you need to find a repeatable method to make this work in the darkroom. I prefer to use weakened developer and remove the print halfway through development. I place it in a tray of water, let it settle, blowing away any air bubbles, and re-expose it to light, before taking it back to the developer to complete the process. It is useful to be able to control the exposure of the flash, so I use a second enlarger with an accurate timer for this, because it will need a short exposure—probably less than a second. The results with paper are variable (see Fig. 1) and will always tend to be quite dark and gray, though this print (see Fig. 2) when dry was contacted onto another sheet of paper. The contrast had to be increased, and the texture of the paper negative is apparent, but this adds to the visual effect.

My preferred method is to make a copy negative onto 5x4in. sheet film. If possible, I will work from a black-and-white transparency (see Fig. 3), though color can be used, and I print or contact it onto Ilford line film to make a negative. It is processed in dilute developer (Kodak Tmax 1:9 for six minutes works well), but the second exposure is given in a tray of water after two minutes' development. The film is then processed for a further

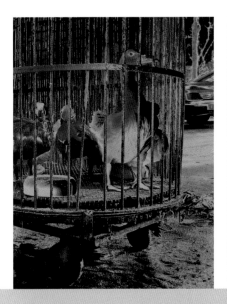

Fig. 1: Solarizing a print requires careful timing of the flash exposure if detail is to be retained.

Fig. 2: The solarized print can be used as a negative and then contacted onto paper of a hard grade. Strange things always happen in solarization, such as the demonic glow in the caged bird's eye.

 Tip

A solarized negative can be made directly from a small print by contacting it onto film which is then solarized during processing. The results will not be as fine, but will add an interesting texture.

four minutes. To find the best fogging exposure, a series of tests should be done and the resulting negatives contacted to compare the difference. On film, it is surprising how long this exposure can be. For the solarization to work well, it is important to use a photograph with a black background (ideally velvet, which completely absorbs the light) so that the subject stands out against it. Where a highlight (or sometimes a midtone)

is adjacent to the black, the mysterious line will form. When the negative is printed (see Fig. 4), it will appear as a black outline, and if the exposure and development are accurate, the original black background can be controlled to appear as any tone from white to dark gray.

Fig. 4: Here, the positive transparency was used. To create a light background with the subject enclosed with a thin line, the original must be shot against solid black.

Fig. 3: Solarizing onto film from a positive can give very good results with the benefit of a negative, which can then be printed easily.

Using Grain and Contrast

For years, manufacturers have strived to improve the quality of emulsions, while many photographers have disregarded those efforts, looking for as much grain as possible. Used carefully, grain can provide an evocative texture, either creating a nostalgic atmosphere or emphasizing bold, graphic compositions. In the 1960s, fashion photographers discovered the freedom of 35mm, having previously been used to larger studio cameras that had demanded a more formal approach to their subjects. The smaller format—which lacked the finesse of today's film—appeared grainy by comparison to 5x4in or 10x8in, especially when pushed.

If you want to create grain with modern emulsions, there are several factors to consider. You should use as fast a film as possible and as small a negative as practical. Pushing a 400 ISO film, such as TriX, will increase the grain slightly, but better results will be gained from using an ultra high-speed film, such as Kodak Tmax 3200 or Ilford Delta 3200. You should also use a high-acutance developer, which increases sharpness and edge detail: Agfa Rodinal is ideal and will give a very detailed negative, but for more extreme and coarser results, a print developer like Kodak Dektol, diluted at 1:15, will be very effective. Be sure to carry out tests first to determine the correct development time. This is very important because you want to produce a negative that has quite a low contrast, which can then be printed on a high grade of paper (grade 5, preferably) to exaggerate the grain. If possible, use an enlarger with a condenser head, which will increase the contrast while keeping the grain of the print crisp. It will also help if the shot is softly lit (see Fig. 1) because the contrast will be raised in the printing. Lith printing also works well with softer negatives to produce grain.

The size of the print is also important. A grainy negative will always look more compelling when printed large than it will as a small 6x4in. photograph. Another way to look at this would be to print just a small section of a negative and make it as big as possible (see Figs. 2 and 3).

If a shot is taken primarily with the intention of being grainy, experiment with the size of the image in the frame, and then crop out the rest of the photograph when printing. If you want

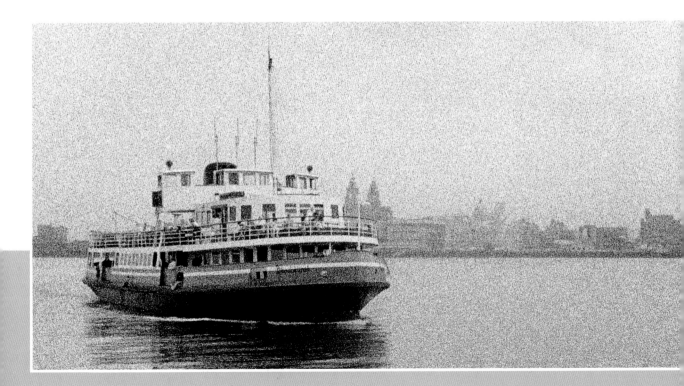

to introduce grain to an already fine-grained negative, it is possible to buy screens that, when sandwiched with the negative, will give the effect of grain in a print—however, they are never that convincing. A more practical way would be to copy a soft print onto 35mm film that is processed for grain, and then print from this negative. If you want to produce contrast but not grain, grade 5 can be used with a softly lit but well-processed negative (see Fig. 4) that has a lot of detail and ideally no large areas of shadow. Keep the print fairly small to reduce grain.

Fig. 2: Here, a small portion of the negative was printed to achieve grain.

Fig. 3: This is the original frame uncropped.

Fig. 1: This was shot on Kodak Tmax 3200 on a very dull, gray day and then printed onto grade 5. The print was slightly flashed to bring some tone into the background.

Fig. 4: Printing on grade 5 from a detailed but soft negative produced a simple line effect.

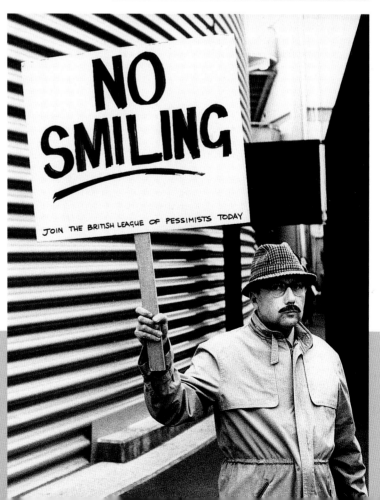

Liquid Emulsion

As an alternative to using normal photographic paper in the darkroom, you can also print on various surfaces and materials that have been coated with liquid emulsion. Several manufacturers produce emulsion in this form; it is usually equivalent to the contrast of a grade-3 paper, but this will be affected by the base onto which it is coated. Although paper is the easiest material to use, liquid emulsion can also work well with glass, wood, fabrics, and stone. Because it is applied by hand, normally with a brush, the results will vary, and each individual print will have its own unique characteristics.

Applying the emulsion onto paper is quite straightforward, but care and practice will be required to achieve a satisfactory coating. First of all, remember it is light-sensitive, so all preparatory work must be done under a safelight or in darkness. A wide range of art papers of various surfaces, textures, and tints can be used, and

this will affect the contrast and tone of the finished print. Make small corner marks on the paper so you know where to coat. The emulsion is a thick white gel and is supplied in a lightproof bottle. It is best to store it in a refrigerator (well wrapped and away

from food), since this will solidify the solution. Before use, submerge the bottle in a jug of warm water (about 104°F [40°C]) to bring it back to a liquid state. Do not shake the bottle—this will cause air bubbles. Pour some emulsion into a bowl, again kept warm over a jug of water. A variety of brushes can be used, and each will affect the textural quality of the print, depending on the thickness of the bristles. Avoid brushes with metal parts, since this can affect the silver in the emulsion; flat Chinese art brushes (Jiaban) are very effective and cheap. Coat several sheets of paper with vertical and then horizontal strokes (the eye is less likely to notice

Applying the emulsion onto paper.
«

Silverprint Emulsion coated onto fine art paper.

horizontal brush marks), and if a finer coating is required, smooth the emulsion with a very soft, flat brush. For extra depth and contrast, a second coat can be added before drying the paper in darkness.

Printing is quite straightforward, though it will be noticed that, even with the same exposure, prints will vary slightly due to the thickness of coating never being exactly the same. However, the emulsion is very delicate. You may need to replace an acidic stop bath with water, and fixer will benefit from the addition of hardener to protect the fragile coating. Never use any heat driers that are in contact with the print; instead, place the print face up on a drying rack or blotting paper. When a successful print is finally made (and it may take several attempts), you can then tone it if required. To use the emulsion with other materials, a subbing layer may have to be applied to the surface before coating, to ensure it will adhere or it will float off during processing.

Liquid emulsion coated onto a heavily textured Bockingford fine-art paper. After processing, the print was given a slight blue tone.

Tip

Coating commercially produced photographic paper requires very precise and large machinery, so do not expect to achieve perfect results when using liquid emulsion. However, watercolor paper is a very easy surface to retouch using either spotting dyes, or even pencils.

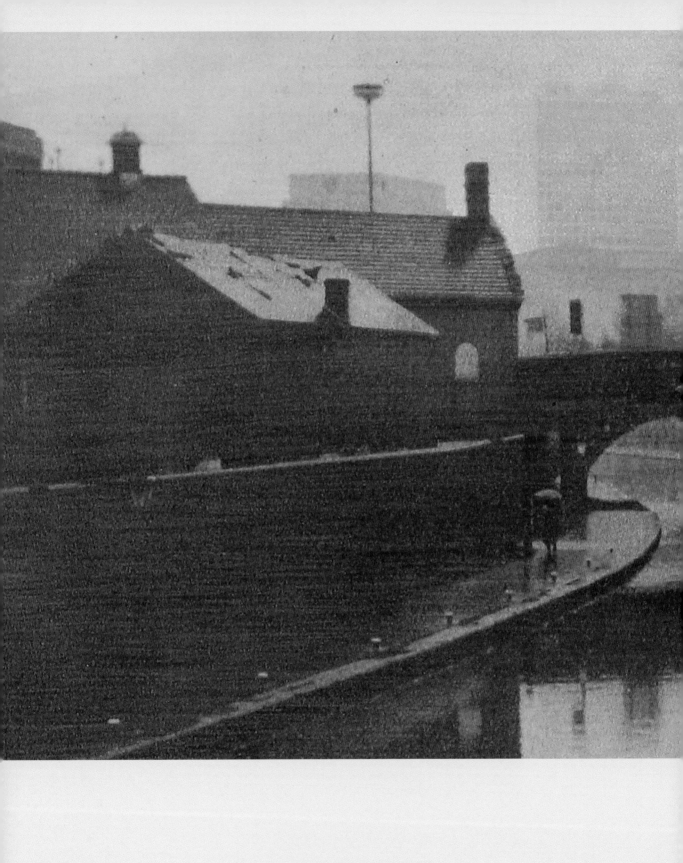

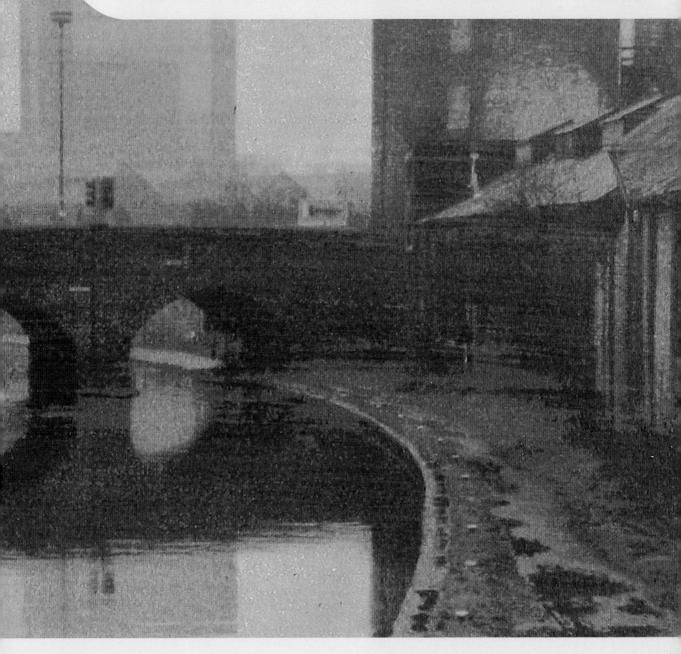

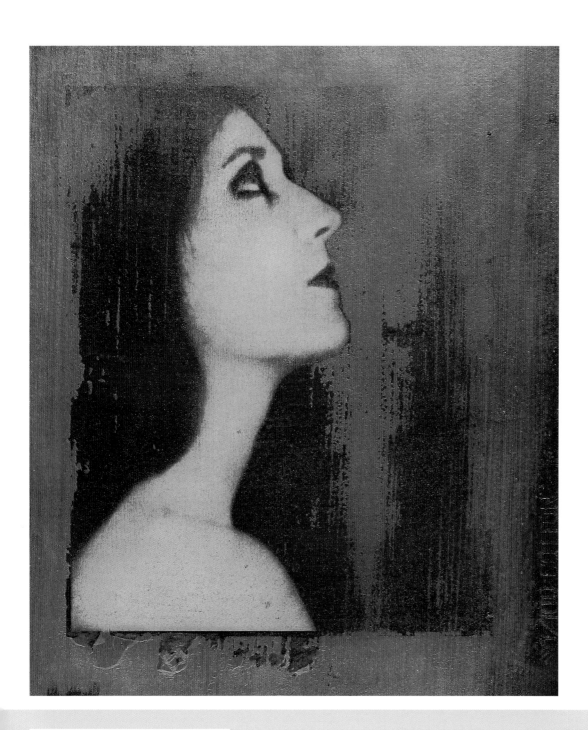

Introduction

No matter how much photographic technology progresses, there will always be a fascination with past methods of printing. Since the 1980s, there has been a growing interest in recreating some of the first photographic processes, which, despite their relative simplicity, can produce very beautiful and distinctive results. Here, I will concentrate on the four most popular processes—salt, platinum, gum, and cyanotype—though there are many more possibilities to explore. (See the appendix for information.)

Although different, all these processes use similar production methods. The emulsion is applied by hand onto good-quality watercolor paper, and a negative is then contact-printed under ultraviolet light or sunlight. Because these processes require lengthy exposure times, even when contacting, using an enlarger with a UV light source would be out of the question. Enlarging only became common practice when the more sensitive silver-gelatin papers that we still print with today were introduced at the beginning of the 1900s. In the past, photographers used large-format cameras to produce their negatives, and although this will still give the finest results, it is common practice now to make enlarged negatives. A simple method is to project a color transparency onto sheet film and then process the negative in a contrasty developer. The negatives required for most processes must be very contrasty—usually equivalent to printing on grade 0 photographic paper—but they must have a full tonal range (see p.36). Print developer is useful to achieve such contrast, and test strips should be made at different exposure times and dilutions.

Starting out

It is common to start with a normal black-and-white negative, so a film positive must first be made, ideally on orthochromatic film. (Orthochromatic film is sensitive to blue and green light, so it can be used under a red safelight.) This positive should be of normal contrast, so standard film developer can be used, and this is then enlarged as above to make the final negative. Specialist darkroom suppliers will be able to advise you about which sheet films are available and which are the best to use. Alternatively, digital negatives can be made by outputting on acetate at a high ppi (pixels per inch) setting, having converted the image to monochrome, inverted it to negative, and adjusted the contrast (pp.142–45).

Coating the paper can usually be done under normal room lighting, but make sure curtains or blinds are closed to prevent fogging. Always use a good-quality, acid-free artist's paper, which is known as "hot pressed." Use the smoother side. A large flat brush (with no metal parts) is ideal, and the emulsion should be applied with even vertical and horizontal brush strokes. The edges of the exposed print will show the brush marks—some photographers like to use them as part of the finished print. For a smoother result, apply a quantity of emulsion (about 4ml / 0.1 fluid ounces per 10x8in [25x20cm] paper) in a line at the edge of the print area with a syringe; then spread it evenly over the paper with a glass rod.

Once dry, the paper is then contacted under the UV light. Unlike in modern printing, the image forms during the exposure. To check its progress, therefore, a hinged contacting frame is ideal, since it allows half the image to be inspected (away from the light source, of course), while the frame keeps the rest of the paper and negative in register.

Platinum Printing

Although it is a luxurious process producing incredibly detailed and very permanent prints, platinum printing requires a great deal of care and attention to get the best results. This process was popular from the end of the 19th century until World War I, when commercial production of the paper was stopped due to the use of platinum in munitions. Over the past 30 years, it has been revised by many photographers, who coat their own emulsions onto high-quality papers. It has become highly sought after in the art market, not only for the beauty and depth of the prints, which have a long and smooth tonal range, but also for the extremely archival qualities offered by the process.

However, this is not a process that you can try from just a brief outline—it would really take another book to describe fully the variations possible in image tone (from a cold black to a sepia brown), contrast adjustment, and processing control. This is not to say it is complicated—it simply requires very methodical working and plenty of practice. It is also not as expensive as it may sound, because once the technique is mastered, there should be little wastage of materials—although the cost of the raw materials will ultimately depend on fluctuations in the world's trading markets. The best way to learn this process is to attend one of the many workshops held around the world by photographers already skilled in platinum printing and gain from the benefits of their experience.

Platinum/Palladium Print, 1994 by Alastair Laidlaw and Christine Marsden.

The Scottish photographer John Thomson was well known for his pioneering travel photography in Cambodia and China in the 1870s and his later series, *Street Life in London*, an early social document of London's lower classes. He later established a very successful portrait studio in London often printing in Platinum. This beautiful portrait was photographed and printed in 1897. It remains in pristine condition.

Salt Printing

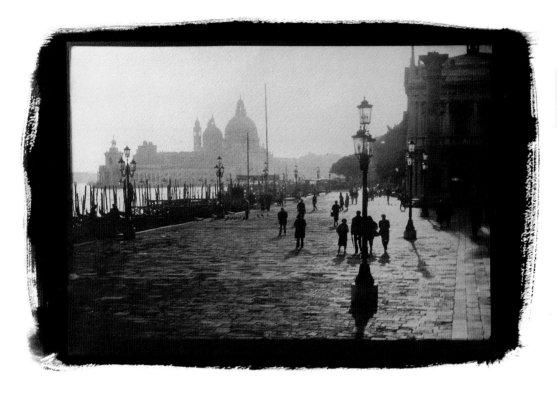

The process of salt printing takes us back to the beginning of photography in 1839. Silver nitrate was known to be light-sensitive, and experiments had been made contacting objects onto leather that had been coated with it. The resulting images were faint and very unstable. Fox Talbot solved these problems with the addition of salt, which increased the intensity of the image, and fixing with sodium thiosulfate ("hypo").

It is a very simple process. Soak a sheet of paper in a sodium chloride (salt) solution and leave it to dry. Then coat the paper with silver nitrate and dry it again; it is now ready to print in a contacting frame using a negative with strong contrast. (Alternatively, the negative can be taped lightly on one side with "magic tape" and placed under a sheet of glass.) Exposure time will vary according to the light, but it will certainly be in minutes rather than seconds. Inspect the print regularly, and when it is about a half-stop darker than required, it should be washed quickly and given ten minutes fixing in hypo or five minutes in modern rapid fixers. The print will brighten to a warm reddish-brown color and should then be washed for a further hour. If well washed, it can be toned in gold toner for a very attractive purple-brown hue, although it is also possible to tone the print before fixing. As with all historical processes, you should take great care when washing and drying, because the emulsion has no coating to protect it and will be very fragile.

Terry King demonstrates the stages required for making a salt print. Silver nitrate is coated onto watercolor paper previously soaked in sodium chloride.

The gamma and contrast of the negative are checked using a densitometer.

The salt print is fixed in hypo.

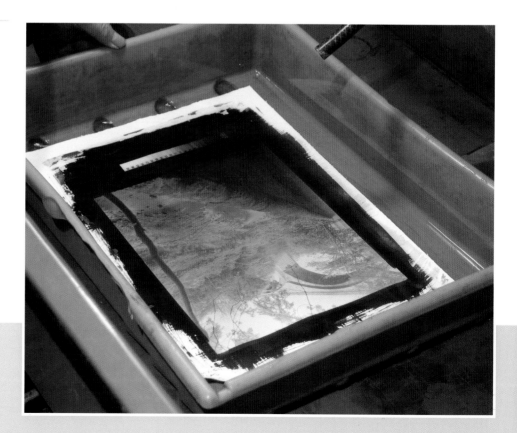

The print is exposed by contact using an ultra violet light source.

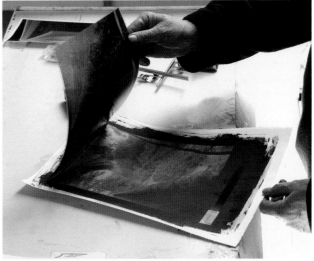

Keeping the negative in register, the density of the print can be checked throughout the exposure.

Following fixing, the print is then thoroughly washed.

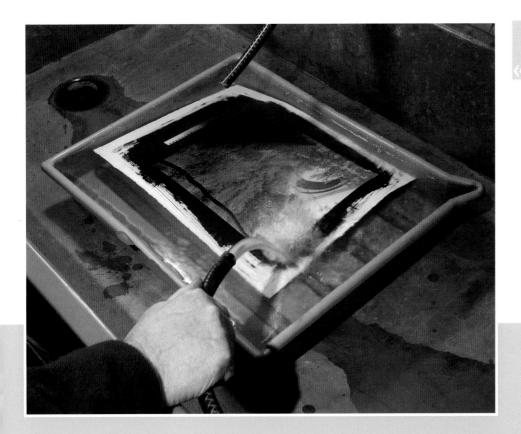

Gum Printing

For the process of gum printing, the light-sensitive chemical potassium dichromate is mixed with gum arabic and watercolor pigment to form an emulsion. "Gum bichromate," as it is often known (the less sensitive ammonium bichromate was the first sensitizer used), can produce prints in any color and displays a very painterly, almost Impressionistic effect, making it very popular with the pictorialist photographers of the early 1900s, such as Edward Steichen and Robert Demachy.

Mix together equal amounts of sensitizer and gum (see appendix) with a plastic palette knife, and then add in the pigment. This is coated onto the paper, and when the paper is dry, it is ready for printing. For once, the negative does not need excessive contrast, and the equivalent contrast required for grade 1 or 2 should suffice. When the correct tone is reached under the UV light, float the paper face down in a tray of water and gently agitate the tray occasionally; the unsensitized parts of the print (the lighter tones) will slowly be dissolved away. This water should be changed several times until there is no yellowing discoloration from the dichromate or any pigment left in the wash tray. When dry, the print may appear flat, so you may have to repeat the process two or three times to build up contrast. When doing this, you can also change the color of the pigment each time to achieve a multicolored print. The first exposure for the highlights should be a lighter color and a longer exposure than the last one for the shadows. To ensure the negative stays in register, make a pinhole through the four corners of the negative and first print so that they can be visually realigned on subsequent printings.

Centennial Square, Birmingham by Terry King. Multicolor gum printed in acrylics on Fabriano Artistico paper.

> ### Tip
> Gum prints can be made by melting fruit gum sweets and mixing them with a dichromate sensitizer. The coloring is so strong that a single coating will produce vibrant, contrasty prints.

Cyanotype

The cyanotype was one of a number of inventions and innovations made by the English scientist and astronomer, Sir John Herschel (1792-1871). His initial contribution was the discovery of sodium thiosulphate—"hypo" as it is more commonly known—as a fixing agent. He was also the first to use the terms "positive" and "negative." Indeed, it is Herschel we thank for the word "photography."

The cyanotype, recognizable by its strong blue color, was first used in 1841 to demonstrate the sensitivity of iron salts and it is still one of the easiest and cheapest photographic processes used today. It involves only two chemicals, potassium ferricyanide and ferric ammonium citrate, mixed with water and coated onto paper.

A contrasty negative, one suitable to print on grade 1 photographic paper, is then contact-printed by sunlight or ultraviolet light, requiring an exposure of between ten minutes and one hour depending on the strength of light.

A blue-green image will have formed, which should be washed for about five minutes to remove all traces of the ferric salts. It is a surprisingly stable process, and one that gave us the term architectural "blueprints." Cyanotypes can be bleached in a five percent solution of ammonia, washed, and then toned in a saturated solution of tannic acid for a more subtle purple tone if you prefer.

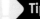
Tip

The first ever photographic book was *British Algae: Cyanotype Impressions,* by the English botanist Anna Atkins, published in instalments between 1841 and 1853. These remain excellent subjects for striking cyanotypes.

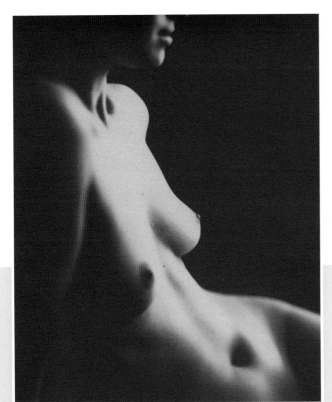

By toning in Tannic Acid, warmth can be added to the Cyanotype. Photo: Allan Jenkins.

Untoned, the Cyanotype has a strong Prussian Blue color.

From Film to Pixels

As the previous chapters have shown, film-based black-and-white photography and silver-based printing is a medium with endless possibilities and choices. When we first learn about photography, we should be open to experimenting with many different methods and processes. In doing so, we will slowly learn more about our own preferences and approach to photography, as well as what we hope to say through the camera. As we become more serious about our work, there may be one particular method, style, or subject that we favor, and a grounding in the many techniques of black and white will hopefully give us the knowledge and skills to make such decisions.

Despite what some theorists and critics might believe, no form is higher in merit than another. A photograph can be a work of fine art, or it can be a documentary record of an event or a person. Sometimes it will be both. It can also be used in advertising, to persuade and influence our choices in lifestyle, or as a tool for important scientific research. Above all, we use photographs as individual records of a visual diary. A snapshot will preserve memories of our family, friends, and the events and places that are important to us. It is no surprise, then, that the fortunes of the photographic industry are dominated by profits from the amateur market, with sales of professional materials and equipment only accounting for perhaps ten percent of turnover. Bearing all of this in mind, we should consider what changes to photography—in all its forms—have been made by the rapid ascent of digital technology, and what this means for those of us working primarily or solely in black and white.

It now seems a long time since the late 1980s when digital methods started being used professionally, but considering the long history of photography, it has actually been a swift change. The first moves were made in photography's companion industry, mechanical reproduction, as analogue and traditional methods of scanning and printing were replaced by computer-based technology.

The rise of the desktop

At the same time, smaller and more affordable computers came onto the market, and the revolution continued into print design and magazine layout, as "desktop publishing" became the norm. Next, computer programs such as Adobe Photoshop were developed; these were initially simple programs to convert and correct digitally scanned photographs for reproduction, but they were soon being used more creatively by photographers themselves. The input of photographers led to vast improvements in these programs, which incorporated the terminology of the darkroom and camera, as well as the disciplines and methods of design and reproduction. The first digital prints of an acceptable professional quality were "Iris" prints—a way of printing one-off proofs from digital files before an image was run by the printing presses. As individual prints, these could be output on fine-art papers and were soon used for exhibitions and portfolios in the early 1990s. Desktop ink-jet printers, which had previously only been of good enough quality for text and simple illustrations, were improved until they too could be used for high-quality photographic work.

While the popularity of digital printing quickly increased in the professional arena, the introduction of digital cameras took several years to take hold. This was simply down to the lack of quality in early models, relative to their initially high prices. However, for the amateur market, where the limitations of the medium were not as critical, digital cameras soon became popular. The final widespread acceptance of digital photography at the professional level occurred when the quality of image capture increased to such a degree that photographers' clients not only accepted digital files—as opposed to

prints or transparencies—but many came to prefer them, with some exclusively demanding them from their rosters of photographers.

A different way of working

The popularity of digital cameras has been responsible for the most notable change in the way we take pictures. The mentality of using digital capture compared to film is certainly different. With digital, we are now used to shooting as many images as we want, instead of being limited to the amount of exposures on a film. We can also see the result instantly and decide there and then whether to keep the image or delete it forever. The final change to consider is that often most photographs are never printed—they are only viewed and stored digitally.

I see these three points as both good and bad. While sometimes it is important to concentrate on getting the best shot of a subject, having the option to shoot potentially hundreds of frames quickly and economically on the same chip can be a boon. It gives us the freedom to take risks and to experiment. However, that LCD screen on the back of the camera can sometimes be a distraction! If a shot is definitely useless, fair enough, delete it, but I usually wait until I've seen all my images on the computer before making such decisions. Remember,

on a conventional contact sheet there will be things we may not notice or appreciate for a long time, and sometimes we need time and space to look at something objectively. Also, while saving images onto a CD or hard drive is similar to having a contact sheet from which only selected frames will ever be enlarged in the darkroom, I feel we are losing some of the pleasure of photography by not making more prints. Part two of this book explores all of the issues and possibilities of working digitally in black and white.

Computer Hardware

Today, computers are everyday, commonplace objects, as familiar to us as the television and the washing machine. Over the last two decades, they have dropped enormously in price, while their efficiency, power, and technical capabilities have dramatically increased. Any computer produced today will have the potential to be used with digital imaging programs such as Adobe Photoshop, but you should give some thought to what is the most suitable hardware and how much it will cost you.

It is, of course, a perennial question, but is there still a great difference between PC and Apple Macintosh systems? Well several years ago, the answer would definitely have swung in favor of the Mac—and I will admit from the outset that this remains my preference—but there is now little difference in terms of the quality of equipment and potential processing power between the two. There are benefits and disadvantages of both. Because many different companies manufacture PCs (though practically all run the same Microsoft Windows operating system), natural competition has led to PCs being cheaper. However, since the advent of the iMac in the 1990s, Macintosh prices are less prohibitive and machines are now available for all budgets. They will probably remain the professional's favorite, having been the industry standard for years, and they still have some advantages over the PC. Recovery after a crash is less painful, monitors are easier to calibrate, and the desktop can be split over two screens. However, the choice of general software is more limited, and this is quite an important consideration, since it is unlikely that a computer will be used only for photographic work, especially if more than one member of the household uses it.

Perhaps more important concerns, though, are power and memory. Photoshop uses lots of memory, so, at the very least,

The Apple G5 is many professionals' choice for using Photoshop, with an incredibly fast processing speed and huge potential memory.

PC workstations from companies such as Dell can be ordered online to the buyer's specifications, to ensure processing speed, RAM, storage, and monitor will give the best results for working with image-editing programs, such as Adobe Photoshop.

256MB of RAM (random access memory) will be required, though as much as possible should be allocated to Photoshop. Even though an image may be 30MB, it is often copied many times when being worked on so, temporarily, its size keeps increasing. Ideally, 512MB of memory should be used, though preferably a lot more. A high processing speed will again improve the efficiency and speed of Photoshop—1GHz is the minimum, although most computers are faster.

Another choice is between desktop and laptop. Laptops are portable, but their screens are a disadvantage, and an external mouse is recommended. Also, with a desktop machine, there will be a large choice of different monitors. Standard CRT (cathode ray tube) screens are excellent, but many people now prefer the flat LCD (liquid-crystal display) monitors.

LaCie CRT monitors give perfect control over color balance. The hood helps to cut out ambient light.

Tip

Your health is something that money can't buy. If you work at a computer for long periods, take regular breaks, drink plenty of water, use a chair that provides good support, ensure your wrists are supported, and make sure the screen is at eye level, if possible. These factors can be a problem with laptops, as the user tends to adopt a bad posture for prolonged working.

A laptop is ideal if portability is a requirement. It is especially useful for shooting on location as you can download, preview, and store images directly from the camera. It is best to get as big a screen as possible and use a separate mouse. Apple PowerBooks are a popular professional choice among photographers.

Scanning

Bit Depth, Pixels, and Resolution

A digital file is a binary code of information, each piece described as a bit (short for the term "binary digit") that can be read and translated by a computer. Digital images are made up of pixels (from "picture elements"), which are tiny colored squares containing basic mathematical information that determine their tone and color. When viewed together, often in the millions, pixels form the impression of continuous tone, similar to the ink dots that make up a photographic reproduction on a printed page. A 2-bit image would only have have two levels of information, which would be the most basic choice of tone: black or white.

Because the computer works mathematically in twos (binary), any increase of possible information available to each pixel is described in the form of 2 to the power of 2, 3, 4, and so on. This is known as "bit depth." So, 2 to the power of 4 (described as "4 bit") would mean 2x2x2x2, therefore 16 possible levels of tonal information per pixel. In digital photography, we work in 8 bit (2 to the power of 8), which equals 256 possible levels, or steps of information, per pixel. But this is, in fact, still just 256 shades of gray, known as grayscale. When we work in RGB (red, green,

Pixels (short for "picture elements") are the basics of a digital photograph, each one realized by its own binary digital code that determines its tone and color. The computer represents each as a single square, which, viewed en masse, create the impression of continuous tone. A scanner will process the analogue information in a photograph and convert it into a series of pixels. The ppi (pixels per inch) setting determines the clarity of the image.

When working digitally from a traditional photograph, whether print or negative, you must first use a scanner to capture the image. The scanner will optically record the analogue information of the image and then translate it into a digital file. Before we look at the choice of scanners, here is a brief explanation of some of the terminology used.

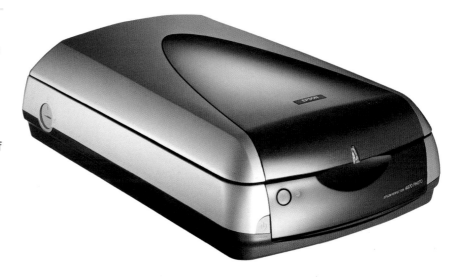

blue—that is, color), we use three separate grayscales, though instead of actually appearing gray, each is seen as a primary color—red, green, or blue—which, when combined, our eyes see as full color. Technically, our 8 bit is really now 24 bit, and the possible levels of visual information per pixel have multiplied up to a staggering 16.7 million. Normally scanners will work at 8 bit (per channel), though some can read up to 16 bit, recording even more information, which is then translated by the computer back down to 8 bit.

The resolution of the image is described as how many pixels per inch (ppi) the file contains. This is still often referred to as dots per inch (dpi), which was the term used by reprographic printers to describe the resolution of halftone printing plates. So if an image was one inch square (confusingly, digital terminology uses a combination of imperial and metric measurements) at a resolution of 200dpi, it would contain 40,000 pixels (200x200).

Choice of Scanners

The quality of a scanner is not simply down to how high its resolving power is; it is also about the quality of its optics and how accurately it can translate the analogue information into digital information. The best results are from drum scanners, where the image is placed around a transparent drum and revolved at high speed while optical sensors make the scan. These machines are very expensive and are used primarily by photographers, designers, and printers to make scans (sometimes up to 4,800ppi) for high-quality printing and reproduction. However, they are an option if you want the best possible quality and can afford the fee that a lab will charge.

The most popular scanner for home use is the flatbed scanner, which can normally scan artwork and prints up to letter-paper size (A4) at a resolution of 1,200ppi. Many flatbed scanners have a light hood, making scans of negatives and transparencies possible. While never previously considered good enough for professional work, the quality of flatbeds has improved considerably in the last few years, and if they are not printed too large, even 35mm negatives can be scanned relatively successfully on some machines. If it is likely that you will only want to work from negatives, a film scanner may be a better option. Most will only take 35mm negatives,

The Imacon Flextight scanner has become a favorite among professionals. It accepts a wide range of film sizes. Though relatively expensive, Imacons come close to the image quality of top-range drum scanners.

though some (sadly more expensive) models working at a resolution of 2,500ppi can accommodate larger formats. Software is often included for removing (or at least disguising) dust and scratches. Another option, which again is aimed more at professional use, is the Flextight. This is a type of film scanner with very high optics and engineering that can produce scans up to 3,600ppi—almost the same quality as a drum scanner.

Using the Scanner

Whichever scanner you choose, follow the instructions carefully to achieve the best quality possible. Often this can be improved by using additional software, though the principles of scanning are usually the same. With flatbeds, it is a common belief that placing the negative or print in the center of the glass will give the best quality; however, manufacturers are quick to dispute this. The first operation is an overview, which you use to select the image and the crop. The resolution can be set at this point, and this will determine the size in megabytes (MB, or "megs") of the final scan (see appendix for recommended settings). A prescan is then made, and the image can be fine-tuned with the contrast and color controls. Sharpening options are also possible, though it usually better to do this in Photoshop (see p.148). In some scanning programs, it is also possible to make a histogram (see p.145), which will indicate the tonal balance of the scan and whether changes should be made to the contrast. Once these two steps are complete, the scan can be made and the file saved ready to be opened in Photoshop.

It is important to get to grips with the scanner's software to achieve the best possible quality scan. Ensure that each command is correctly set, and, as the contrast and tonal range of every photograph will be different, take care to input new settings for each one.

Digital Capture

Digital Cameras

While scanning gives us the option of making digital prints from our conventional negatives or photographic prints, the easiest method is to shoot digitally. Like film cameras, there is a diverse range available from easy-to-use compact models to serious, professional SLRs.

Digital technology has created the biggest change to photography since its invention. Just as 35mm gave us the ability to shoot a lot of film cheaply and quickly, so the memory card in each camera can, depending on size, capture perhaps a thousand shots before the need to download to a computer or hard drive. However, the number of photographs recorded will be dependant on their size and quality.

Digital images are made up of pixels (picture elements), and a camera's resolution is indicated by the millions

For professionals and many amateurs, the digital SLR is the ideal camera for high quality images, and there is a wide choice of functions.

of pixels it is able to capture on each image at the camera's highest quality setting. It is inevitable that the number of available megapixels will continue to rise as imaging technology is continually improved. The effect will be to raise the quality bar at the entry level. Smaller compacts currently offer

up to five million (five megapixels, or 5M), enough to make small prints of good quality, while more sophisticated cameras can achieve up to 22M, giving outstanding detail on large prints.

Digital compacts have become smaller, cheaper, more powerful, and are now capable of producing excellent results.

Digital and other formats

Some medium-format film cameras can be used with a digital back, giving the professional the choice between shooting on film and digital capture. The revolutionary Hasselblad H System is specifically designed for both film and digital, though with the ability to record several hundred high-resolution images on one back, before the need for downloading, digital has become the obvious option for most users. This capability is increased significantly when the camera is linked to either a computer or a portable hard drive, though the extra time required to process and download these images from the computer can be awkward when clients are present. Previously, film for a large commercial job would usually be given to a lab and could then be edited when processed. This has had serious implications for traditional photographic manufacturers, though film (especially black and white) retains an appreciative, though smaller market.

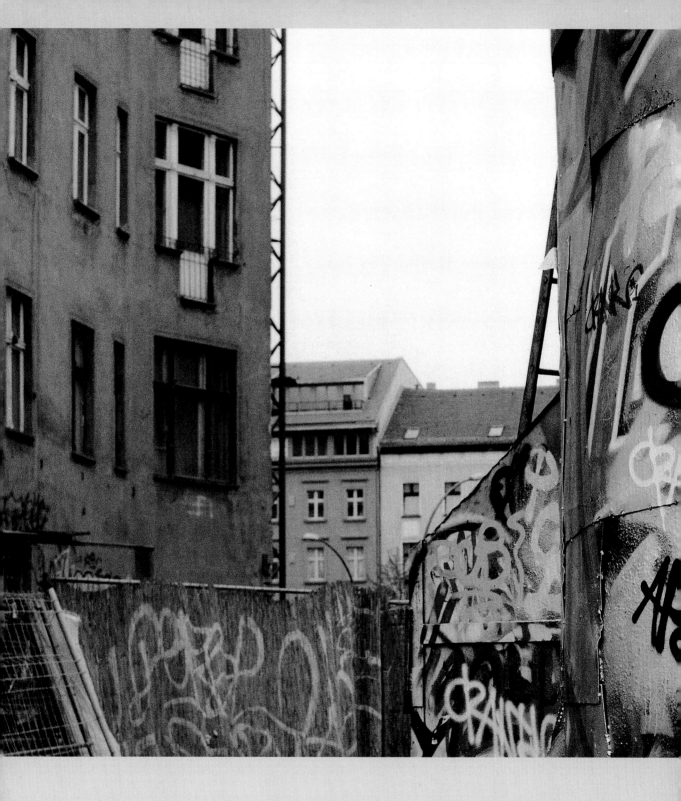

Photoshop Basics

Most people reading this book probably have an understanding of the principles of Photoshop or have perhaps used other similar programs. Though the main techniques applicable to digital black-and-white photography are covered throughout these next three chapters, it is worth briefly covering some of the basic features that are required for working with Photoshop. When the application program is open, the computer screen will display three main sections. At the top is a bar containing ten different menus, each offering a list of various commands and functions and some opening into submenus that can be used to make changes to an image or part of the photograph. To the left (though this can be placed anywhere on the screen) is the Tools palette, which has many different creative tools that can be used to make other visual changes to the image. Finally, when a photograph is being worked on, there is also the main window, known as the Canvas.

Menus

Image Menu

The Image menu contains some of the most important features that affect the shape and form of the image, as well as adjustments that are made to its tonal balance and color rendition. Under Mode is the choice of which color scale the computer and subsequent hardware, such as printers, will recognize the file as. In RGB, the colors will be seen as the combined values of red, green, and blue, which is how the computer screen displays the image. CMYK uses the opposite colors to RGB: cyan, magenta, and yellow, as well as black (K stands for Kohle, the German for coal; B was already used for blue). These are the colors of the inks that printers use to translate the RGB image. Grayscale is a monochromatic rendition of the image, but surprisingly you will find that most black-and-white images will require the RGB mode.

The main Photoshop screen, with the Tool bar to the left and the image in the center of the Canvas.

RGB Color mode selected from the Image menu.

Pixel Dimensions: 11.7M

Width: 2006 pixels

Height: 2040 pixels

OK

Cancel

Auto…

Document Size:

Width: 16.98 cm

Height: 17.27 cm

Resolution: 300 pixels/inch

☑ Constrain Proportions

☑ Resample Image: Bicubic

The Image Size palette, where you can set the size and resolution of the image.

Next down the Image menu are various Adjustments, most of which will change the contrast and color of the image. Many of these commands, as well as other features of Photoshop, can be activated by using various keyboard shortcuts, such as holding down the Ctrl key and pressing B (or Command+B on a Mac) to open the Color Balance, which is then used to adjust the colors throughout the tonal range. These shortcuts are written next to each relevant item in the various menus and are also in the program's manual. In this book, I will list each command in full—for example, Image › Adjustments › Color Balance, though most readers will naturally start to adopt the shortcuts once familiar with the program. Further options available in the Adjustments submenu to work on color are Hue/Saturation, Desaturate, Relative Color, Selective Color, and Channel Mixer. Commands to correct or alter the tonal range include Levels, Curves, and Brightness/Contrast. To switch the image from negative to positive, or vice versa, select Invert.

Under Adjustments is Duplicate, which will make an exact copy of an image, and that is followed by Image Size. This is an important feature since it determines not only the size of the image (described as a document) but also its resolution or its ppi (see

p.128). Different documents require different sizes of resolution, depending on their final use. For online viewing, a 72ppi JPEG downloads quickly and displays well. For printing with an ink-jet printer, it should be set from 200ppi upward, depending on the size and quality of the print.

I normally work on images in Photoshop at 300ppi, but the printer will usually be set at a different resolution to increase the quality, though this will not affect the image size (1,440ppi is recommended for very fine quality). If an image is being reproduced in a book or magazine, it will need to be of a specific size, depending on the fineness of the print. The actual resolution and the size of the file (expressed in MB at the top of the box) will have been determined by the size of the scan or the settings on a digital camera. If a new resolution is entered, you will see that the overall size of the file will decrease or increase, though not the document

size. If the file has relatively good detail to begin with, increasing the resolution (known as interpolation) can increase the quality by replicating, as best it can from the surrounding digital information, the missing pixels from the image when it is increased. Options for this are next to Resample Image, usually set by default to Bicubic, which is reckoned to be the most accurate.

If the document size is altered to change the size of the photograph, the image size (in MB or pixels) will again change accordingly. Entering one dimension, either the width or height, will automatically change the other unless the Constrain Proportions box is unchecked.

Tip

Photoshop appears daunting, but it is not as daunting as the situation you'll face if you don't plan now to manage all of your files in the future as your image library grows.

Final print size and position on the paper is determined by Print with Preview.

The Photoshop File Browser.

File Menu

This handles all the "bureaucratic" issues to do with Photoshop, such as creating new files, importing and exporting images, saving a document, previewing saved images, and printing the photograph. Several of the commands are similar to those in other programs: New to create a new document, Save to preserve any changes, and Save As to rename a document once changed. Print will open the Print Options box, where the usual choices can be made concerning copies and paper settings, as well as final color corrections to the print (see p.174). It also offers page layout, but a more sophisticated option is to go to Print With Preview, where exact placements can be made and the image size temporarily changed, which is useful for printing out small tests before making the larger final print. Another very useful feature in the File menu is Browse. This can quickly display and open thumbnail images from any file on the computer, making it easy to find images on a very full hard disk.

Window Menu

The Browse function can also be accessed from the Window menu. Most of the other important commands from this menu will be looked at later, but several are worth pointing out. Navigator is a quick way to isolate areas of the image when using Photoshop. It shows a small picture of the full image and an inserted red box, the size of which is controlled by a slider. While Navigator is open, the enlarged image within this box will be displayed on the canvas, which is convenient when retouching or adjusting small areas of the shot. Other useful options in Window are History, which lists all the most recent actions taken and can be used to retrace one's steps when things go wrong, and Layers, being the different slices that make up an image (see p.152). If you are using several items from the Window menu, they can be tiled together to tidy up the desktop by going to Window > Workspace > Reset Palette Locations.

Tip

When you have finished working on an image, you can "flatten" the separate layers to form a single, unlayered image. This will save space in terms of storage, but keep a layered backup somewhere in case you need to revisit and change the image's elements in the future.

Tools Palette

The Tools palette contains all the different options of tools that can be used for selectively working on images. It is supported by the Tools option bar, just underneath the list of menus, which allows instant access to change the characteristics of the tool being used. The palette contains more than 50 different tools, many hidden behind another. These are found by clicking the small black triangle at the corner of each box. Again, the program's manual will have a comprehensive list, but there are several important ones to highlight.

Selection tools

To move elements of the image, or to isolate areas that require individual changes, there are various Selection tools. When applied, only the selected area will be changed. For defined shapes, there are four Marquee tools, though only the Rectangular Marquee tool is regularly used. Area selections are made by clicking on one corner with the mouse, holding it down and dragging it across the screen to form the shape, and releasing the mouse when it is the right size. The three Lasso tools—Freehand, Polygon, and Magnetic—are very important for making selections to fit a particular shape. Freehand is used by drawing a line with the mouse around the object to be highlighted (a graphics tablet and pen are useful accessories for this job), and Polygon draws only straight lines. The Magnetic option will supposedly correct a very roughly drawn selection as it is done, but I have never had much luck with it. The path each selection takes must join

back to its beginning to form a complete shape. When using the Marquee and Lasso tools, you must set a rate of feathering; this controls how the edge of the selection is faded and can be found in the Tools option bar. It can be set for 0 pixels upward. The effectiveness of this will depend the image resolution, but with most selections only a very small feathering will be required (certainly less than 5), if any at all. However, when making a selection that needs a very smooth gradation, a feather of 100–200 pixels is not uncommon. Another option is the Magic Wand, which will make a selection to fit a particular shape when it is clicked in the middle of the area. The accuracy depends on how neutral in tone the area is and what the Tolerance level is set to, which again is found in the Tools option bar and expressed in pixels (20 pixels is a good starting point). It does not work on busy, confused areas and is best applied on low-resolution images.

To make more exact selections, there are four modes that can be used in the Tools option bar. The first is to make a new selection, and this is the default setting. It is very difficult (and frustrating) to make a precise selection in one attempt. By using the second mode, Add to Selection, it can be done in several stages: Simply click this option and make another selection, ensuring that the two at some point overlap each other. They will then be joined together, and this can be repeated until the selection is complete. The third mode, Subtract from Selection, works in the same way, except it removes part of the selection.

When working on exact details, it is a good idea to zoom in to the image using the Navigator. The last mode, Intersect Selection, removes parts of the selection that don't intersect the latest one. I have yet to find any use for this option! The shape of the completed selection can be reversed by choosing Inverse from the Select menu; to save a selection that can be used again, go to Save Selection from the same menu. Selections can also be moved within the canvas or dragged to another Photoshop document with the Move tool.

Brushes

All the brush tools are worth getting to know—the effects possible, the sizes used, and the possible edge effects. The manual will give full instructions for how to use them, but one particularly worthy of mention is the Healing Brush. This makes the inevitable retouching of images—removing dust, scratches, and blemishes—an absolute dream. To remove marks, you select a suitable brush size, and then a nearby area, similar in tone, is sampled by pressing Option/Alt and clicking the mouse. The brush is then placed over the mark, the mouse clicked again, and with luck the mark will disappear. To retouch a photograph quickly, it is advisable to enlarge the image first with the Navigator. Then you can move the red box to the top-left corner, retouch this part, and keep moving the red box, retouching each part methodically, until you have finished.

The Tools palette contains over 50 different tools, as well as allowing you to determine color choices from the commands beneath these options. It also gives you three choices for presentation of the image on the screen: Normal mode showing the Photoshop image canvas within the usual monitor set up, or alternatively against a neutral gray screen. The last option is against black, which looks appealing but will make your image appear more contrasty than it really is, so avoid using it. I find it easiest to work in Normal mode, but I make sure my monitor is set to mid gray, so it won't clash with the tonality of the image.

Make selections using a combination of four different select options, four different Marquees, three Lassos, and a Magic Wand.

The Brushes Palette, showing some of the many available sizes and styles.

Crop tool and Measure tool

The Crop tool (below left) is applied by clicking onto the image, dragging the mouse to form a rectangle, and then releasing it. This frame will then be surrounded by a shaded area showing the cropped section within. The shape can be changed by moving the sides of the crop outward or inward. It can also be rotated by moving the cursor beside any of the eight small boxes placed on the edge of a crop and then, with the mouse, rotating it in either direction. Once the crop is correct, it can be carried out by pressing either the Enter or Return keys on the keyboard. If an image simply needs to be rotated but not cropped (often necessary when a scan is slightly skewed), this can be done quickly with the Measure tool (below right), which is hidden behind the Eyedropper tool. Draw a line with the mouse within the canvas, at the same angle as the slant. Then select Rotate Canvas from the Image menu, and then choose Arbitrary. The box will display the angle of rotation required (or you can input any plus or minus angle). Hit OK, and the photograph will automatically correct itself.

The Crop tool in operation. Above, the area to be cropped out is tinted dark gray. The completed crop is shown, right.

Tip

Photoshop includes a History function that allows you to step back through each of the edits you have made while you are working on the file. So don't panic!

Black-and-White Conversion

With traditional photography, there is always a definite choice made by the photographer over whether to shoot on color or black-and-white film. When shooting digitally, it is almost inevitable that the original photograph will be color, requiring the image to be converted to black and white later. There is a black-and-white mode on many digital cameras, and this is useful for seeing the image in monochrome before shooting (similar to using Polaroids); however, it records on only one of three channels, and it seems pointless to make a file containing just one-third of the available information. Likewise, if we scan color film, that will also have to be converted to monochrome later. Indeed, even scanned black-and-white film has to be converted, since it will still be in RGB format and display a color bias from the film base. Converting color digital files to black and white is a straightforward operation, and there are three customizable options in Photoshop to choose from.

Grayscale

A simple conversion is done by converting the image to grayscale (Image > Mode > Grayscale). However, similar to the black-and-white mode on our cameras, this will create a far smaller file by using only one channel. Thus, an 18MB file would become 6MB, and having previously had 8 bits per channel to record the full tonal range over three channels, it is now condensed to one single channel. On smaller files, this will probably result in a compression of tones.

Desaturate

Desaturating the image (Image > Adjustments > Desaturate) is similar in tonality to converting to grayscale, but the file will remain in the RGB mode and each of the three channels will also retain their 8-bit status. However, all three channels will be identical in tonality, having been converted to an average monochromatic reading.

Channel Mixer

Probably the most versatile way to convert to black and white is to use the Channel Mixer (Image › Adjustments › Channel Mixer). Each of the three different channels that make up a digital file—red, green, and blue—can be individually adjusted to balance the overall tonality of a converted color image. This is important because the strength of each color channel will vary depending on the range of colors present in the photograph. In the Channel Mixer dialogue, you first have to check the icon labeled Monochrome. The three sliders for each channel are then adjusted to find the correct tonal balance. As a starting point, I usually select 30 percent red, 60 percent green, and 10 percent blue; whatever

the ratio, all the percentages should add up to 100 percent. If you then change the levels for each channel, you will see what effect each one has on the overall tonality of the photograph. It is also very useful if you want to exaggerate a tonal range—for example, when using colored filters with black-and-white film (see p.42). Always remember that a color will be darkened by adding more of its opposite and lightened by adding the same color.

The Channel Mixer set at standard conversion settings for monochrome.

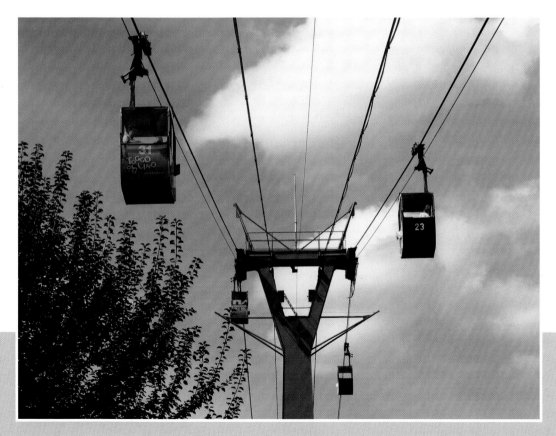

The converted image. To emphasize the output gray tones of the sky, more red and less blue could be set in the Channel Mixer.

File Formats

An image saved in Photoshop or other similar programs will have a file format that determines the digital characteristics of that particular document, as well as which applications it can be used with. To save a file in a particular format, choose from the selection in Save As › Format in the File menu. This also allows you to choose the location on your computer to which the file will be saved. Some of the listed formats are directly concerned with publishing and design, and these are the most appropriate ones for our use.

Photoshop

Once a scanned image or digital-camera image is opened as a Photoshop file, all of the features Photoshop has to offer can be used. For other applications and uses, it may be necessary to save it in a different format; however, if all you want to do is print it out from your own computer, the file can stay in this format.

TIFF

This stands for Tagged Image File Format. If a file is to be given to a lab to output or if it is to be reproduced, a TIFF is the preferred format because it will retain all the digital information in the file, which can then be opened and

adjusted by another computer. It has a profile attached (hence "tagged") that contains the correct digital information necessary for a printer or another computer to translate the colors, contrast, and density accurately (see p.174).

JPEG

Saving as a JPEG (Joint Photographic Expert Group) compresses the visual and digital information of a file by replacing several pixels with one. The quality will be affected depending on the amount of compression—or, in other words, how many pixels are replaced during this compression; settings are from 0 to 12. This is very useful for sending images by e-mail or if you want to prepare an image for a

Web site. A computer screen requires far fewer pixels than are needed for printing, and the best-quality JPEGs will be made by selecting Save for Web in the File menu. Most digital cameras save image files as JPEGs; however, the actual image sizes of these files are very large, so the compression is reversed when the final image is reduced in size.

RAW

A RAW file will have no compression whatsoever, and most digital cameras have an option to save images in this larger format. It will often be used by professionals requiring a bigger file size for reproduction, but it must be converted to a TIFF or Photoshop file before it can be manipulated.

File Formats are found under Save As. Remember to choose the correct folder or location into which to save the new file.

Levels and Curves

A simple way to alter the tonal qualities of an image is to use the Brightness/Contrast command in the Image menu. However, this is a crude approach, and finer control can be achieved by selecting Levels (Image › Adjustments › Levels). This will open a histogram showing a visual graph of the amounts (or "levels") of tone present in the image, from the shadows to the highlights (see Fig. 1). The left-hand side represents the shadows; the right, the highlights; and the midtones are naturally situated in the middle. Ideally, the histogram should have an even spread of tones (or troughs and peaks), though a very dark shot would have high levels to the left, and a light one would have high levels to the right.

There are two sliders: the top one has three pointers, which allow manipulation of the density of the shadows, midtones, and highlights; the bottom one alters the contrast in relation to the shadows on the left and the highlights on the right. Empty space on the left or right of the histogram (known as "clipping") means a lack of density in these areas.

Curves (Image › Adjustments › Curves) is another sophisticated method of altering density and contrast. The "characteristic curve" was originally used in conventional photography as a way of visually plotting the contrast of a negative. The bottom left represents the shadows, rising to the top right, which are the highlights. The angle of the curve will change the overall contrast (the steeper the angle, the higher the contrast), and both ends of the curve can be manipulated to change their respective density and contrast. Moving any point of the curve up or down alters the density of that part of the tonal range, while moving left to right changes the contrast.

Fig. 1: The Histogram should show an even range of tones reflecting the tonal values of the photograph. This example shows the photograph has more highlights than shadows.

Fig. 2: However, the jagged look of this Histogram means that there is a lot of distortion happening to the tones.

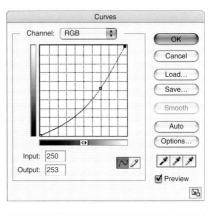

Fig. 3: Curves can be used as a sophisticated means of making subtle changes to the contrast and density.

Dodging and Burning

The Dodge and Burn tools in Photoshop are perhaps the ones most obviously inspired by conventional printing methods (see p.56). They replicate the action of selectively darkening parts of the image (Burn) or holding back some of the exposure to lighten areas (Dodge). As with the traditional skills applied in the darkroom, these tools must be used with care and attention so that they will improve, rather than degrade, the tonality and balance of the photograph.

The controls are found in the Tools palette and are used as a brush, working over the area of the image to be changed. Having selected either Dodge or Burn, you must the choose the correct brush size, the range of tones, and the "exposure" (or intensity of the action, to be more precise). I felt the image in Fig. 1 needed the Burn tool to darken down the bottom left of the shot and to add tone slightly to the top right, so as to balance the image. It is quite a claustrophobic image, and I wanted to reinforce this feeling by emphasizing the tonal difference between the murky sidewalks and the brighter, wet road leading out of the shot. I usually prefer quite a large brush with a very soft edge—in this case, 100 pixels—since it has to be applied to quite a large area. In applying the tool, it must flow quite smoothly. It will hopefully not affect the adjoining tone too noticeably. A smaller brush would require lots of moving backward and forward over the same area; this would probably show as a pattern. The choice of the range of tones is important, and the shadows, midtones, or highlights can be selected. It is worth experimenting with all three to see which gives the most natural action. Shadows may darken the whole area. I tried this first, but the black cracks between the paving stones suddenly became too dark and noticeable. For this photograph, I found midtones to be the most effective, applied with an exposure of four percent. The exposure setting is very critical, and the slightest

> The brush should be used smoothly, set at a low exposure rate.

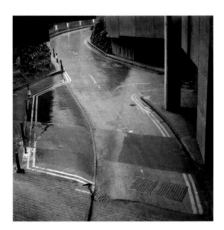

Fig. 1: The original image requires only simple burning to balance the photograph.

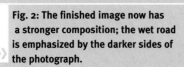

Fig. 2: The finished image now has a stronger composition; the wet road is emphasized by the darker sides of the photograph.

Again, this photograph requires little work as it is tonally very balanced.

Dodging the whites of the monkey helps to make it a more dominant feature.

Fig 3: The Dodge tool works in exactly the same way as the Burn.

amount makes a difference. The setting may go up to 100 percent, but I can't imagine any occasion when this would be necessary. Always start with a very low setting and gradually increase the percentage until the darkening is complete (see Fig. 2). To keep track of how much has changed, open the History folder (under Window) and click on the top icon of the image to see how it was originally.

The Dodge tool works in just the same way but it brightens parts of the photograph rather than darkening them. Again, it is important to choose the correct range of tones to avoid obvious dodging. In this example (see Fig. 3), I wanted to brighten the whites of the graffiti monkey, so I selected to work on the highlights and then, with a very low percentage of exposure, applied the brush over

the gray parts of the face. The exposure was so slight that it is difficult to see any change in the shadows where the tool touched them.

Sharpening and Softening

Unsharp Mask

The useful Unsharp Mask function is found in the Filters menu (Filters › Sharpen › Unsharp Mask) and can be used to improve the apparent sharpness of an image by increasing the clarity of the pixels that form tonal divisions. It can be very effective when applied carefully but can ruin a photograph if overused. There are three simple commands: Amount will change the strength of the filter; Radius will alter the size of the area affected around the sharpened edges; and Threshold will limit the effect in plain, even areas of tone. The Preview icon should be checked constantly to compare the sharpened and unsharpened image. It is best to keep the Radius at a low setting, usually just 1 or 2 pixels, and then slowly increase the Amount. If the setting of either of these commands is too high, bright halos will start to appear between the highlights and shadows.

Gaussian Blur

For the opposite effect, the Gaussian Blur filter will add softness to the image (Filters › Blur › Gaussian Blur). It is essential for adding a feeling of soft focus, and because digital photographs are sometimes too sharp, it can also smooth harsh textures, especially skin tones. There is one simple command to change the amount, and not much is required to make a difference. Again, the Preview icon is useful to make sure the effect is not overdone. A more sophisticated approach to softening is to create two layers (see p.152) — one very softened, the other sharp — and dissolve the two together until the preferred level of softening is reached.

Gaussian Blur

OK

Cancel

☑ Preview

100%

Radius: 2.1 pixels

Blurring can be very effective for softening skin tones. Gaussian Blur will give the most controllable results, especially if used in Layers.
Photo: Huw Walters.

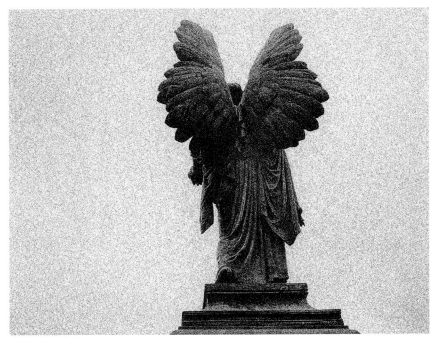

Although the most natural-looking grain is still to be found by using conventional black-and-white film, Photoshop can create a good simulation using Gaussian Noise.

Noise and Grain

There is no denying that a lot of digital effects are used to recreate some of the attributes and characteristics of conventional photographic materials. The Noise filter certainly falls under this category, and it can be used to give the appearance of photographic grain. This is a straightforward filter to use (Filter > Noise > Add Noise), and the level is controlled by the percentage amount of Noise added. There are two choices of grain texture: Uniform or Gaussian. Uniform will give the smoothest effect and retain the best contrast, while Gaussian is more random and closer in appearance to photographic grain. Consideration should be given to the final image size, since, as with a grainy photographic print (see p.110), the effect will be less noticeable on a smaller print.

There is a particular problem with black-and-white images when using an RGB file, either desaturated or converted to monochrome. Due to the nature of the digital filtering, speckles of color will appear within the grain. This is not a great problem if you are printing with black inks, but it may be distracting if you are using color inks to produce black and white. There is a Monochrome icon in the box, which you can select to desaturate the image; this will usually remove the speckles of color, though the contrast may have to be adjusted using Levels or Curves (see p.145).

 Tip

Always remember that Unsharp Mask only appears to improve the sharpness of an image by increasing the contrast between edge pixels — you cannot pull a critically unsharp image into focus. Used subtly, it can fool the eye, but don't apply it too strongly or the image will begin to display artifacts.

Advanced Techniques

Layers

One of the most useful functions of any imaging program is the ability to use layers. Instead of having a single image consisting of a file that contains all the visual and digital information, separate elements can be controlled by adding layers on top of the original photograph. If we could imagine such a file as a three-dimensional object, it would consist of a photograph on which transparent cells are stacked, each containing either part of the photograph or a different version of the original, which, when viewed from above, would combine to present a complete photograph. Layers have countless uses, several of which will feature throughout this chapter. Once you are familiar with the concept, layers become an intuitive method of working. They are essential for creating montages and composites, and the ability to dissolve or merge several layers together gives greater control to many effects and filters.

Fig. 1: Knowing that another image would be placed on top, I purposely made the canvas size bigger than the background image.

Simple Composites

The Layers control box is opened from the Window menu in Photoshop (Window > Layers). The image will be represented by a small icon called Background (see Fig. 1). This is the original file, and all layers will be added on top of this. If you simply wanted to add a smaller photograph on top of this one (see Fig. 2), you would open another image and, having selected the Move tool from the Tools palette, click anywhere inside this image and drag it into the original photograph using the mouse. What is important to remember in Layers is that all images used must have the

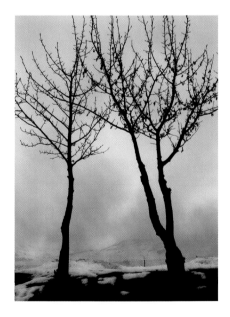

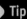
Tip
Keep the Layers palette open while you are working on your file. Clicking on any layer in the window will allow you to work on it.

Fig. 2: The second image is adjusted in size to make it smaller than the first.

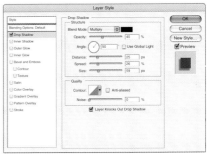

The Drop Shadow option, as well as other layer effects, are found under the **f** command in the Layers palette. The small square on the right will preview the effects of the changes possible to the style of drop shadow.

The finished simple composite is emphasized by adding a drop shadow to each layer.

same resolution, which is found under Image Size. The Layers box will now display the new layer on top of the original, or Background, layer. It will be called Layer 1, but it is a good idea to click on this name twice and rename it, so it is obvious at a glance which layer is which. In this box are several important features. Whichever layer's name is highlighted is the open layer, and only this one can be manipulated. To change this, simply click on the name of the layer you require. Each layer also has an eye icon, which means that the image is visible. If a

layer is not required temporarily, click on the eye and the layer will disappear from the screen until you need it again.

As the layers are stacked one on top of each other, you will see that the top one covers anything beneath it. To change the order of layers, click on the name of the one you want to move and drag it up or down to the desired position. To duplicate a layer, drag the layer down to the copy icon. To delete a layer, drag it to the Trash.

Because increasing layers takes up more memory, once you are sure that no more changes will be made, you

can merge (flatten) the layers. You can do this by going to the Layers menu and selecting Flatten Image. Once you do this, you will see that the layers shown in the box will be reduced to one, containing the finished composite. Any changes you make now will apply to the whole image. It is advisable to keep backups of the original layered files as a precaution.

Adjustment Layers

Most of the image controls that Photoshop can offer will be of the greatest benefit by being applied in Layers. Though it is certainly possible to make all the changes to the Background layer—such as adjusting the contrast, dodging and burning, adding color, or using filters—any further changes you may want to make to these adjustments would be limited to going back over the image's History. In Layers, you can simply return to the appropriate layer and make the changes or delete it and start again. Also, if you are returning to work on an image once it has been closed, the History will have been purged, but the layers remain in place until you choose Flatten Image.

Adjustment Layers contain the instructions for one particular action, which is then saved as a separate layer. This example shown here (see Fig. 1) is a very straightforward use of Layers to control the tonal balance. From the original Background layer, I have made two duplicate layers and labeled them as illustrated in Fig. 2. The top layer (Main Image) is highlighted, and using the Polygon Lasso from the tool bar, I have selected the sky, which I wish to darken. The Feather control is set to 70 pixels, so any adjustments made will be smooth and gradual. (The size of feathering must always be selected before making the tool selection.) I then went to the Layers palette, and from the list of Adjustment Layers, selected Levels. A new layer is visible in the palette

called Layer 1, and any changes made will only affect the selection made in this layer. The levels were adjusted until the sky was the right density, and this procedure was repeated to darken the right-hand side of the image and the bottom-right corner. Each time, a new Adjustment Layer was created.

Next I wanted to brighten the water, so I opened the duplicate layer named Light, and I brightened this with Levels. The Main Image was highlighted and I applied the Eraser over the parts of the photograph I wished to lighten. The Eraser will remove part of the top layer, showing the layer underneath. The opacity and flow of the brush were set to 15 percent so any changes would be gradual. The Background layer was kept intact and a new duplicate layer had to be created.

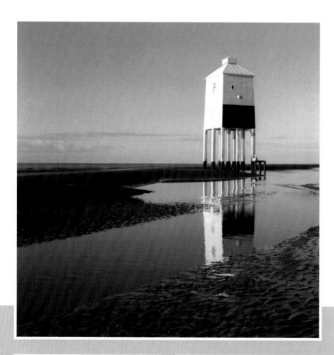

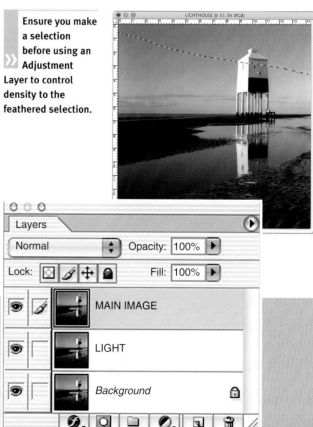

Ensure you make a selection before using an Adjustment Layer to control density to the feathered selection.

Fig. 1: The original image unadjusted.

Fig. 2: Naming each layer avoids confusion. The layer highlighted in blue is the active layer.

Blending Layers

There are numerous options in the Layers palette to allow a layer to be blended with the one beneath it. This is very useful for controlling the effect of filters (mixing a filtered and unfiltered layer together), and for this particular image it gave finer control in balancing the lighter layer with the top layer, which had been partially erased. It is also very effective for brightening clouds or altering the contrast in parts of the shot. The opacity of the blend is controlled by a slider.

If you are happy with the result, then flatten the layers to complete the image.

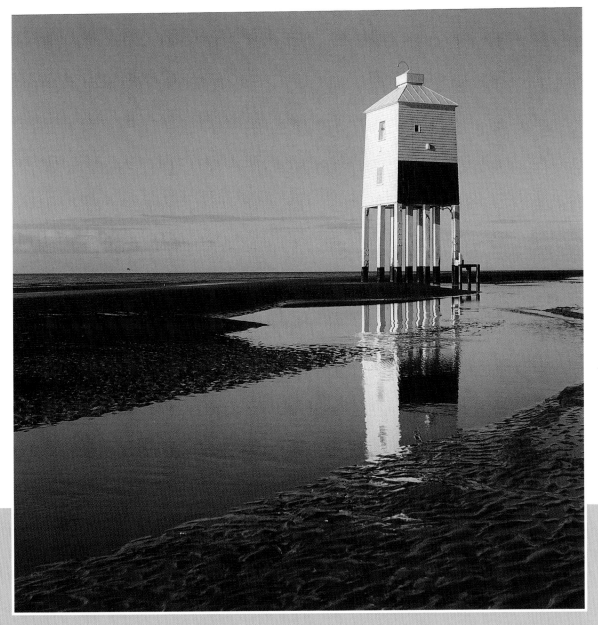

Digital Toning

Using Color Balance

If the conventional darkroom offers us innumerable methods to change the tone and color of our black and white prints chemically, the digital darkroom can, with a breathtaking range of different possibilities, transform our images into every conceivable shade and hue. There is no single method of digital toning, but the simplest uses the Color Balance controls in Photoshop and other image-editing packages.

It is important to work with a photograph converted to monochrome in RGB mode. From the Image menu, select Adjustments > Color Balance, which then offers the possibilities of converting either the highlights, midtones, or shadows to a color of various intensities. For a single tone, it is usually sufficient to adjust only one of these, though all will give a different emphasis to the resulting depth of color and contrast.

Using layers

In most instances, it is prudent to start with a softer and darker image that can be quickly changed using the Brightness/Contrast control, but you will gain more exact results from adjusting the Levels or Curves (see p.143).

Coloring only the midtones will provide good results throughout, though the highlights may appear gray and need similar treatment. Using just the highlight control creates an image similar to a photographic print that has been partially bleached and toned. If we select the shadows instead, the contrast and depth of the image will usually increase unless a light color, such as yellow, is selected. Sepia tones require careful use of yellow and red (Fig. 1). Adding 20 red to 20 yellow in the midtones is close to a conventional colder sepia tone, while adding more

Fig. 1: The black and white negative, scanned and adjusted in Photoshop. 16 yellow and 16 red in the highlights give a good warm brown.

yellow and perhaps subtracting some of the red will create warmer browns. Split tones, using different colors in the same image, are best achieved by adding a light highlight color first and then introducing another color, usually a darker one, into the shadows. Similar to the effects achieved by multiple toning in the darkroom, it is best to keep the tones on both channels quite subtle so they mix together well (Fig. 2). However, this is a matter of personal preference, and high levels of strong, bold colors when mixed can create vivid results.

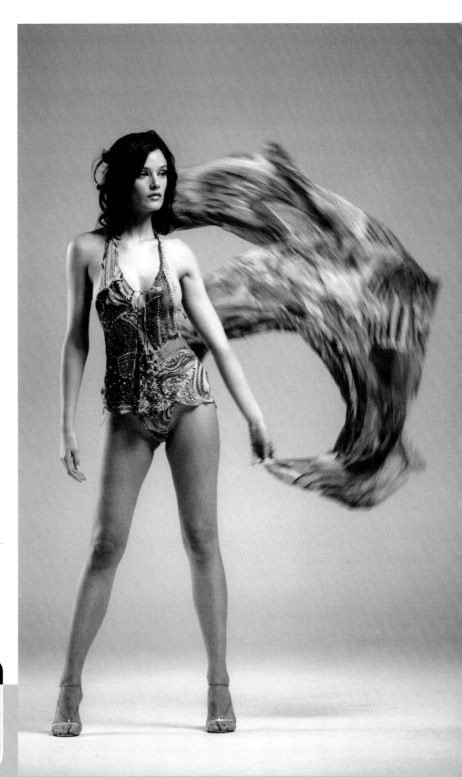

 Fig. 2: Adding blue to the shadows, creates a subtle split-tone effect. The difference in the two tones also adds contrast to the photograph. Photo: Dean Chalkley.

! Tip

Colors onscreen are always more intense than colors on prints. Under the View menu, apply Proof Colors to get an indication of how colors will translate as a print.

Duotone

Although much of the methodology behind Photoshop comes from the conventional darkroom, the concept of Duotone arises from mechanical printing techniques, in which a black and a colored ink are used to introduce a color bias to the black. Its intensity and contrast are controlled by the ratio of black to color—though purely colored inks can also be combined for a wide variety of possible tones.

First you must convert the image to grayscale (Image > Mode > Grayscale), and then you can correct the contrast using Levels. If there are any very strong highlights, it may be useful to add a slight gray using Replace Color (see p.166) so that the colored tone is visible throughout the image. It is then converted to Duotone, which is directly under Grayscale in the Mode menu. The Duotone options panel will open, and

you can now explore the choice of colors. It is possible to use four colors (Quadtone), but two will normally be sufficient. Ink 1 is usually black, and Ink 2 will be the color. (Bear in mind that the terms "Ink 1" and "Ink 2" refer to reprographic printing and not to the inks used in your own printer.)

In this example, I have kept the black ink and have then chosen blue as the second color. Clicking on the indicated color box displays the Duotone options. Under "Book" is a wide range of commercially produced inks available to the printing industry. To use your own, click on Picker and any color available to Photoshop can be used. The intensity and balance of the two inks and their effect on the image's contrast are controlled by the Curve boxes, which are beside the chosen colors in Duotone options. Click on each one to edit the

curve, and adjust them in the same way as using image-adjustment Curves (see p.145). Percentages can be set at different points of the grid, or the curve can be controlled by changing its physical shape. To start with, make each one a balanced 45-degree angle and then try altering each curve. For softer colors, the curve needs to be at a flatter angle. Reducing the percentage of the top right of the curve will subsequently reduce the strength of this color. To give the black more contrast, keep the top right of the curve at 100 percent and then make it a steeper angle. Be careful not to introduce any twists or the photograph may solarize slightly.

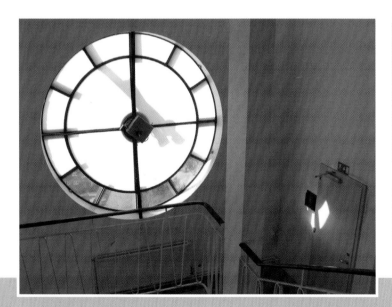

The original digital photograph has a soft, warm color, almost the same as a sepia-toned print. As it was taken on a very cold winter's morning in Iceland, (10.55 according to the clock), I decided to give it a cool blue tone.

The Duotone Options palette, where you can make your two color selections.

Tip

Any colors used in Duotone can be saved by selecting Save in the Duotone Options box. This can be recalled to use with other images by selecting Load and choosing the correct file.

The settings of the curves in Duotone Options reflect the intensity and contrast of the two chosen colors.

By adjusting the slope of both curves to a steeper angle, contrast and density is increased.

A softer result is achieved with a less contrasty curve set for Black.

Selective Color

One further method that is very effective for "toning" black-and-white digital images is to use the Selective Color command found in the Image menu (Image > Adjustments > Selective Color). This is designed specifically for adjusting the main colors that are used in either RGB or CMYK, but it can also be used for black, white, and gray, which are referred to as "neutrals." At the top of the Selective Color box is the range of colors that can be altered, though obviously we would only be concerned with the three monochromatic tones. The file to be converted must be in RGB mode, since you are going to introduce colors into the different tones. Before starting, however, you should analyze the black-and-white image you want to use and consider how the tones are separated.

In this example (see Fig. 1), there is a strong division between the sky and the airplane, and adding color to these two different tones will create an obvious spilt. To emphasize the tonal difference, it may be useful to adjust the contrast with Levels or the Brightness/Contrast command. I initially selected whites from the Colors menu and added 27 percent red (otherwise, –27 percent Cyan) to give it a warm base color similar to a selenium-toned print (see Fig. 2). Of course, the sky is not white, but it is close enough to a highlight for the coloring to affect only this area. There is a choice of Methods at the bottom of the box: Absolute will give very strong, bold colors, while with

As the tones converted by Selective Color are limited to White, Neutrals, and Blacks, it is more effective to choose opposite colors if a definite split tone is required.

Fig 1: The original image, scanned as an RGB file.

Relative, which I prefer, the tones are less exaggerated. Pleased with the tone of the sky, I then chose Neutrals and introduced a slight green tone (20 percent yellow and 5 percent cyan), which contrasted well against the reddish sky. The basic colors used can be mixed to provide different tones, and there is also a black slider that can be applied to brighten or darken the selected color. To create

the feel and appearance of a very slightly toned thio print (see p.88), try introducing a sepia color into the whites, or into the neutrals. In Fig. 3, the whites have been altered, adding 90 percent yellow and 28 percent red (–28 percent cyan). Some black in the neutrals emphasizes the leaf textures.

> **Tip**
>
> Use Selective Color for vibrant color splits, such as those in Pop Art images. In this case, use the White and Black commands at high levels from the Color Menu.

Fig. 2: The result. The choice of tones is similar to a soft lith print.

Fig. 3: Even using one color in the highlights (Whites) can give good results. Photo: Huw Walters.

Digital Lith Prints

In the darkroom, lith prints are created by carefully controlling the exposure of the negative onto suitable paper, and then managing the development of the print in a highly diluted lith developer. Sometimes negatives are over-exposed and then partially developed; on other occasions they are under-exposed and developed slowly, or over-exposed and over-developed – it is a matter of finding the right timings for the image.

Lith prints are characterised by their wide array of tones, from hard, deep shadows to compressed midtones and soft, delicate highlights. This distinctive difference in tonality allows for very personal interpretations of a scene, with shadows gaining greater contrast as the development time is increased, while midtones and highlights take on a warmer aspect from brown to pink.

To create such effects digitally, we need to make two versions of the image, one with delicate highlights,

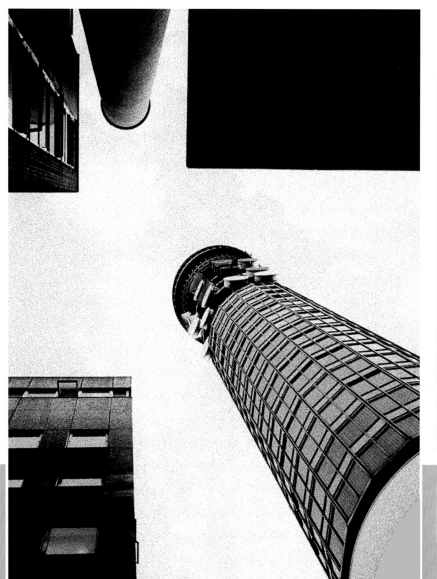

Fig. 1: The original photograph was scanned from a color print.

Fig. 2: The digital lith recreates the mood and feel of darkroom lith prints.

Fig. 3: The Layers palette shows each composite element of your image, and each is fully editable.

and the other with hard shadows, and blend them together in Layers (Figs. 3-7). In this example, a color print has been scanned and converted to monochrome using the Channel Mixer. As two very different results are required, it is useful to convert the images separately to produce the correct tonality for each layer. To emphasise the "blue" tones of the sky, the image that will become the soft background is given a higher percentage in the red channel. (Fig. 2) Likewise, the layer producing the shadows will have more blue added, to lighten the sky and emphasise the depth of tone in the tower.

The contrast of the background layer also requires softening. This can be done using the Levels command (Image› Adjustments› Levels). Adjusting the right-hand marker of the bottom slider will soften and also darken the image, but only a slight adjustment is necessary.

There are several options available to color an image (see pages 154-159). In this instance, I have chosen to use the Color Balance. Adding 50 red and 25 yellow gives a fair approximation of the color of a lith print's compressed midtones, however the highlights need to be brightened, which can be done using Selective Color (Image› Adjustments› Selective Color).

Fig.4: The Channel Mixer.

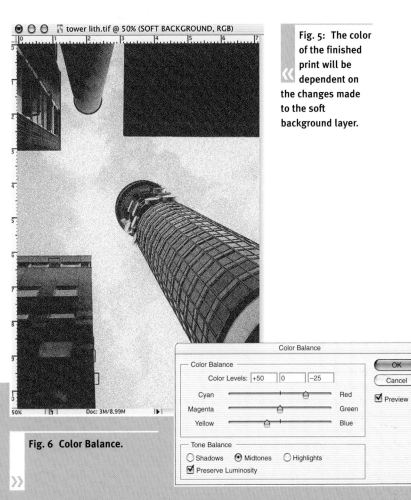

Fig. 5: The color of the finished print will be dependent on the changes made to the soft background layer.

Fig. 6 Color Balance.

Sharpness and sparkle

I have chosen white from the available range of colors, and reduced the percentage of black until the clouds have regained a degree of sparkle. The last corrections to make to the background layer use two filters to further enhance the mood, though (as always) take care not to overuse them.

Applying Gaussian Blur will reduce the sharpness, and Noise will add the appearance of grain, though it is purely a matter of choice as to whether the image requires such treatment. We want the two different layers to complement each other, so the hardness of shadows will sit comfortably on top of the slightly diffused background. We can make fine adjustments later once we have seen how the two completed layers work together.

The shadow layer is quite straightforward. Use the Brightness / Contrast command to enhance the shadows and clear the midtones and highlights; alternatively, adjust the curves (Image> Adjustments> Curves) for greater flexibility. Here, we need to change the curve to a steep slope, (see p.143) by either physically changing its shape or altering the input and output figures until we achieve the correct contrast. It is possible to also use the Pencil icon to draw a curve, though the lack of a straight line will usually result in a distorted, sometimes solarized image.

Again we can fine-tune this layer if required by applying some filters to it, add noise if appropriate, and sharpen

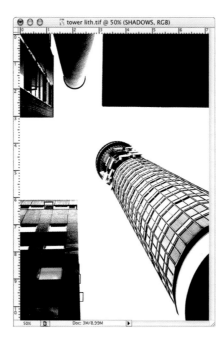

slightly using Unsharp Mask to give the shadows more of an edge.

It is now a simple matter of dissolving the two layers together to achieve the desired effect. There are sometimes too many potential choices of dissolve when working in layers so it is best to start at the top with Normal, making changes to the Opacity and Fill sliders to see how the two layers work together.

Darken can work well to create very solid looking images, while Lighten will provide results similar to soft darkroom lith prints. However, Multiply will immediately give a very balanced combination, which can be fine-tuned to achieve the most suitable finished result.

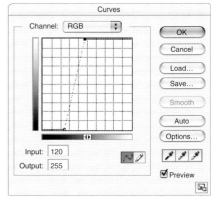

Although Brightness/Contrast will give a strong graphic layer to use for the shadows, changing the curve will provide greater flexibility.

The Curves dialogue box, in which you can make fine adjustments by plotting a complex curve.

Once you are happy with the result, select Flatten Image (to combine the layers into a single layer) from the Layers menu and the digital lith is complete and ready to print. As always when working with image-editing programs, it is worth keeping copies of the unflattened layers for future reference.

Tip

Though we are trying to mimic the look of a conventional lith print, do not be afraid to experiment and to use these methods to create something totally different.

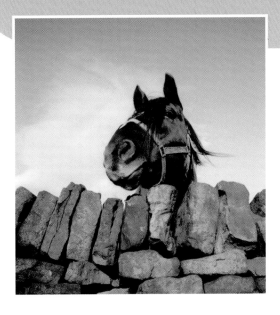

In this print, the background layer was diffused quite strongly with Gaussian Blur. In mixing the two layers together using Dissolve› Multiply, a more pronounced difference between the shadows and midtones became apparent.

Different photographic papers yield different colors when lith printing conventionally, so it is important to try out different combinations of colors. This example has had more yellow than red added to the soft background layer.

Digital Solarization

Creating a solarized image with Photoshop is very simple; in fact, there is a command in the Filters menu that does the job for you (Filters > Stylize > Solarize). Also in this menu there are many other different effects to play with. Some of them are very useful, but many are rather gimmicky, such as Crystallize and Mosaic Tiles. The Solarize filter is a bit limited in effect. The result is quite similar to solarizing a print in the darkroom (see p.108), but unfortunately it is uncontrollable.

Instead, you can make a copy in Layers, adjust one of the images using other controls, and then either dissolve the two together or blend parts of one layer with the other. In the end, we want to reverse some tones, usually the shadows, while leaving the rest of the photograph as a positive. One method is to use the Replace Color command (Image > Adjustments > Replace Color). With the Eyedropper tool, click on the area to be changed, then click on Selection, and adjust the Fuzziness until this area is relatively isolated (see Fig. 1). Next, use the Lightness slider to change the tone. In this example, the black becomes a light gray. Back in Layers, make sure the original image is the top layer, set the Eraser tool to 100 percent Opacity and Flow, and with a soft-edged brush, carefully remove the top layer to reveal the reversed tones underneath.

Fig. 1: Replace Color is a very useful command and has many applications for monochromatic work.

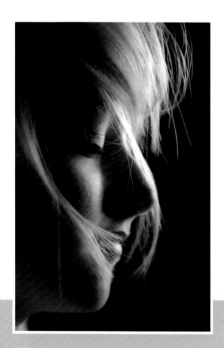

The original digital photograph, converted to monochrome.

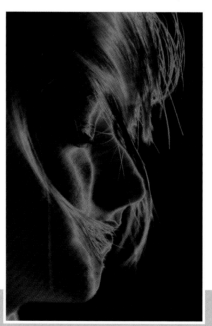

The Solarization filter can be effective with the right choice of subject.

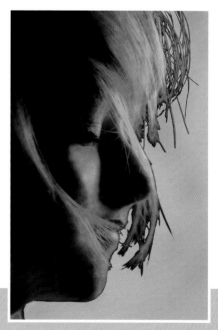

Removing sections of one layer, to show a partially reversed image underneath, can give the impression of a solarization. Photo: Huw Walters.

Digital Hand-Coloring

Hand-coloring a black-and-white print using inks or dyes always endows the photograph with a very nostalgic feel. It can also be reminiscent of picture postcards from the early 1900s, which used basic block inking to give the impression of color. This effect is very easy to achieve in Photoshop using the Selection and Airbrush tools.

First, convert the image to monochrome, but keep it in the RGB mode. It may be an idea to introduce a very slight sepia tint, similar to the methods of conventional hand-coloring (see p.99), though this could be done later in Layers. Then make a Selection of the first area to be colored using either of the Lasso tools. Make full use of the different Selection techniques to create the right shape, and save any that could be used again or inverted. Multiple areas that are to be given the same color can be selected together using the Add to Selection option. The amount of feathering is down to personal choice—whether a straight edge is wanted or some bleed between tones. I usually keep it to five pixels.

Choose each color with the Eyedropper from the Foreground Color Picker, which is near the bottom of the Tools palette. Click on the Brush tool, and select Airbrush from the Options bar. Set the size—perhaps 100 pixels— and then choose the Overlay mode. Overlay will brush the color on but leave the original image underneath intact. The rate of Opacity and Flow determines how strong or vibrant the color is. Similar to using a real airbrush, multiple coats will build up the intensity of color.

Brush size, mode and opacity are chosen from the tool bar, once the selection is made for each area to be colored.

The photograph, though contemporary, feels nostalgic to me, probably as it is close to where I grew up in Scotland and played as a child.

I deliberately used very pastel colors for this image. Increasing the Opacity and Flow of the brush would make the colors more vibrant.

Printers and Inks

When making digital monochrome prints, there are many options to consider regarding the hardware used and the choices of inks. Initially, when professional photographers started to embrace the possibility of digital technology in the early 1990s, the cost of machinery and the knowledge required meant that specialist labs had to be entrusted to produce the final prints. Since then, the development of affordable high-quality ink-jet printers has put digital printing within the reach of everyone.

Prices vary, but it is important to look at the specifications of different models. Often, two machines will produce prints of a similar quality, but a premium price will be charged for extra features and faster printing. Two other types of printer can be used, but both have their drawbacks. Laser printers are recommended for producing text documents, but they do not match the photographic quality of ink-jets. Dye-sublimation printers can actually achieve superior-quality prints but are more expensive, slower, and will only work successfully on glossy paper, using a limited range of inks.

The ink-jet printer is the most popular choice for printing digital images. A4 models are now incredibly cheap, (unlike the inks), though one capable of printing to A3 size, like the Epson 2100, will ultimately prove more versatile.

Color Inksets

The ubiquitous ink-jet printer has become the standard for printing, but careful consideration must be given to which inks to use. Each machine will be supplied with a black and a color (cyan, magenta, and yellow) ink cartridge specified for use with that particular printer. The manufacturer will naturally prefer that only their

Tip

Always switch the printer off when it is not in use, as the ink heads are more prone to drying out when it is on, which can result in streaks and lines on prints.

brand of inks are used, which will undoubtedly give good results, but the reality is that replacing them with other specialist inksets will often improve the tonal and archival qualities of a print. Be warned that if a fault develops with your printer— and they can be temperamental machines—that the makers may not offer any support if other brands of ink have been used. There are two main types of ink: dye-based and color pigments.

The dye-based inks, which are the most commonly used, will produce a wider range of colors (this potential range is known as a gamut), closer to the image as seen on screen, but they do not have such a high permanence as pigment-based inks. The archival qualities of ink-jet prints is a much debated subject. Initially, they often displayed a degree of fading or change in color rendition soon after printing,

especially if exposed to light. Realizing this, much research and development has now been undertaken by all the ink manufacturers to improve stability.

Can color inks give a successful interpretation of monochrome? The printer outputs the image using CMYK, mixing levels of the four inks to create the range of possible colors. Black will be achieved if the correct mix of these inks is accurately set (the exact settings should be 95C, 83M, 82Y, and 90K). There are certainly advantages to using color inksets: One printer can be used to produce both color and black and white (as well as images that have been toned to a particular color). On the other hand, it can be difficult to achieve the correct balance of tones. A print may appear to have a neutral black in daylight-balanced light, but it may display a noticeable color shift toward magenta when viewed under tungsten room lighting.

Single Black Inks

Logic suggests that selecting the black ink in Print Options would give the most neutral tone. To an extent, this is true, but resolution and quality is greatly reduced. However, I still use single black for making small proof-prints that I will only use for editing. If you opt to do this, the image should be in Grayscale mode when printing. In the Color Settings palette, select a 20 percent dot gain in the Gray Working Space to improve tonality. Because the resulting tonal values may be different in grayscale, it is worth making an Adjustment Layer (see p.154) for either Levels or Brightness/ Contrast on a sample photograph, which can then subsequently be used for similar images to save time.

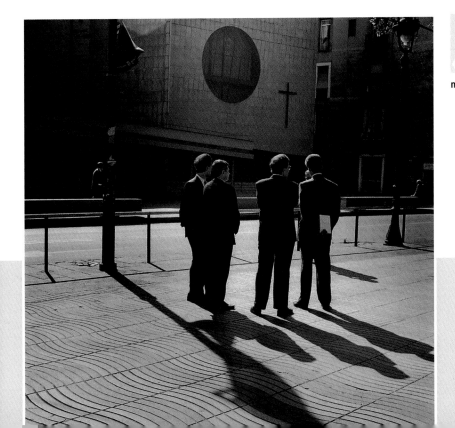

Spanish Street, Michael Wildsmith. Courtesy of Millennium Images UK. Using the single black ink on a printer, though not ideal, will be sufficient for making proofs to edit.

Paris Steps, Michael Wildsmith. Courtesy of Millennium Images UK. Monochrome inksets will provide a full black and white tonal range.

Monochrome Inksets

For true black-and-white digital prints, another option is to use ink cartridges that replace CMYK with a range of blacks and grays, producing perfectly neutral prints but with a full tonal range. Similar to the subtle differences achieved through using different traditional photographic papers—which range from a warm to a cold black (see p.50)—inks are available in a choice of different blacks. Piezography, the first company to produce dedicated monochrome inks, lists Cool Neutral and Carbon Sepia among its wide range. Because these inks are usually pigment-based, they will also have good archival qualities, which is important for photographers who sell their work through galleries. Other inks, such as Permajet VT Blax, can produce variable sepia tones as well as a range of different blacks, offering greater versatility from a single inkset. Print settings will have to be adjusted, though profiles, which set the tonal accuracy of the printer (see p.174), are available from each manufacturer. The one disadvantage of using such inks is that cleaning cartridges will have to be applied to the ink-jet printer before and after each use of different inks.

Many photographers, given the relatively low cost of printers, find it is easier to buy an extra machine solely for printing their black-and-white photographs.

There are many specialist inks that can be used for monochrome printing.

Continuous Ink Systems

Unfortunately, the low price of ink-jet printers is leveled by the relatively high cost of ink cartridges. A substantial saving can be made by investing in a continuous ink supply system. This will replace the two normal inksets with empty cartridges connected by tubes to bottles of ink outside the printer. Because each ink will be used at a different rate, the bottles can then be replaced one by one, instead of having to change a whole color cartridge just because one color has run out. The initial cost of the system is quite expensive—often more than the printer itself—but once in operation, the relative saving on ink can be higher than 80 percent. If a printer is to be used only occasionally for photographic work, it may not prove economical to make such a large outlay, especially since the tubes and print nozzles may dry out from underuse. However, for large volumes of work, especially if printing 16 $\frac{1}{2}$ x 11 $\frac{3}{4}$in (A3) or larger, a continuous ink system is a great bonus.

> ### Tip
>
> Before investing in such a system, do lots of research to find which inks you prefer; whether a color system is preferable to monochrome; and how the printer works with different papers.

Continuous Ink Flow systems will prove far more economical in the long term, but make sure of the choice of inks as it will be costly to replace a whole set.

Color Management

One of the most troublesome aspects of digital printing is the problem of achieving the correct colors and tones on ink-jet prints. Sadly, this can be even more frustrating when printing black and white, since even a slight color cast will be obvious. There are several steps you can take to overcome this, but as with many aspects of digital photography, they require lots of testing and usually the spending of more money.

First of all, you have to ensure all your equipment—monitor, camera, scanner, and printer—is calibrated, so that each piece is working in the same color space, or, in other words, that they are able to recognize and produce the same range of colors. The digital coding that defines which color space is applied is called a profile. Other profiles will be used to control monitor calibration and printer settings. The software for your digital equipment will usually come with many profiles to choose from, though for some applications, you can create custom profiles (or have them built). In the Photoshop menu, under Color Settings you will find the choice of different Working Spaces (see Fig. 1). The generic profile for RGB is usually Adobe RGB (1998), which your cameras and scanners should also be set to, though CMYK (to which the printer will convert the color space) is dependent on geographic location. In the United States, US Sheetfed Coated V2 is used; in Europe, Euroscale Coated V2 is used.

Fig. 2: A monitor calibrator is essential to ensure the monitor is showing correct color and contrast.

The next consideration is screen calibration. The computer and monitor will have adjustment settings that can be used to give a relatively correct color balance, but for the most accurate results, a monitor calibrator must be used. This device (see Fig. 2) is attached to the screen, and will record how it is currently set, and then create a new profile, which is automatically placed in the monitor

Fig. 1: The choices of profiles for different working spaces are found in the Color Settings palette.

settings. The monitor will then be reset to the new color balance. Many calibrators also record the ambient light, so the screen will be balanced under the lighting of the room where the monitor is situated. Calibrate your screens regularly—every three months for CRT, and once a month for LCD.

Color bias

Having calibrated your equipment, it is still unlikely that your prints will be the correct color, but at least now you are on the way. The problem is that all inks will have slightly different color renderings and biases, and all types of paper, no matter how similar they may appear, will change the tone and contrast of the print. This applies to sets of black inks as well as color. The easiest—and most expensive— way to correct this is to have a custom profile built by a specialist lab. They will supply a digital image of a color chart (see Fig. 3) that you will have to print out. The lab will then measure the print's colors using a photo spectrometer (a specialist scanner that, similar to a monitor calibrator, records color values) and, once calibrated and corrected, will send or e-mail you a new profile. You then place this profile into the computer's Color Sync Library, and it is used each time a print is made. If it has been well made, the profile will give very accurate colors and contrast, which will correspond to the newly calibrated monitor. Of course, this profile will only work with one inkset and one type of paper. If there is a slight adjustment to be made (perhaps one degree of magenta has to be added to remove a slight green bias), an Adjustment Layer (see p.154) can be made on a test image. If this corrects the color, save the image with the Layers still active, and then, each time a print is made, drag the Adjustment Layer from this document and drop it into the image that you intend to print.

Generic profiles

Many ink suppliers can supply a generic profile for their inks to be used with certain printers (often available as downloads from Web sites), and these can help in getting near the correct color, but we can also create our own profiles. In the Print command box is a setting for Color Management. Open Color Controls and you will find three sliders that adjust Brightness, Contrast, and Saturation and another three to correct color bias (see Fig. 4). When you think it is correct, go to Presets, choose Save As, give the profile a name, and then use it next time you make a print.

Fig. 3: When having a custom profile built for a certain ink and paper combination, a specialist color chart will have to be printed for the lab to analyze. (Image courtesy of Chau Digital.)

Fig. 4: If precise adjustments are made to correct the color balance for an ink in the Color Management palette, these details can be saved as a profile to be used again.

Storage Media

One of the great debates that continues to rage within digital photography circles is the best method to store all the countless images that we produce. Though the potential memory of computer hard drives is continually increasing, there will come a time when we simply won't have any space or memory left. What has been unsettling in the relatively short time that digital photography has been around is the number of storage methods that have come and gone. Ten years ago, the standard floppy disk was the usual method for storing text, but with about 1MB of memory, it was hardly suitable for images. Zip disks for use in external Zip drives became the favored medium for many professionals using digital imaging but, even with a memory of up to 750MB, it is likely that they too will soon become a thing of the past.

Currently, the most convenient method for storing or distributing data is by using either CDs or DVDs. All computers currently being produced have at least a CD writer to burn discs, and many even have a DVD writer. There are two types of recordable CD available for storing digital information. The standard CD-R holds up to 700MB and is incredibly cheap, but it can only be used once. Slightly more expensive is the CD-RW, which benefits from being rewritable. The

External Hard Drives are another method of storing huge amounts of images, and considering how delicate CDs and DVDs can be, they are probably a safer option.

advent of recordable DVD technology has allowed far more information to be stored on one disc. The DVD-R and the rewritable DVD-RW discs are more expensive than CDs but can currently hold 4.7GB—it is probable, however, that this will increase in size. All discs should be treated with care, because their recording surfaces are incredibly

delicate: They are not as robust as commercially produced music CDs, which use a more permanent method of burning discs. They should be kept in a safe place away from heat, just as you would store negatives. You should also avoid buying the cheapest brand available, since they will vary in quality and may soon degrade.

Storage media are very cost effective. A rewriteable DVD can contain 4.7GBs of data—470 10MB digital files.

An increasingly popular storage solution is the portable external hard drive, which can be connected to a computer to copy and transfer files. These are relatively inexpensive and many can hold up to 160GB. It is not uncommon to hear of photographers backing up their work on several different formats, or even buying an external hard drive for every major job. We should also consider more tangible methods of filing our images. Photoshop can very easily make contact sheets containing thumbnails and titles of each image from a folder or file. These can then be stored within each folder or printed out and filed separately. This function is under the File menu (File › Automate › Contact Sheet II). There are several choices to make regarding the final document size, the number of rows and columns, and text preferences. If printing out onto letter paper (A4), always make sure the document is slightly smaller so no clipping occurs. Once started, the computer takes over, transferring each image onto the contact sheet, making as many sheets as it takes to copy all the images in the file. For CD inserts, it is also a good idea to use this function to make a sleeve showing, if not all the photographs on the disc, at least some of the main images.

CD covers can also be made to keep your digital archive in order.

berl 103

berl 109

berl 12

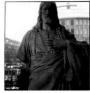
berl 121

berl 133

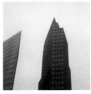
berl 38

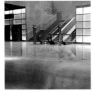
berl 4

berl 79

berl 88

A digital contact sheet.

Digital Paper Choice

After all the skill and work involved in producing your photographs on the computer, you must next do them credit by choosing the most suitable paper to print them on. And there is a vast selection to choose from, with a wide range of different materials available from an increasing number of suppliers and manufacturers. Naturally, the large photographic companies and makers of digital equipment tend to dominate the market, but there are also plenty of smaller producers making some very fine papers. Companies such as Hahnemüle in Germany and Somerset in England have specialized in fine-art paper for years (Hahnemüle for 400 years!) and are now producing some of the best-quality ink-jet papers available—though such specialist material comes at a higher price. There are visual and tactile choices to make in choosing a paper: its finish, weight, and base color, as well as its suitability for use with certain inks and its archival qualities.

As with photographic paper, there are several different paper surfaces available, too, such as high gloss, smooth pearl, and matt, as well as many textured varieties. I find glossy papers too reflective and the heavy textured papers distracting to look at, since the surface often dominates the image. As always, this is down to personal preference, and having spent many years making photographic prints in a darkroom, I admit to preferring papers that look more conventional. A paper's thickness is measured in gsm (grams per square meter). Plain paper, used for printing text and making photocopies, is normally about 80gsm, whereas a resin-coated photographic paper is about 190gsm. Very basic ink-jet paper starts at 120gsm, though this will probably feel (and look) very cheap. Most quality papers start at about 200gsm, but fine-art papers of 460gsm are not uncommon. Be aware that some of the heavier papers are not compatible with all ink-jet printers, so check the machine's specifications before buying anything too grand. White paper comes in many subtly different shades—from a sparkling, bright white, to more creamy tones. This will actually make a big difference to both the color of your prints (especially with black and white) and the contrast. Usually, when switching from one paper to another, changes will have to be made to the tonality of an image—or, ideally, a new profile will have to be built (see p.174).

There are now a wide range of papers available with different surfaces, weights and tones, to give finer controls and choice to our prints.

Tip

Using different papers means building new color profiles. Two papers might seem similar, but the color base will change contrast and color range in the print.

Digital photography has been described as a very democratic medium, opening up creative possibilities to millions, so it is important to spend some time (and money) on trying to achieve the best quality possible for your work. Make sure that your best images are printed, instead of just being filed away on disc or simply viewed on the computer. One way I like to show my work is to make small books of my photographs, using double-sided ink-jet paper, and have them bound by a professional bookbinder. Though they are totally digital prints, the binding gives them a handcrafted quality, making them very individual. Their compact size also makes them a convenient alternative to a large portfolio.

Simple books can be made using double-sided paper, though careful planing is required to plan which photographs are printed on each sheet of paper, and what order they appear in.

The Somerset Enhanced Range of photographic papers.

Traditional/Digital Hybrids

The invention of photography was revolutionary in many ways—not only in changing our perception of the world, but also the whole nature of our visual culture. The French painter Paul Delaroche, on seeing his first daguerreotype in 1839, is said to have remarked, "From today, painting is dead." A noble declaration, but if anything the reverse was true. The precise and exact nature of photography encouraged painters to explore new and exciting styles, opening themselves up to a wider range of influences, since there was less need for a purely figurative style of art. In a similar manner, digital technology has, in a very short space of time, changed traditional photography forever. I hope this book has demonstrated the importance of

both working practices, along with the relevance of an understanding of each. You will obviously use your knowledge of digital and traditional when making scans from negatives to be printed digitally. A single frame of black-and-white 35mm film can record an impressive amount of detail, and it would probably take at least a 50MB scan to translate accurately all of this information to a digital file. Using this analogy between the two, our humble roll of TriX has the potential of almost 2GB of memory!

Today, there is an increasing number of processes and techniques in professional use that draw on the benefits of digital and film-based photography. The Lambda process outputs digital files onto traditional photographic paper and is often used

by photographers for very large exhibition prints. Using very precise equipment, the digital image, usually scanned from film, is projected with red, green, and blue lasers directly onto the surface of the paper, which is then processed conventionally. The benefits of this method over normal darkroom prints are the ability to control the quality of the image digitally and then to easily make dust-free prints that are pin sharp from corner to corner—two of the many drawbacks in making very large photographic enlargements. Though primarily designed for color, Lambda technology is increasingly used by black-and-white photographers, outputting on either resin or archival fiber-based papers. Needless to say, the cost and size of the equipment dictates that only professional photo labs are able to use this process, though perhaps this may change—technology is becoming cheaper, as ink-jet printing has proved.

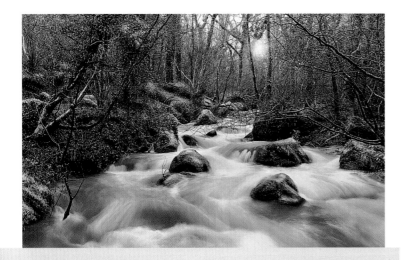

Photographed digitally, this image has been printed onto fiber-based paper using the Variochromat enlarger.
Photo: Kai Sander.

The Variochromat enlarger head manufactured by Polycolor uses a high-resolution digital light source, connected to a PC. Digital files can then be printed and processed in a conventional darkroom.

Another possible hybrid method is the digital enlarger, pioneered by the British company, Odyssey. This combines an enlarger with an LCD digital light source connected to a computer. The image is projected onto photographic paper, using the normal controls of an enlarger, and processed conventionally. Again, the equipment is relatively expensive, but it would be an invaluable tool for a lab or photographer with a high turnover of digital images requiring archival prints.

The easiest way of making prints from digital files is to have a conventional black-and-white negative on photographic film made by a lab (using technology similar to that of a Lambda printer); this can then be printed in any darkroom.

Hiro Matsuoka often enlarges very small sections of a negative to make new and previously unseen compositions. The original negative will be scanned by a drum scanner set at the highest resolution recording part of the negative. A conventional negative is output onto black-and-white film and is then processed and printed archivally in the darkroom. Photo: Hiro Matsuoka.

Photographer's profile

Black and white is the favored medium for many photographers. It has the potential to explore and express mood, atmosphere, and shape in ways that are not possible in color. Here are profiles of four very different leading exponents of the art.

Brian Griffin

Brian Griffin is one of Britain's most celebrated photographers, who for the last 30 years has worked primarily in black and white, in his characteristic and highly influential style. He was born in 1948 in Birmingham, UK, and studied photography in the early 1970s.

Attention to detail has always been a strong element in his work, where precise compositions are complemented with a skillful use of lighting. However, such exact technique only gives form and shape to his photographs. Additionally, he draws on a diverse range of influences, from Surrealism, Expressionism, and Symbolism to cinema and literature to give his work greater depth and meaning. Although he normally photographs people, his shots of businessmen, artists, politicians, and musicians rarely comply to a standard notion of portraiture; instead they are imaginative, visionary studies of his subjects, creating an event or drama from them.

His first commercial work in the mid-1970s was for the business magazine *Management Today*, where he collaborated with the journal's art director Rolland Schenck. Bored with the standard photographs of businessmen sitting behind their desks, Schenck commissioned Griffin to explore creative possibilities with his subjects, and if he was not happy with the results, he would send his photographer back until he had produced new and exciting work. His photographs were soon widely exhibited and published in several books—a rare accolade for a commercial photographer. Throughout these works were reflections of the strangeness and dislocation that Griffin saw within the business world, not to mention the changes occurring in British and American society in the 1980s. It is difficult to imagine that many of his photographs from this period are of professional business people, and not actors playing a role.

He has also worked frequently in advertising photography, and notably in the music industry, producing some of the most celebrated record sleeves of his time. Unsurprisingly, given the cinematic references in his work, he moved into film and video in the 1990s, producing numerous pop videos, commercials, and short films—for a time abandoning still photography. However, the late 1990s saw Griffin return to his first medium and he continues to photograph, bringing his imaginative mind and distinctive style to an increasingly wide range of subjects.

Moët et Chandon, 1987.

George Melly, 1990.

Photographer's profile

Michael Kenna

It would be too simple to describe Michael Kenna as merely a landscape photographer. His atmospheric photographs, often shot at night, or at the first dawning of a new day, are as much about time as they are about place. They frequently require exposures of several minutes and capture much more than just an instantaneous recording. He views his photographs as an emotional response to his chosen subjects, and uses the qualities of light to reveal new details and untold stories. His themes usually involve the signs of man, be they buildings or statues, and their place within the natural environment.

He was born in 1953 in Widnes in the North West of England, and studied photography in London in the mid 1970s. Kenna soon moved to the United States and since the 1980s, has established a successful career as both a commercial and fine-art photographer. He has perfected his craft behind the camera and in the darkroom, to convey the unique qualities of nocturnal light and the mystery it creates. "I like the dramatic quality of the lighting at night," he has written. "There are often strong shadows, and that relates to hiding things. It is as if the shadows invite the observer in to share their secrets. One can bring one's own experiences and thoughts into these areas of shadow. The power of suggestion has always been more important to me than accurate description."

His exhibitions and over 20 books embrace many different ideas and locations, often concentrating on one particular place or theme, such as French public gardens, the strange prehistoric statues of Easter Island, or the industrial beauty of a power station. A major long-term project has been an ongoing study of Japan, photographed over several years. Many of these photographs display a more open and purer sense of design, concentrating on elements found in the landscape, which reflect compositional styles common to Eastern art.

Other books have dealt with more insular, often personal subjects. *Monique's Kindergarten* is an enchanting series showing a warm remembrance of childhood away from the technological influences of today's education system. Another book, *Calais Lace*, records the factory and machinery used by the French town's remaining traditional lace manufacturers.

In content and composition, such photographs could have been taken in the 1920s, and it is probable that Kenna is also reflecting on the demise of the English cotton mills, formerly one of his home county's main source of employment. In 2000, he published a collection of photographs taken over 12 years documenting the remains of 28 concentration camps used during the second world war. Though not photographed as a commercial project, (all negatives and prints were subsequently donated

to the French Ministry of Culture), its success lies in the photographer's ability to provoke thought and remembrance without reliance on artifice.

The quality and emotional impact of his prints, are supported by their intimate size, usually printing no bigger than 10x8 inches, and in the last decade he has seen his work become very popular with photographic collectors from around the world. Kenna places great importance on printing his own work, seeing the darkroom as "a critical component of the photographic process."

*Fifty Fences, Taisetsu
Hokkaido, Japan 2004*

«

Photographer's profile

Britta Jaschinski

Photography is often most effective when it is used to promote and encourage a greater understanding of significant issues. In Britta Jaschinski's photographs, we see the harm done to animals by placing them in captivity and how we have endangered their natural habitat.

In the latter half of the 20th Century, commercially run zoos were widespread, doing little for the welfare of their inmates by caging them in restrictive and unnatural environments. Jaschinski's highly acclaimed book, *Zoo* (Phaidon Press, 1996), addressed the confinement of animals and the inappropriate conditions in which they are often housed.

Born in Bremen, Germany, in 1965, Jaschinski has lived and worked in England since 1990. She started photographing in zoos while studying at Bournemouth Art College. Her work is characterized by somber studies, with many of the photographs dominated by the artifice of the enclosures, within which the animals appear lost and confused. In one photograph (opposite), a tired rhinoceros walks slowly towards the end of a path which can only lead to a cage. Its tracks show the countless times it has made the same journey. Other photographs emphasize the visible, rather than implied, barriers—the fences and cages, through which the animals return our curious gazes. For example, two black macaque monkeys (opposite, top) look out through finger-scratched glass, in an image that is visually reminiscent of an old, distressed photograph thanks to these signs of attempted escape. Whatever zoos' conservation role might be today, Jaschinski's photographs make us question their right to keep animals in captivity and display them primarily for our entertainment.

Animals have always been a popular subject for the photographer, but in what context do we expect to see them? Wildlife photography and television documentaries might show animals in their natural habitats, but all too often those habitats are damaged by our presence in them. This theme is considered by Jaschinski in her second book, *Wild Things* (powerHouse Books, 2003), which she describes as an "elegy for nature." The choice of images is certainly elegiac, balancing the fragility of the landscape with photographs of animals, both free and in captivity. Her accompanying short essay is an affecting tribute, addressed to the animals which have suffered from the devastation mankind has caused to the wilderness. "It seems clear," she writes, "that we have been doing to you what we are on the verge of doing to ourselves."

From *Wild Things*, 2003

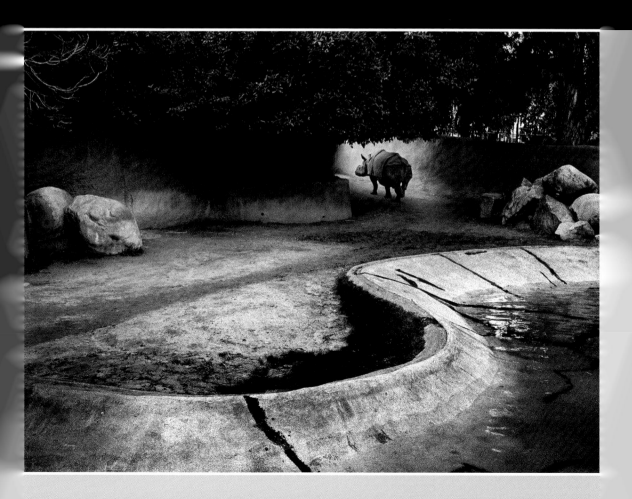

Photographer's profile

Giles Revell

For many photographers, the digital revolution has simply meant a change of workflow. For Giles Revell, its potential has prompted him to take his own work much further, combining a number of different working methods, from digital and film-based photography, to scientific research.

Born in 1965, his career prior to photography reflected a fascination with nature and science. He studied geology at university, and later worked in Australia for two years, analyzing rock samples in an opencast gold mine. Photography had long been a passion, and by the early 1990s, he had changed profession and was working in London as a commercial photographer. His first work to receive wide acclaim—as well as several awards—used X-rays of fish, output as digital negatives and then printed onto platinum paper. This led to Revell exploring other means of showing natural forms, notably his incredible series of large-scale prints of insects. Printed up to eight feet (2.4 meters) in length, these seemingly insignificant creatures become powerful in an extreme magnification that highlights their complexity and strange beauty.

Each image was pieced together in Photoshop from up to 500 digital recordings from a scanning electron microscope—a process that sometimes took as long as three months to complete. Before Revell made a new image, he undertook an in-depth study of each species.

The precision and quality of Revell's work is reinforced by their presentation. He always intended the final images to be large, working closely with Ian Cartwright—one of the first specialist digital printers to use archival inks and handmade papers. It took several years to complete the series, and throughout their collaboration, Revell's requested changes of paper, inks, and equipment resulted in several lasting improvements to materials and printers.

Revell describes the tonality he achieved with the electron microscope as being "like a pencil drawing," and the images appear both hyperreal and fantastically unreal. Other subsequent work has extended this theme, including a series titled

Whirligig Beetle.

Skinsheds, showing the body shells some insects discard and replace in their short lives. Instead of appearing solid, pure and sculptural, like his previous images, they appear like ghosts of the insect, emphasizing the creatures' fragility. There is, however, much more to his work than technical precision. For Revell, technique and technology are secondary to the result. Design and shape are paramount, and throughout the work his fascination with how an object is seen, particularly its form and surface, are apparent, and take preference over all other considerations.

Fish.

Appendix

Black-and-White Films
(pages 28-29)

AGFA
Agfa APX 100	35mm, 120
Agfa APX 400	35mm, 120
Agfa Scala 200	35mm, 120, 5x4 (B&W reversal film for slides.)

BERGGER
Bergger 200	35mm, 120, 5x4, 10x8

CLASSIC
Classic Pan 200	35mm, 120, 5x4
Classic Pan 400	35mm, 120, 5x4

FORTE
Fortepan 100	35mm, 120
Fortepan 200	35mm, 120, 5x4
Fortepan 400	35mm, 120, 5x4

FUJI
Neopan 100 Acros	35mm, 120
Neopan 400	35mm, 120
Neopan 1600	35mm

ILFORD
Delta 100	35mm, 120, 5x4, 10x8
Delta 400	35mm, 120
Delta 3200	35mm, 120
Pan F Plus	35mm, 120
FP4 Plus	35mm, 120, 5x4, 10x8
HP5 Plus	35mm, 120, 5x4, 10x8

KODAK
Plus-X	35mm, 120, 5x4, 10x8
Tri-X	35mm, 120, 5x4, 10x8
TMax 100 (TMX)	35mm, 120, 5x4, 10x8
TMax 400 (TMY)	35mm, 120, 5x4, 10x8
TMax P3200 (TMZ) High Speed	35mm
Infra Red	35mm

MACO
Maco UP25Plus	35mm, 120
Maco UP100Plus	35mm, 120, 5x4
Maco UP400Plus	35mm, 120
Maco CUBE400	35mm, 120
Maco IR 820c/750c	35mm, 120, 5x4

ROLLEI
Rollei R3	35mm, 120, 5x4, 10x8

Chromogenic Black-and-White Films

FUJI
Neopan 400CN	35mm, 120

ILFORD
XP2	35mm, 120

KODAK
T400CN	35mm, 120, 5x4
Portra 400BW	35mm, 120

Chemical Formulae

Thiocarbamide Toner and Bleach.
(pages 88-91)

Bleach Stock Solution.
Potassium Ferricyanide	50g
Potassium Bromide	25g
Water	1000ml

Alternatively, for a more vigourous bleach.
Potassium Ferricyanide	100g
Potassium Bromide	100g
Water	1000ml

Toner.

Solution A
Thiocarbamide (Thiourea)	100g
Water	1000ml

Solution B
Sodium Hydroxide (Caustic Soda)	100g
Water	1000ml

Always add Sodium Hydroxide slowly to the water. Do not use warm water, 25°C is recommended. Adding the chemical to the water will increase the temperature.

Blue Toner (p.95)

There are many published formulae for Blue Toner. The following toner can be kept as stock solutions and equal parts are mixed together prior to use. It can be diluted further to control toning times.

Iron Blue (Ilford IT-4)

Solution A.
Water (50°C)	750ml
Potassium Ferricyanide	2g
Sulphuric Acid	
(48% Concentrated)	4ml
Cold Water to make.	1000ml

Solution B
Water (50°C)	750ml
Ferric Ammonium Citrate	2g
Sulphuric Acid	
(48% Concentrated)	4ml
Cold Water to make	1000ml

Salt Printing (p.118)

There are numerous variations published (and online) for different formulae for most historical processes, many containing additional chemistry. The following are basic but workable solutions.

Salt Solution
Sodium Chloride. (Salt)	25-50g
Distilled Water	1000ml

Sensitizer
Silver Nitrate	12g
Distilled Water	100ml

Fixer
Sodium Thiosulphate (Hypo)	100g
Water	1000ml.

Avoid skin contact with Silver Nitrate. The substance is also sensitive to ultraviolet light, so do not mix the solution, or coat and dry paper, in sunlight or under UV or florescent lighting. Store solution in a darkened glass bottle.

Gum Printing (p.120)

Sensitiser
Potassium Dichromate*	30g
Distilled Water (40°C)	750ml
Cold Distilled Water to make	1000ml

*Alternatively, Ammonium Dichromate can be used. It is more expensive and more toxic, but will reduce exposure times by a half.

Gum Solution
Watercolor pigment is mixed with the following solution.
Gum Arabic	50g
Distilled Water (20°C)	200ml

The Gum Arabic (which can be ground in a mortar and pestle), will need at least a day to dissolve. Remaining lumps of gum can be strained out. Otherwise, simple craft glue can be used instead.

Cyanotype (p.121)

Solution A
Ferric Ammonium Citrate (Green)	25g
Distilled Water	100ml

Solution B
Potassium Ferricyanide	10g
Distilled Water	100ml

The two stock solutions can be stored, (in dark bottles away from the light). For single use, the two chemicals can be mixed together in 200ml of water.

Safety guidelines for chemistry

All raw chemicals should be handled carefully. Please consider the following guidelines:

- Store chemicals in a clean, dust-free place, away from food.

- Always mix and use solutions in a well-ventilated area.

- Pour chemicals into a solution slowly to avoid excessive chemical dust rising into the air. If possible. wear a protective mask over the mouth and nose.

- Avoid contact with the skin; wear protective gloves (rubber or disposable vinyl) when mixing and using chemicals.

- Splash goggles are recommended.

- Ensure chemicals and mixed solutions are labelled correctly.

- On no account store photographic chemicals in food or drink containers.

- Wash all measuring cylinders, filters, and stirring rods with at least three changes of water.

- Mix solutions at between 30-40°C. (Except Sodium Hydroxide; see note.) To lower the temperature of the stock solution, place the container in a vessel of colder water. Do not store in a refrigerator.

- Mix the solution with a chemical stirring rod, not a kitchen utensil. Stir until the chemical has dissolved in the water.

- Always slowly add acids to water, never water to an acid.

Recommended Resolution for Scanning and File Sizes for Printing (pp.128-130)

MB	Pixel Size	Megapixels	200ppi	300ppi	400ppi
6MB	1600x1200	2M	8x6in	5.5x4in	4x3in
12.5MB	2400x1800	4.5M	12x9in	8x6in	6x4.5in
17.5MB	3000x2000	6M	15x10in	10x6.5in	7.5x5in
25MB	3500x2500	8.5M	17x12in	11x8in	8.5x6in
32.5MB	4000x2850	11.5M	20x14in	13.5x9.5in	10x7in
41MB	4500x3200	14.5M	22.5x16in	15x10.5in	11.2x6in

Online Resources

Photographic and Digital Manufacturers, Materials, and Equipment

Adobe Photoshop
www.adobe.com

Agfa
www.agfa.com

Apple
www.apple.com

Canon
www.canon.com

Dell
www.dell.com

Durst
www.durst.it / www.tetenal.com
(for Durst enlargers)

De Vere
www.odyssey-sales.com

Epson
www.epson.com

Folex
www.folex.com

Forte
www.forte-photo.net

Fuji
www.fujifilm.com

Hahnemühle
www.hahnemuhle.com

Hasselblad
www.hasselblad.com

Imacon
www.imacon.dk /
www.bodoni.co.uk
(UK distributor)

Inveresk
www.inveresk.co.uk

Kentmere
www.kentmere.co.uk

Kodak
www.kodak.com

Ilford
www.ilford.com

LaCie
www.lacie.com

Leica
www.leica.de

Lyson
www.lyson.com

Mamiya
www.mamiya.com

Marrut
www.marrutt.com

Minolta
www.konicaminolta.com

Moersch
www.moersch-photochemie.de

Nova
www.novadarkroom.com

Nikon
www.nikon.com

Odyssey
www.odyssey-sales.com
(also for De Vere)

Paterson
www.patersonphotographic.com

Polycolor
www.polycolor.de

R.H.Designs
www.rhdesigns.co.uk

Sinar
www.sinar.ch

Polaroid
www.polaroid.com

Permajet
www.permajet.com

Piezo
www.piezography.com

Print File
www.printfile.com

Rollei
www.rollei.de /www.robertwhite.co.uk
(UK distributor)

Tetenal
www.tetenal.com
(also for Durst)

Wista
www.teamworkphoto.com
(UK distributor)

UK Photographic Suppliers

Chau Digital
www.chaudigital.com
Digital papers, inks, custom profiles
built, digital hardware, printing
service.

Process Supplies
www.process-supplies.co.uk
Wide range of traditional and digital
photographic materials.

Retro Photographic
www.retrophotographic.com

Specialist importers of black-and-white
materials from a diverse range of
countries.

Silverprint
www.silverprint.co.uk
Extensive range of traditional and
digital photographic materials,
chemistry for alternative processes
and toners, books, 'Silverprint' liquid
emulsion and archival print washers.

US Photographic Suppliers

Bostick & Sullivan
www.bostick-sullivan.com
Supplies for alternative processes.

Calumet
www.calumetphoto.com
Traditional and digital photographic
equipment and materials.

Fine Art Photo Supply
www.fineartphotosupply.com
Wide range of traditional
photographic materials.

J and C Photo
ww.jandcphoto.com
Wide range of traditional, specialist
black and white materials.

Photographic Magazines and Journals

Ag Plus
www.ag-photo.co.uk
UK

Aperture
www.aperture.org
US

Black and White Photography (UK)
www.thegmcgroup.com
UK

Black and White (US)
www.bandwmag.com
US

Blind Spot
www.blindspot.com
US

British Journal of Photography
www.bjphoto.co.uk
UK

Camera Austria
www.camera-austria.at
Austria

Double Exposure
www.doubleexposureonline.com
US

European Photography
www.equivalence.com
Germany

Photo Techniques
www.phototechmag.com
US

Shutterbug
www.shutterbug.net
US

Professional Photographer
www.ppmag.com
US

LensWork
www.lenswork.com
US

Photo District News
www.pdn-pix.com
US

Portfolio
www.portfoliocatalogue.com
UK

Source
www.source.ie
UK

Photographic Bookshops with Online Catalogues

Aperture
www.aperture.org
US

Photo Books International
www.pbi-books.com
UK

Photo Eye
www.photoeye.com
US

Schaden Books
www.schaden.com
Germany.

UK Photographic Workshops

Duckspool
www.duckspool.com
Somerset

Hands On Pictures
www.hands-on-pictures.com
Richmond, W.London.
(Historical Printing with Terry King.)

Inversnaid
www.inversnaidphoto.com
Loch Lomond, Scotland

Photofusion
www.photofusion.org
London

Quairing Lodge
www.quaring-lodge.co.uk
Isle of Skye, Scotland

US Photographic Workshops

MV Photoworkshops
www.mvphotoworkshops.com
New York City

New Mexico Photography Field School
www.photofieldschool.com
Santa Fe, New Mexico

Rocky Mountain School of Photography
www.rmsp.com
Missoula, Montana

Santa Fe Workshops
www.santafeworkshops.com
Santa Fe, New Mexico

European Photographic Workshops

Spéos
www.photo-paris.com
Paris, France

Toscana Photographic Workshop
www.tpw.it
Bologna, Italy

Internet Discussion Groups and Forums

www.apug.org
(Analogue Photography Users Group)

www.computer-darkroom.com
(Digital Photography)

www.contactprintersguild.com

www.dpreview.com
(Digital Photography)

www.ephotozine.com

www.photo.net

www.photogs.com/bwworld
(Black and White)

Resources for Historical Processes

www.alternativephotography.com

www.bostick-sullivan.com

www.hands-on-pictures.com

www.mikeware.demon.co.uk

Other Useful Web sites

http://cameraclubs.photopro.co.uk
(Directory of UK Camera Clubs)

www.digitaltruth.com
(Contains the 'Massive Dev Chart,'
listing practically every film /
development time possible.)

www.eastmanhouse.org
(George Eastman House, Photographic
archive and library, Rochester, US)

www.magnumphotos.com
(World famous press agency /
photographers collective.)

*http://members.aol.com/photolink/pne
thome.htm*
(Photographic education in
UK & Europe)

www.photobase.fromru.com/eng/
(World wide listing of photo colleges)

www.photobetty.com
(E-zine for women photographers)

http://photography.about.com
(Extensive internet resource on all
aspects of photography)

www.photography-now.com
(International listing of photography
exhibitions and galleries)

www.PhotographySchools.com
(Photographic education in the US)

www.photojpn.org
(Comprehensive resource on
photography in Japan)

www.rip-arles.org
(Annual photography festival in Arles,
South of France)

www.rleggat.com/photohistory
(Excellent resource on photographic
history)

www.rps.org
(Royal Photographic Society, UK)

Glossary

Agitation
Film and photographic paper needs to be agitated during processing to ensure that fresh chemistry continues to flow over the emulsion. For paper, the developing tray is rocked continuously, while film requires an intermittent but regular agitation pattern, usually involving inverting the developing tank two or three times every 30 seconds.

Archival Prints
The archival qualities of a photographic print depend on how well it has been processed. Correct fixing and washing will ensure the print will remain pristine for decades, however selenium or gold toning will greatly improve the life of a print. As photographs have become more collectable on the art market, the question of archival quality has become important to photographers, galleries, and collectors, especially with regard to digital prints, which is still a relatively new medium. All prints will benefit from correct storage or display, away from direct sunlight, and ensuring mounts and storage boxes are made from acid-free materials.

Chromogenic Film
This type of film uses the same emulsion technology as color film. The benefit of this is that it can be developed (and printed) anywhere that normal C41 color film is processed. It is relatively fine grained, with a smoother tonal range than many conventional black-and-white emulsions, but it requires careful exposure to avoid prints appearing flat.

Contact Print
Contacts are made by directly placing negatives onto photographic paper and exposing both to light, while the negatives and paper are held flat by a sheet of glass. They are an essential reference for seeing what is on the film, and for larger film formats can be used as prints in their own right.

Continuous Ink Systems
A continuous ink system fitted to an ink-jet printer is useful for making large quantities of digital prints. Each ink has its own bottle, which can be replaced when empty. Compared to buying individual ink sets, such systems can amount to a substantial saving in the cost of ink.

Cyanotype
Early (discovered in 1841) photographic process that uses potassium ferricyanide and ammonium ferric citrate as a sensitizer, and which only requires washing after exposure. Prints are a distinctive "Prussian Blue" color. The process was once commonly used to produce engineers' and architect's blueprints—as they became known.

Developer
An image exposed onto photographic film and paper is known as a "latent image." It cannot be seen, even though some of the silver halide crystals within the emulsion will have partially darkened by the action of light. The chemicals used in a developer intensify and enlarge these darkened crystals until an image is formed on the film, or paper.

Dodging and Burning
In making a photographic print, it is usual that some parts of the image may require less exposure, while others will need more to get the correct balance of tones. Dodging (or Holding Back) can be done with a hand or a tool designed to block the light from the enlarger for part of the exposure. Burning in, again using either the hands or a piece of card to cover the correctly exposed parts of the print, will let more light fall on the underexposed areas. In Photoshop, the Dodge and Burn tools recreate these actions digitally.

Enlarger
An enlarger has to be used to make prints bigger than a contact print. In its simplest form, it is a light source, held on a moveable column, which is projected through a negative held in a carrier underneath. This light is then focused by a lens onto a baseboard.

Modern enlargers often use dedicated Multigrade enlarging heads, which change the color of the light to alter the contrast of the print. Usually, an enlarger will be connected to a timer to ensure the exposure of a print is accurate and repeatable.

Filters
A filter can be placed over a lens to change the action or the properties of the light that passes through it. For black and white, the most common filters are colored to alter the tonality of the negative. For example, a red filter, often used to darken and dramatize skies, will block out all colors except red, so skin tone will appear darker on the negative and subsequently lighter on the print. Its opposite color, blue (or Cyan to be precise) will not register on the negative and so print as black. In practise this will never happen exactly, as most colors are not pure, but a combination of different tones.

Fixer
A developed image is still light sensitive, so to stabilize the image, fixer is used to neutralize and prevent the negative or print from developing any further. An unfixed image would soon turn black if exposed to the light. As it is an acidic chemical, which can damage the film or paper base, all traces of the fixer have to be carefully washed out before drying.

Focus Finder
The focus finder is a useful tool used in the darkroom that lets you see the negative's grain magnified to check that the print will be sharp. Even under a safe light, it is easy to knock them off the baseboard onto the floor, so it is wise to buy a rugged model that will survive the odd fall!

Fiber-based Paper
A traditional photographic paper, which has emulsion coated onto a base made from rag fibers. If processed correctly it will give long-lasting prints of exceptional quality. It requires a lengthy wash to ensure that all traces of the chemicals are removed from the fibers.

FireWire
A popular, high-speed connection system for transferring data between computers and peripheral devices, such as cameras, or scanners. Many computers have one or two FireWire "ports" (sockets) as well as multiple USB ports. (See USB.)

Gum Print
A popular "historical" process that uses watercolor pigment mixed with gum arabic and a potassium or ammonium dichromate sensitizer. It can only be printed by contacting due to its insensitivity, but will result in a very "painterly" quality of the type that was very popular with the Photo Pictorialists of the early 20th Century. You can also use fruit gums.

Hard Drive
In a computer, the hard drive is the largest section of digital memory, which contains the many applications used, as well as saved files. Hard drives might have a capacity as large as 160GB or more, but this can be easily filled if large numbers of files (especially digital images) are stored on it. Separate, often portable, hard drives are often used by photographers for additional storage, backups, and security.

ISO
Short for International Standards Organization, ISO is a universally accepted rating system to indicate the sensitivity of photographic material. (Previously there were several possible measures of a film speed across the world, including ASA, DIN, and GOST) The higher the ISO rating, the more light sensitive the film. It is calculated arithmetically to correspond with each stop of camera exposure. A100 ISO film is a stop slower than a 200, and a stop faster than 50. Digital cameras have adopted essentially the same method of rating, sometimes known as ISO-E (ISO equivalency).

JPEG
A method of compressing a digital image, to reduce its file size and resolution, by removing a percentage of its pixels. The quality of a JPEG (short for Joint Photographic Experts Group) depends on the amount and method of compression. High-resolution JPEGs are of print quality, whereas low-resolution (72dpi) ones are ideal for images on Web sites (which will display at a high resolution, as the resolution matches that of computer monitors). Low-resolution images have much smaller file sizes, and therefore download much more quickly via a browser.

Memory
The basic component of digital memory is a Byte (short for binary term), which comprises eight bits (short for binary digits) of binary information—a series of ones and zeros that the computer can recognize and process. Memory (storage capacity) is expressed in terms of megabytes (one million bytes of information) or gigabytes (one billion bytes). Computers have two sections of memory, the desktop and the hard drive. (See Hard Drive.) Desktop memory is used temporarily to process files that are open, and is referred to as Random Access Memory (RAM). Photographic images will often require hundreds of megabytes of RAM when being worked on, so it is common to buy extra memory, which is easy to install, to improve temporary storage capacity as well as the performance speed of the computer.

Monitor
A computer uses one of two very different types of monitor, CRT (Cathode Ray Tube) and LCD (Liquid Crystal Display). The slim, flat LCD screens are standard with laptops and Apple iMacs, and are also a popular choice for use as a separate monitor for a PC. However, they are more expensive than the conventional CRT screens and require regular calibration.

Multigrade Paper
Photographic paper was traditionally manufactured in different grades of contrast, from 0 (very soft) to 5 (very hard). Multigrade paper uses two layers of emulsion, hard and soft, on the same paper. The enlarger light is then filtered, depending on the grade required, to allow different levels of light to fall on these separate layers, which will then appear as different grades of contrast.

Photoshop
Adobe Photoshop is the industry standard computer program for editing digital photographs. It has countless options, commands, and features for editing and altering images, which can then be outputted as digital prints, stored as files for reproduction, or even converted into an analogue source for producing traditional photographic prints.

Pixel
Short for "picture element", the pixel is the basic component of a digital image. The number of pixels per (square) inch defines the resolution (quality) of the image.

Platinum
A contact printing process, first used in the late 19th Century to produce black-and-white prints, using platinum salts instead of silver. The prints have a longer tonal range than other black-and-white materials, and even greater archival qualities. Production of platinum papers stopped in the early 20th Century, but the process, using handcoated paper. has been revived and remains very popular with fine-art photographers.

Print Washer
Photographic prints require an efficient system of washing to remove all traces of the processing chemistry. Washing many prints in a sink is problematic, due to the tendency for the prints to stick together. An archival washer has separate channels, which let a fresh supply of water flow over each print.

Processing Speed
Although a computer may have a large amount of RAM, which is required for working on digital images, it also needs to have a high processing speed, which is expressed in terms of Gigahertz (GHz).

RAW
Images taken with consumer digital cameras are usually saved and processed initially as a JPEG or a TIFF file (see JPEG and TIFF). More expensive cameras have the option to capture images as a RAW file, a format that contains raw, uncompressed data. Most professional photographers shoot RAW files to capture as much data as possible, before later converting the image into a TIFF or high-quality JPEG file.

Resin Coated (RC) Papers
RC papers have a thin plastic coating on both sides of the paper. This prevents the processing chemistry from being absorbed by the paper, which reduces washing time down to a few minutes. Automatic processing machines used in professional darkrooms can process, wash, and dry RC paper in one minute.

Resolution
A digital image's resolution is expressed as ppi (pixels per inch) or dpi (dots per inch). The higher the ppi, the higher the quality of the image. In Photoshop, it is advisable to work on images at a relatively high resolution (300ppi, the resolution of images for print publication in books and magazines), before reducing resolution at the output stage, if need be (such as for posting images on a Web site).

Safe Light
Black-and-white photographic paper is not sensitive to all colors of the visible spectrum, so in the darkroom a red or yellow safe light can be used. It should only produce a low amount of light as it will eventually fog the paper if the paper is exposed for a lengthy period. Black-and-white film, on the other hand, is sensitive to all colors, so a safe light cannot be used when handling the film before processing.

Salt Print
Salt prints were the first photographic prints to be produced on paper in the 1830s. They use a coating of silver nitrate, which is sensitive to light, but the action of this chemical is intensified by precoating the paper with sodium chloride (salt).

Scanner
A scanner records and converts negatives, slides (in some cases), and prints into a digital file, which can then be read by a computer. Light is transmitted through film or reflected off a print, which is then passed through a lens, digitally processed, and converted into pixels. The quality of the original scan will determine the final quality of the digital print from it.

Solarization
If a photographic image, on film or paper, is briefly exposed to light during processing, the underexposed shadows will be reversed and change the tonal range. This effect has been used since the 1920s to create photographs that have a surreal quality, most famously by Man Ray. Similar results can be produced digitally using Photoshop.

Stop Bath
Stop bath is a weak acidic chemical, usually acetic acid, which stops the action of the alkaline developer, before the film or print is fixed. As it neutralizes the developer, it will also prolong the life of the fixer. Most brands contain a color indicator, which changes from yellow to purple when the stop bath is exhausted.

TIFF
TIFF (Tagged Image File Format) files are the most popular standard format for processing and saving high-quality digital images for print.

Toning
The color or tone of black-and-white prints can be changed by using a variety of different chemical toners that convert the silver into different chemical compounds. They are either used as a single bath, or, in the case of sepia, the image is first bleached and then redeveloped in the toner to bring back the image in a brown color. Toners such as sepia, gold, and selenium can also be used to increase the archival qualities of a print.

USB
USB (Universal Serial Bus) is a common connection system and protocol to link computers with peripherals, such as digital cameras, scanners, and video cameras. As many devices will often be connected to a computer at the same time (for example, scanner, printer, hard drive, and camera), a USB hub can be fitted, which will allow multiple inputs to be linked to a single USB computer port. Many computers also include the faster FireWire connection system.

Wetting Agent
After washing, it is advisable to soak film in wetting agent, which is a very weak soap solution. This will disperse the remaining wash water from the }film evenly and should prevent drying marks appearing.

Index

Acknowledgements

I would like to thank the following for all their help, assistance, and contributions in producing this book:

Sharon Louise Aldridge; Sabine Bauer; Dean Chalkley; Danny Chau; Donald Christie; Ant Critchfield; Fineline Studios; Gaby Gassner; Brian Griffin; Tessa Hallmann; Britta Jaschinski; Allan Jenkins; Jakki Joyce; Ferial Kasmai; Michael Kenna; Terry King; Alastair Laidlaw; Kenneth MacBeth; Christine Marsden; Chris Middleton, my editor at Rotovision; Millennium Images; Renny Nesbit; Ralf Nöcker; Hiro Matsuoka; Richard Pullar; Martin Reed at Silverprint; Giles Revell; Kai Sander at Polycolor; Poppy Szaybo; Malcolm Venville; Spela Vrbjnac; Huw Walters; Michael Wildsmith; and Wolfgang Zurborn.

Finally I would like to thank my parents, George and Valerie Crawford, for all their support, and to whom this book is dedicated.